$25 —

The Nude in Art

D. M. Field

EXCALIBUR BOOKS/NEW YORK

Designed by Groom and Pickerill

Copyright © 1981 The Hamlyn Publishing Group

First published in the USA in 1981
by Excalibur Books
Excalibur is a trademark of Simon & Schuster
Distributed by Bookthrift
New York, New York

ISBN 0 89673 087 5

For copyright reasons this edition is only for sale
within the USA.

Composition in Baskerville by
Filmtype Services Limited, Scarborough, North Yorkshire

Printed in Italy

CONTENTS

Introduction

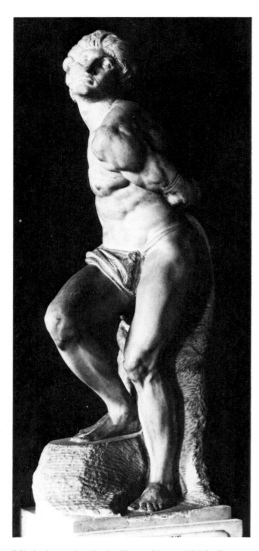

Michelangelo. *Rebellious Slave*. 1513. Some of Michelangelo's contemporaries thought his concentration on the male nude was a limitation, but his mastery of this limited field enabled him to achieve an extraordinary range of expression and profoundly affected the future of Western art. Musée du Louvre, Paris.

Far right: Agnolo Allori (Bronzino). *St. John the Baptist*. Probably before 1553. Borghese Gallery, Rome.

In nearly all the periods of greatest achievement in the history of Western art, the nude has been a major theme. Learning how to draw the human body used to be the first lesson taught in art schools, and it seems to have been taken for granted that the nude is somehow a basic form in the graphic arts. As a modern photographer of the nude described it, the nude is the 'epitome of all creation and the supreme transmutation of matter into form'.

All artists, including musicians and writers, are concerned with communicating the same kind of ideas, and among the many changing themes of art, one of the most enduring is Man himself. In the graphic arts and in sculpture, human ideas and feelings are communicated symbolically. The symbolism can be straightforward and obvious, as in a picture of a fat man over-eating to represent greed, or it can be more subtle and indirect. Since the Renaissance, European art has been especially concerned with the fate of the individual human being, and for that purpose the nude has been a rewarding form of expression. It is impossible to paint a human soul as the 'soul' is an abstract idea, but in a painting like Rembrandt's *Bathsheba*, a human soul is what we see portrayed.

The function of the nude as a means of expressing ideas or emotions is not the only reason why it has been such an attractive subject for Western artists. The nude has also been seen as a significant aesthetic form. Renaissance artists, influenced by the ideas of classical Greece, believed that there was a kind of perfect model for the nude figure which could be defined in mathematical terms. There is still prevalent a belief that any beautiful form, i.e. a shape that is pleasing to the eye, is related to the form of the human body. It is obvious to anyone that the flowing line in, for example, the shoulder of a wine bottle has a certain kinship with the outline of a woman's body, and according to this theory, the connection between the two is a causal one so far as the human eye is concerned: the shape of the wine bottle is beautiful *because* of this relationship. Volumes of profound aesthetic studies have been devoted to these questions, but the reason why we respond so positively to certain forms has not been satisfactorily explained; some primitive instincts may lie at the root of it.

It is interesting to observe how all the great artists of the nude have tended to concentrate on a comparatively limited number of forms. Even so vastly creative an artist as Michelangelo was constantly preoccupied by certain shapes and combinations of form, and the 19th-century painter Ingres was still obsessed by the same basic form of a seated woman half a century after he had first drawn her. The study of artists' sources shows how frequently these formal ideas were absorbed and transmitted by later generations.

The nude in art represents a beautiful form, and from 5th-century B.C. Greece to early 19th-century France, beauty was seen to exist largely as a matter of proportions: beauty, in a word, equals form. However, that is not the only possible conception of beauty, and in the modern period especially, 'beauty' has become rather an elusive concept. To some artists it is irrelevant. Jean Dubuffet complained that short-sighted people supposed that he enjoyed painting ugly objects: 'Not at all! I don't worry about their being ugly or beautiful; furthermore, these terms are meaningless to me. I even have the conviction that they are meaningless for everybody. I don't believe that these notions of ugliness or beauty have the slightest foundation; they are illusion.' The sculptor Henry Moore has denied that beauty is his objective: 'Between beauty of expression and power of

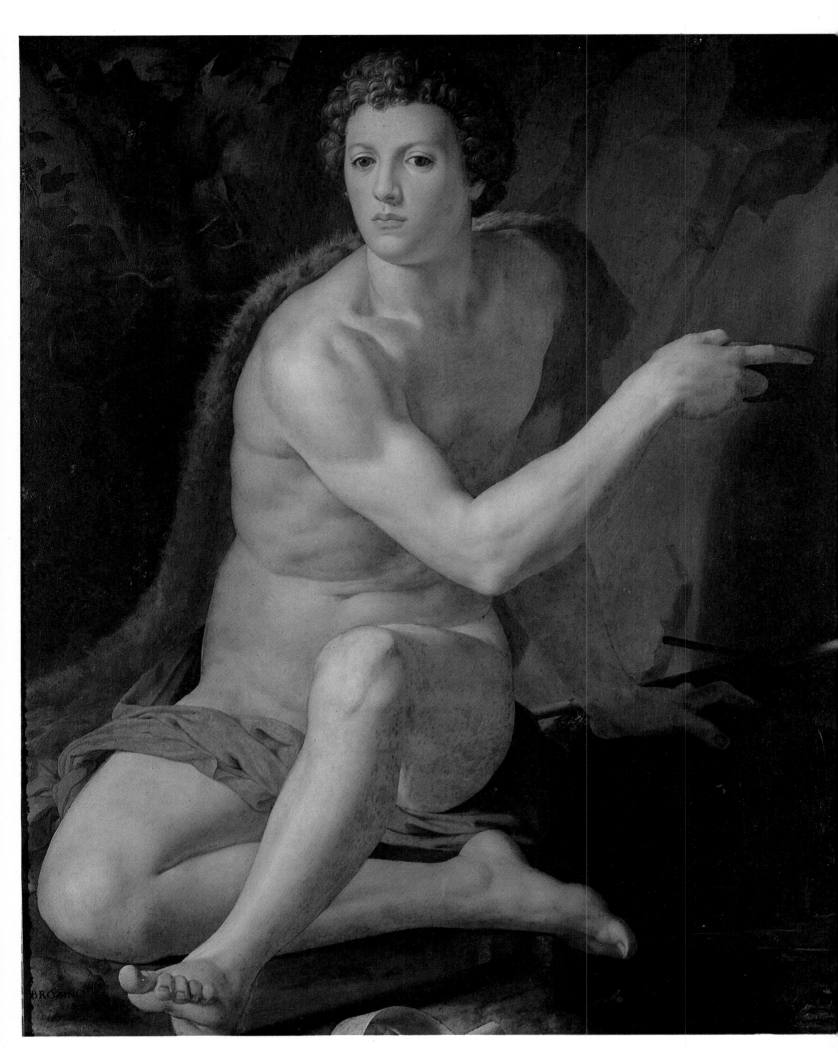

Right: Francis Bacon. *Triptych*. 1972. Bacon's brilliant handling of paint earned him a world-wide reputation and, like Michelangelo, he employed the male nude to express violent emotion and torment. Tate Gallery, London.

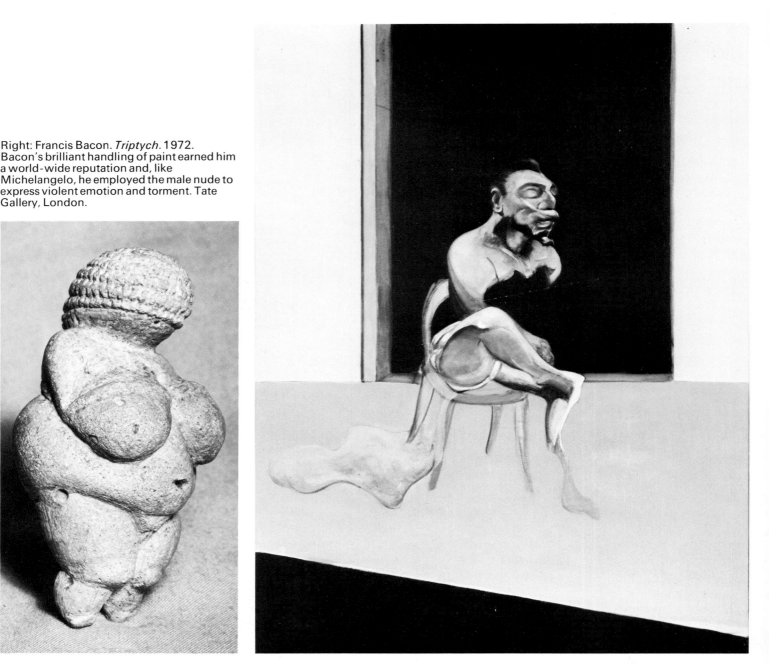

Above: The *Venus of Willendorf*, a Paleolithic carved limestone figure only 4½ inches (114 mm) high, found near the River Danube in Austria and assumed to be a figure symbolic of fertility. Naturhistorisches Archeologico Nazionale, Naples.

Far right: Otton Friez. *Le Printemps*. 1908. Musée d'Art Moderne de la Ville de Paris.

Overleaf: Titian. *Reclining Venus with Putto and Musician*. Given to Charles V in 1548. Museo del Prado, Madrid.

expression there is a difference of function. The first aims at pleasing the senses, the second has a spiritual vitality which for me is more moving and goes deeper.' Michelangelo might have said much the same.

When the Greeks said something was 'ugly', they did not mean that it was necessarily unpleasant to look at; they meant that its proportions were wrong. 'Ugliness' is not the same as absence of aesthetic value; if that were so we should have to throw away a great many modern paintings. No one would call the nudes of, for example, Georges Rouault or Max Beckmann or Francis Bacon beautiful, but no one would suggest they are not art. In the 18th century a distinction was drawn between the 'beautiful' and the 'sublime'. According to this idea, 'beautiful' objects were generally small in scale, delicate, perfectly defined, smooth and polished, while 'sublime' objects tended to be large, solid, rugged, dark and even gloomy, rather than light. An egg might be beautiful, a mountain sublime.

In art, the nature of the subject may be different from the nature of the artist's representation of it. Thus a painter may choose an 'ugly' object and make it, by his art, something in which we take pleasure. A naked man nailed to a cross might be assumed to be an object from which the spectator recoils in horror. As a matter of fact, certain Gothic carved crucifixes do have rather that effect, but in general our reaction to a crucifixion – as painted, let us suppose, by a Florentine artist – is very different. It does not seem horrible at all. The artist takes an

intrinsically horrible subject and transforms it by placing himself – his skill and imagination – between the object and the spectator.

The artist may of course create the opposite effect; he may take a subject which is generally assumed to be beautiful and make it into something startling, frightening, even 'ugly'. A nude woman we assume to be fundamentally 'beautiful' (especially if we base our judgment on paintings and sculpture rather than actual experience), but Picasso's *Demoiselles d'Avignon* are not beautiful; on the contrary, the original girls would surely have been far more attractive than Picasso's representation of them. The nude figures of primitive artists (by whom Picasso was, incidentally, much influenced) are seldom 'beautiful' in the conventional sense; they are more often, like the *Venus of Willendorf*,

grotesque. Their purpose was not to arouse a pleasurable response in the spectator, but had some deeper purpose, and were meant to inspire awe and respect, possibly fear. They represented an idea – the presence of an ancestor's spirit perhaps – which was conveyed by deliberate exaggeration or contortion of the human figure. They are therefore not 'beautiful' but rather 'sublime'.

The sculptures of classical Greece also represented an idea, though something less mystical and also less specific. They represented the idea of beauty with its associations of truth and virtue, and were not merely representations of beautiful young people. If they were, they would not rise far above the contemporary pin-up in terms of artistic value. It is to the Greeks that we owe our idea of the beautiful nude, and this idea has proved so powerful that even today,

when the legacy of classical Greece has been largely discarded, the nude remains a subject of interest to many serious artists.

Much worry and confusion has arisen over the relationship between artistic quality and eroticism. In the past, art historians often discussed representations of the nude in aesthetic terms exclusively, totally ignoring any erotic content. It seems to have been assumed that high art was by its very nature non-erotic, and there prevailed an idea, usually unspoken though occasionally stated frankly, that any erotic feelings communicated by a particular work of art actually detracted from its artistic quality. On the other hand, more recent writers on erotic art have tended to concentrate on erotic content alone, ignoring aesthetic considerations. There is, of course, plenty of material in which the erotic

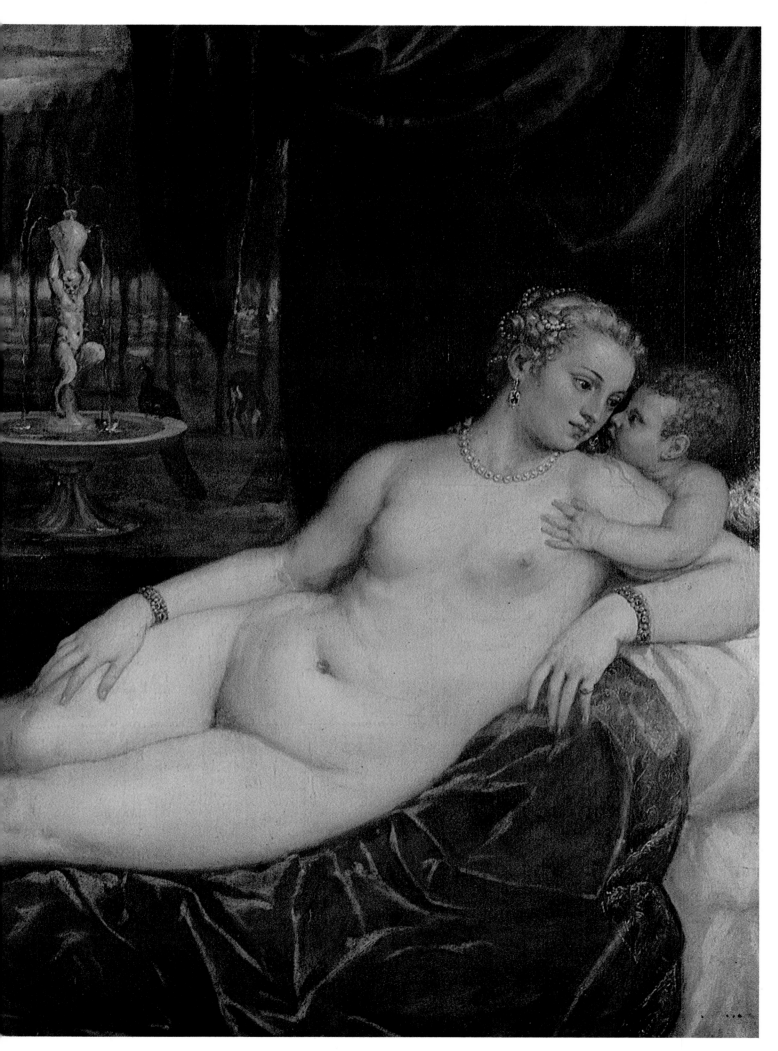

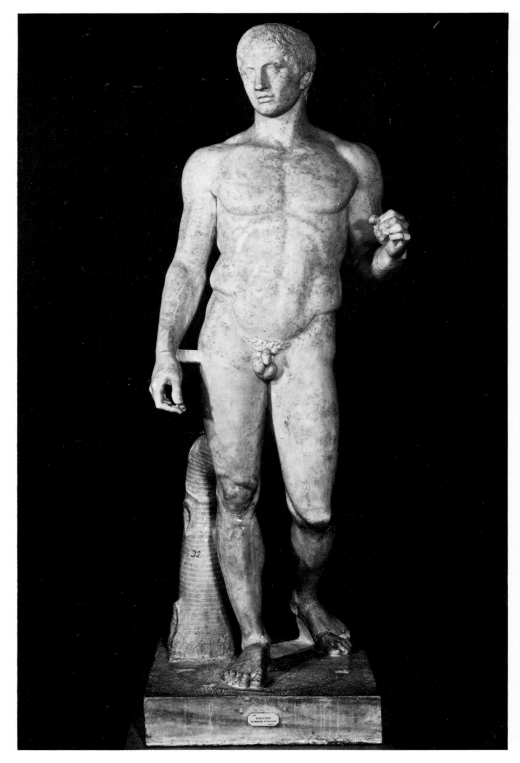

Polykleitos. *The Doryphorus*. This is a Roman copy of the 5th-century B.C. original, which was designed to illustrate Polykleitos's theory of the ideal proportions of the human body. Museo Archeologico Nazionale, Naples.

quality is dominant because it was created with no other purpose in mind, but it would be difficult to find in this narrow and unsubtle category any work which can be taken very seriously as art.

The uneasiness caused by art that is undoubtedly of the highest quality while at the same time undeniably erotic is largely a legacy of a fear of the body. We may associate this fear particularly with the Victorian age, but it is a factor of some influence in virtually the whole history of Christian society. Despite the so-called sexual permissiveness of the present age, we are still not free of it.

The subject of this book is not eroticism but the nude. A painting may be erotic without a square inch of flesh to be seen (one thinks of Cézanne's apples), and a nude is not by definition erotic. The nude in Western art is essentially an idea, and the idea of the nude in this Western sense scarcely occurs in the art of different cultures. Nude figures may and do appear in the arts of other countries, but with some exceptions they are mentioned in this book only insofar as they relate to the Western idea of the nude.

Prehistoric and Primitive Art

Making art seems to be a biological necessity for mankind. Every society that has ever existed which we know anything about has produced various forms of art – manufactured objects of some kind which have a more than utilitarian value. The first tool that man learned to make was probably a simple chopper, roughly fashioned from flint by flaking pieces off. The next stage was to make a better chopper, and this was not a very large step as there is a limit to what can be done by chipping flint. The third step was to go beyond that – to make a chopper that was more than a simple and efficient tool, perhaps to be used as a ritual implement in some form of sacrifice. It may have been made out of a material more precious, though no more efficient, than flint, or it may have been fashioned more carefully than was strictly necessary for the job of chopping. With this third stage, man was creating art, since the skill and labour that went into making the object were more than what was required to make a perfectly efficient tool.

The oldest art that we know is to be found in the caves of certain parts of southern France and northern Spain, dating from the Paleolithic or Old Stone Age, roughly between 20,000 and 10,000 B.C. The most striking examples are pictures of animals at Lascaux, Altamira and elsewhere, painted in rich reds, browns and yellows. The people who made the pictures were hunters, and the animals they painted were their prey. By painting an animal on the walls of their dwelling place they hoped to possess it in reality. These boars and buffaloes were not just good-luck tokens; in a sense, they *were* the animals. For that reason they were painted in a strikingly naturalistic way – they look exactly like what they represent. Human figures also appear in some of these paintings, often as hunters, but they are represented quite differently. Little stick-like men, they are not

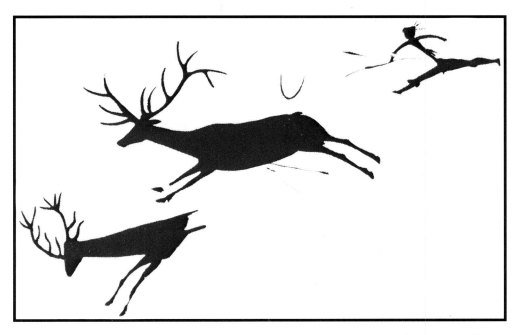

Paleolithic cave painting of a stag hunt, from the Valltorta Gorge in north-east Spain.

naturalistic at all and are often hardly more than symbols of human beings, like the earliest drawings of a child. The artists were clearly not interested in the human figure as a subject.

Other objects have been found in paleolithic sites among the jumble of stone tools and bones. The most interesting from the point of view of this book are certain small sculptures of female figures, carved from mammoth tusks or chunks of limestone. It may be that some of these statuettes and relief carvings are the earliest art objects that man created.

A well-known example is the little figure, less than 5 inches (127 mm) high, which is known (rather inappropriately) as the *Venus of Willendorf* and is probably about 20,000 years old. Apart from its age, no one could say that this is a particularly distinguished object. We would certainly not call it beautiful, although beauty, as the poet said, lies in the eye of the beholder and is a decidedly slippery term in art. The most obvious characteristic of these earliest female nudes is the exaggeration of the features associated with motherhood – fat, expansive hips and belly,

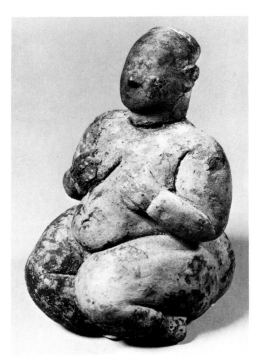

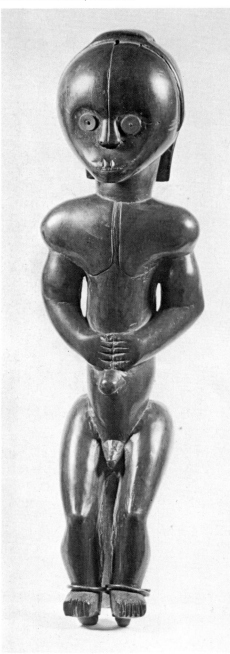

Far right: Carved wooden female figure with three children of the Afo people, Northern Nigeria, possibly a fertility figure used by a female secret society in rites associated with the first appearance of the young corn above the ground. Horniman Museum, London.

Right: a 'mother-goddess' terracotta figure from Çatal Hüyük in Anatolia, about 4 inches (102 mm) high, from the 6th millennium B.C. The figure was probably originally painted. Archeological Museum, Ankara.

Below: A carved wooden figure of the Fang people, Gabon, originally mounted on a box containing the bones of an ancestor whose spirit is immanent in the wooden figure. British Museum, London.

generous, pendulous breasts. Cosmetic beauty was of no interest to the people who made these figures; what did concern them was the continuance of the clan, fertile mothers and healthy children, and an abundance of food without which they would not survive. Although we cannot be sure of the exact significance of the *Venus of Willendorf* for the people of that distant Stone Age society, there is little doubt that she is some kind of symbol of fertility. She is a forerunner of the Earth-Mother figure, who was to play an important part in the culture of the earliest historical societies.

During the Neolithic or New Stone Age, very roughly between 10,000 and 2000 B.C., man ceased to be a hunter and became a farmer. He formed permanent communities and lived a more sedentary and technologically more complicated life, sowing crops, keeping animals, making pottery and more specialized stone tools. He had time, occasionally, to think about the world around him – why did the rain fall, the sun shine and so on – and he came to the conclusion that super-natural forces were responsible. In a word, he acquired religion.

Man's new awareness of the spiritual nature of the world and his new interest in thought and feeling produced dramatic changes in his art. He began to look for and to portray the spiritual essence of things, not just to represent their physical appearance. Art became more abstract. Artists still took their

imagery from nature, but it became transformed into stylized shapes and patterns. Generally speaking, when neolithic artists portrayed an animal or an object they aimed to capture the spirit of that animal or object, not just the way it looked.

African art of quite recent times shows this concept at work. According to religious belief in much of sub-Saharan Africa, the universe consists of spiritual forces. Everything is defined as a force – animals, trees, stones, people, even abstract concepts like time. The task of the artist in African society was to give these forces a concrete form, with the aim of capturing them for the benefit of the community. Nearly all traditional African art is in this sense religious in nature. The carved wooden figures of West Africa are always recognizably human, with head, body, legs and so on, but they are not naturalistic. They are often an assembly of geometric shapes (which were to exert a powerful influence on Cubism in Europe) and sometimes are embellished with mysterious symmetrical patterns, These decorative devices, as modern Europeans might call them, are intended to emphasize a particular spiritual characteristic or feeling, and though they are usually obscure to outsiders, they would have been perfectly comprehensible to the people for whom the figures were made.

The world of spirits is evoked in the art of many early societies, for instance among the people of the Pacific islands. Their strange and rather frightening figures must be judged by different standards than those that govern most European art. They are impressive, although often grim, and they are far removed from our usual idea of the nude, which is rooted in the art of classical Greece.

Much closer to this idea are the small female figures carved in marble from the Cyclades, a group of islands in the Aegean Sea. They are sometimes called idols and sometimes simply dolls; no one really knows just what their significance was, but they are probably related to the Earth-Mother figures, so pervasive in early human society, which were usually fashioned in clay. What makes them so interesting and attractive to us is that they have acquired a definite

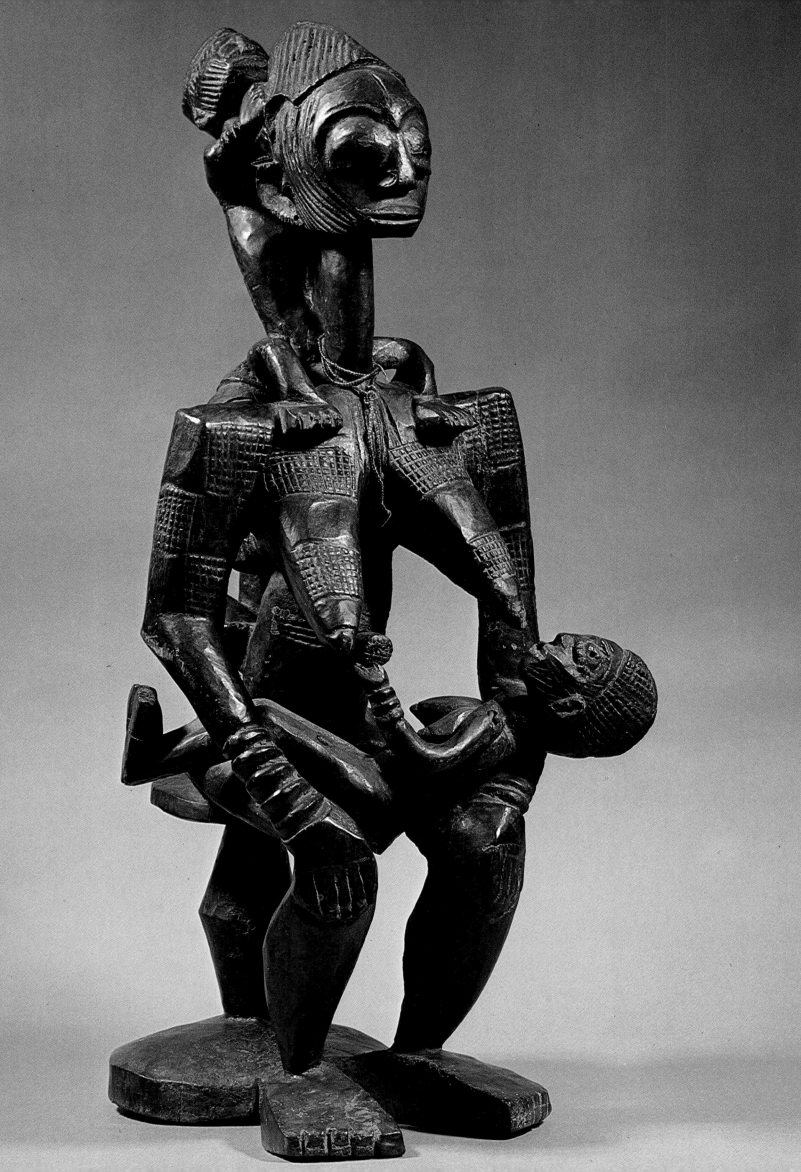

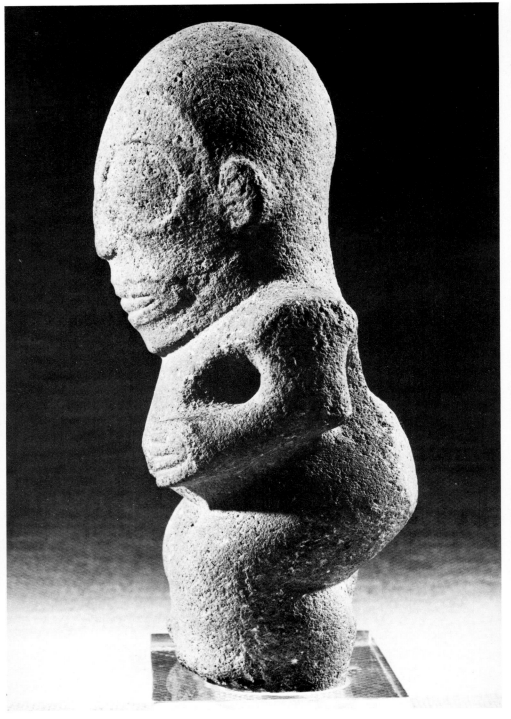

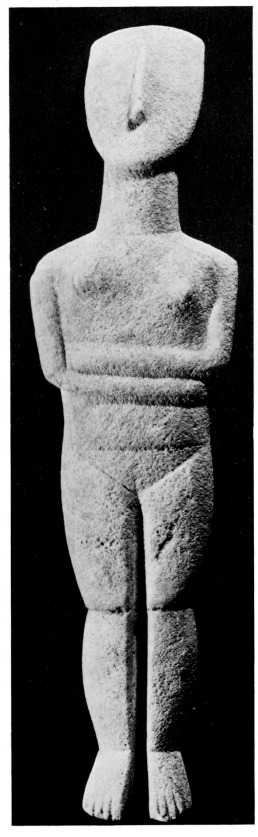

form and are more easily
recognizable as attempts to
represent the human figure
according to rules of proportion than
the grotesque symbolic carvings of
earlier times. Whatever ritual
significance they may have had, we
may perhaps detect in them the
earliest representations of the
human figure for its own sake, not as
a mere symbol of growth and
fruitfulness. They certainly appear
remarkably 'modern' to our eyes,
bearing an obvious similarity to the
efforts of some recent sculptors to
refine and reduce the female figure
to a simple, basic form. Some art
historians detect in these Cycladic
figures the influence of the island of
Crete.

A Bronze Age civilization (known
as Minoan, after the legendary King
Minos) flourished in Crete between
about 3000 and 1400 B.C. This
culturally rich society is usually
regarded as an ancestor of classical
Greece, though Minoan art is in fact
very different and perhaps easier to
relate to other Near Eastern societies
than to 5th-century Athens. One of
the most striking characteristics of
Minoan art is its interest in
movement, as seen in the famous
paintings at Knossos of athletes
leaping over bulls' heads. The
Minoans were not particularly

interested in the human figure as a subject, and people are portrayed according to conventions similar to those in other ancient Near Eastern societies – with faces in profile but eyes painted as if seen from the front, etc. Another convention in Crete was to paint men in red and women in white. Three-dimensional figures were usually small. The 'snake goddess', dating from about 1600 B.C., is bare-breasted because Cretan ladies normally dressed that way, not because the artist was especially interested in that feature of the female body.

To find the origins of Western art it is necessary to go farther back in time than the Crete of King Minos, to the ancient Near East.

The naturalism of the Old Stone Age had never entirely disappeared during the Neolithic era of more abstract, geometric concepts, and the tension between these two broad styles can be traced throughout the art of ancient Egypt and the Near East. In particular, the tradition of portraying animals naturalistically and human beings in a more stylized way continued well into historic times. In Egypt, broadly speaking, art tended to become less naturalistic and more formalized (following rigid, long-established conventions) as time went on. Under the Old Kingdom, roughly from 2700 to 2200 B.C., the figures of the dead which, carved in stone, stood in every tomb and temple, follow strict rules of symmetry derived from the block of stone out of which the figure was carved. The lines of shoulders, arms and legs are parallel to the rectangular outline of the original stone. The figure faces squarely forward, one foot slightly in front of the other but with the weight of the body resting equally on each, and the whole pose is unnatural. Within these strict rules, however, there is still room for strikingly realistic portraiture, the faces often seeming to be copied from life, and it is possible to imagine the subjects as individual human beings rather than stylized conceptions.

From about 2000 B.C., this element of naturalism disappeared almost completely. A king or a priest was not so much a man as a personification of authority, and a sculpture like the gigantic figure of Rameses II is not a portrait of a man, but is a symbol of pharaoh's power,

created according to strict conventions. The sheer size of the figure is also conventional: Rameses's queen is portrayed as a very insignificant figure by comparison, barely reaching as high as his knee. All this is, of course, deliberately artificial but must have seemed perfectly normal; after all, the Egyptians around 1500 B.C. had been accustomed to seeing their

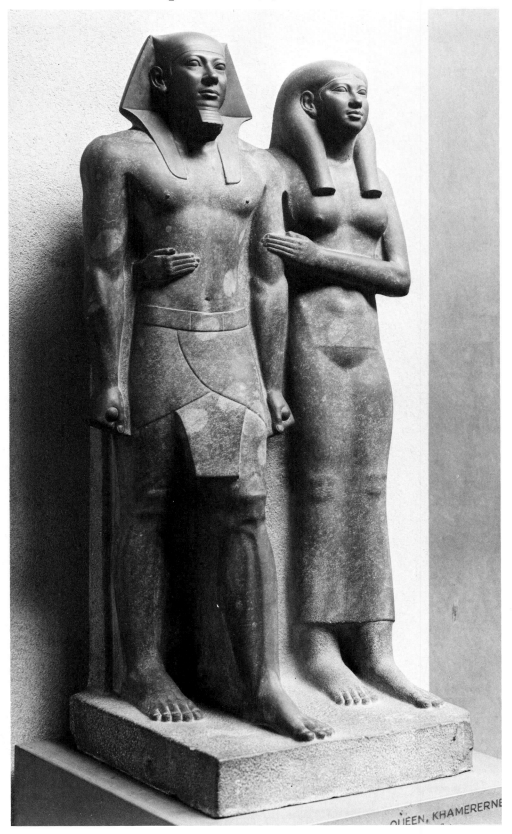

Mycerinus and his queen, carved in a type of slate, from Giza, about 2500 B.C. Museum of Fine Arts, Boston, Massachusetts. Museum Expedition Fund.

queen, Hatshepsut, portrayed as a man. No one thought that Rameses was really so much larger than his wife, nor did the ancient Egyptians have such wide shoulders and regular features as their artists suggested.

In paintings and relief carvings throughout the ancient Near East another curious custom, allied to the uncompromising 'frontality' of figures in the round, was to show a person half in profile and half front-on: the legs walked from left to right and the torso faced directly forwards. Each part of the body had a standard, characteristic shape and was always recorded in that way, regardless of whether reality demanded it. The standard pose for the feet, except in three-dimensional representations, was in profile, for the simple reason that it is much easier to draw a foot from that angle than from the front. Therefore, the feet are shown from that point of view even if the figure is facing outwards. The relief sculpture of Seti making an offering is a subtle, accomplished piece of carving, and the fact that the king has two right feet is not the result of a genetic freak nor absent-mindedness on the part of the artist; this is a conventional way of showing feet with the toes pointing towards the left. The legs are also in profile, though recognizably a right and a left leg; the chest faces forwards, the head again is in profile, but the eye is frontal. It is necessary to abandon the criterion of realism when judging ancient Egyptian art, just as it is when looking at much of the art produced in the 20th century.

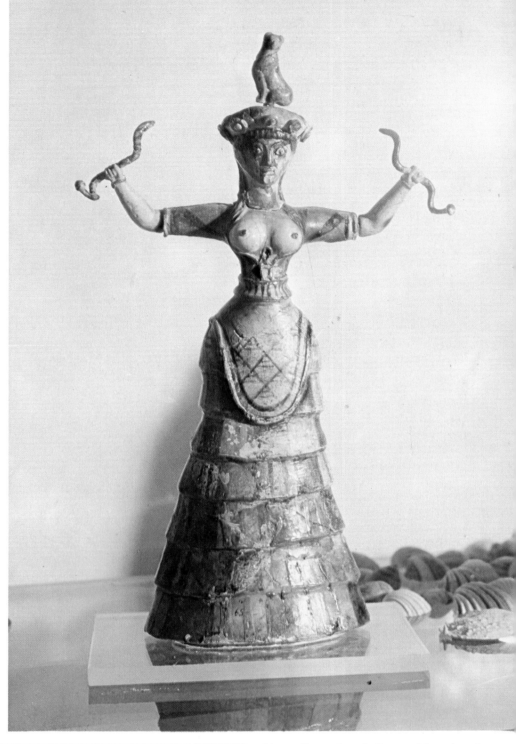

Above: Cretan famale figure with snakes, from the Palace of Knossos, about 1600 B.C. It is uncertain whether she represents a goddess, a queen or a priestess. Archeological Museum, Heraklion.

The gigantic figures from the temple of Abu Simbel in Nubia erected by Rameses II in the 13th century B.C. The figures are chiefly impressive for their sheer size, being about 65 ft (20 m) high.

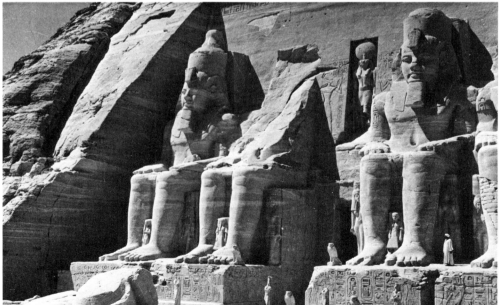

The Classical Nude

The ancient Greeks were the forerunners of modern Western civilization and they stand not only closer to modern Western man than other societies of long ago, but closer than a great many societies of much more recent times. In art, it was the Greeks who first began to represent man in what seems to us the natural way. It is not difficult for anyone to appreciate the beauty of a classical nude (or a classical building), but this very fact can lead to misunderstanding. However close we may feel to the ancient Greeks, their society and their ideas were very different from ours, and the motives of the Greek artists were not the same as the motives of modern artists – or Renaissance artists for that matter. It is also important to remember in this period, and in other periods too, that what was once a radical new departure or a revolutionary discovery may have become, over the course of time, something quite obvious which we accept without question and regard as perfectly normal.

The purpose of Greek art was to show the perfection of man and the gods, and to illustrate the superiority of Greek civilization over that of the non-Greek 'barbarians'. It had therefore a moral purpose, and when classical art is described as pagan, that means no more than that it was non-Christian, not that it lacked religious intent.

The gods of Greece were not abstract concepts, like the gods of other early societies. Zeus, Hera, Apollo and Aphrodite (better known by her Roman name of Venus) were divinities but they were also very human. The numerous myths told about them by Homer and Hesiod gave them individual characteristics and personalities. Unlike, for instance, the animal gods of Egypt, the Greek gods were seen in human form: Zeus might be able to turn himself into a bull or a shower of gold, but his true form was that of a man – a very magnificent man of

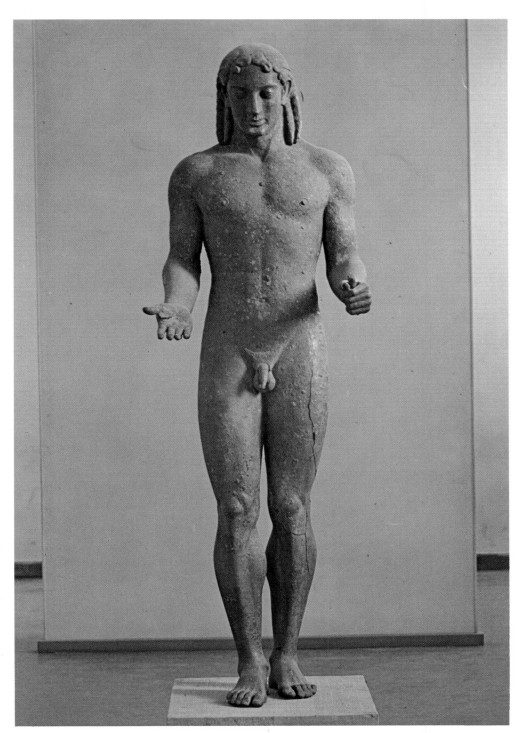

The bronze *kouros* from Piraeus. *c.* 530 B.C. An early example of the use of hollow casting by the Greeks. National Archeological Museum, Athens.

course. When the Greek sculptors came to represent the gods in bronze or in marble, they represented them as human beings but, because the gods were divine, it would not do for them to look too like ordinary men and women with all their physical imperfections. Impelled by religion,

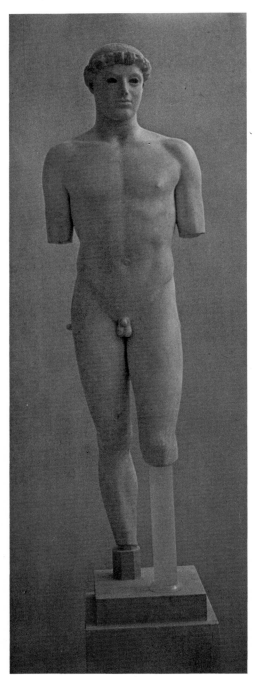

The Kritian Boy. c. 480 B.C. Generally regarded as marking the artistic revolution which occurred in Athens early in the 5th century and led directly to the highest achievements of Greek art. Acropolis Museum, Athens.

the Greek sculptors strove to achieve ideal perfection of form – something that was realistically human but at the same time displayed a degree of perfection that no ordinary mortal could attain. Thus the Greek Apollo became an idealized version of a handsome youth. In this sense, classical Greek art was not as 'realistic' as people sometimes assume.

The sculptors of 5th-century Athens were to achieve this aim with astounding success, but it was not achieved all at once. The Greek sculpture of the Archaic period (from the 7th century B.C. to the early 5th century B.C.) displays the steady development of their ideas and their technique. The most common figures of this period are the nude Apollos (not all of them were actually meant to be Apollo, though many were) which bear more resemblance to Egyptian traditions than to the nudes of later 5th-century Athens. Called *kouros* figures (*kouros* means 'young man') they are stiff, 'frontal' figures, with one leg forward but the weight evenly distributed, and arms straight down at the sides. They wear the vacant, slightly smug expression characteristic of nearly all Archaic figures. The original rectangular block of stone from which they were fashioned is still evident in the lines of the finished figure, and it is clear that the sculptor's nerve failed him while he was chipping away the space between the arms and the body: unwilling to risk a break which would ruin his work, he left the hands – and sometimes, as in Egyptian statues, the whole of the arms – attached to the sides. The general impression is of a soldier performing the slow march, and not finding it a very comfortable exercise.

By about 600 B.C. some signs of what was to come were already evident. Greek artists were not bound by long-established conventions like their Egyptian counterparts; if they had been, they of course would have made little aesthetic progress. On the contrary, they were eager to experiment. This can be seen, for example, in tentative efforts to outline the muscles of the torso. Compare the two *kouros* figures (pages 19 and 21), both created during the 6th century B.C. but the second at the very beginning of it and the first towards the end of the century. The first figure is one of the few large bronzes to have survived from ancient times (it was discovered in the 1950s by workmen digging a drain in Piraeus, the port of Athens), and the discovery by the Greeks of the technique of hollow-casting in bronze was an important step in their artistic progress. Nearly all the most famous sculptors of 5th-century Athens preferred to work in bronze – making the original model in clay, which is much easier to work than marble – although, unfortunately, we often know their work from marble copies only. Bronze was all too easily melted down for other purposes.

Both these figures clearly belong to the established conventions of the Archaic period, but there is a vast difference in feeling. The stance of the later figure is still rather stiff and 'frontal', but there is a much greater sense of rhythm, and the different parts of the body flow into a more harmonious whole than in the earlier *kouros*, where different areas seem to run together rather uneasily. Perhaps it should be noted that this effect may be accentuated by the fact that the figure was assembled from broken pieces found near the temple of Poseidon at Sunion; the left arm was missing altogether and had to be replaced by a modern one. Although the device of long hair is still used in the bronze *kouros* to strengthen the neck area – always vulnerable in free-standing statues, hence all those headless marble figures from the gardens of villas – the arms have sprung away from the sides; originally, there was probably a bow in the left hand. Altogether, enormous progress has been made in the course of two or three generations; Archaic conventions have not yet been discarded, but the intense interest of the sculptor in the anatomy of the human body has modified them considerably, and the figure is far more human and lifelike. For the first time, artists are taking a close interest in the nude as a subject in itself. In the relief sculptures of the late 6th century we can see that artists were also becoming more interested in movement, though still unable to escape from Archaic conventions.

The word 'revolution' is sometimes used too freely to describe changes in history, but if there are any revolutions in art, then surely one of them occurred in Athens near the beginning of the 5th century B.C. The suddenness of the breakthrough may have become exaggerated in our eyes because we are not aware of all the developments leading up to it, but it certainly was sudden nonetheless. Social and cultural changes are often speeded up by the

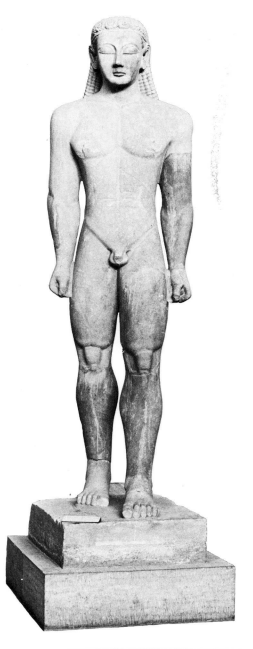

Kouros from Sunion, marble, 10 ft (3 m) high, about 600 B.C., an example of Archaic sculpture, which was reconstructed in recent times from broken fragments. National Archeological Museum, Athens.

effects of war, and early in the 5th century Greece was attacked by the mighty empire of Persia. Against the odds, the Greek city-states successfully combined to defeat the invaders, and this tremendous victory marked the beginning of the Golden Age of Greece, a period of prosperity, confidence and extraordinary achievement in literature and the arts, with Athens the leader (though her leadership was not undisputed) of the proud city-states. Like most golden ages, it did not last very long. The Peloponnesian War (435–404 B.C.) ended the dominance of Athens and drastically weakened the whole city-state system. In 338 B.C. the Greek cities were absorbed into the empire of Philip of Macedon (father of Alexander the Great) and that event can be taken as a convenient point roughly signifying the end of classical Greece.

The *Kritian Boy*, so called because this may be the work of the sculptor Kritios, was probably made shortly before 480 B.C., when it was knocked down by the Persians in their attack on the Acropolis of Athens. It represents the dramatically sudden and successful completion of the 5th-century revolution in Greek art. The conventional Archaic standing figure has utterly vanished: rigidity and awkwardness have been replaced by easy balance and rhythm. It is easier to see the vast step forward that has been taken than to describe it in words, because the changes, though so striking overall, are in fact quite subtle. The head, for instance, still looks forward, but not dead square; there is a very slight inclination, just

enough to seem natural, and the rather irritating smirk of the Archaic style has been replaced by a calm and thoughtful expression. The body is no longer an assembly of awkwardly associated parts; it is beautifully articulated and rhythmical, showing an unprecedented mastery of human anatomy. One foot is still slightly forward of the other, but no longer in the stiff stride, like that of a wooden doll, seen in the older statues, for the weight is now resting more on one foot than the other. We would be able to recognize this even if the whole of the legs was missing because the sculptor has carried the stance skilfully through to the hips, one being slightly higher than the other. But no description of technical changes can convey the extent of the revolution that has occurred. The sculptor has achieved that union of naturalism and idealism – of the human and the divine – for which his predecessors had been striving. The *Kritian Boy* is, as Kenneth Clark wrote, 'the first beautiful nude in art'.

The sculptor of the *Kritian Boy* has not solved all the technical problems of sculpture in the round, although some people may feel that the additional freshness and charm of this sculpture more than compensate for its small deficiencies. In the event, it leads directly to the apex of Athenian achievement in the mid-

Athletes sculpted in relief on a stone slab, late 6th century B.C., with a pair of wrestlers and (right) a javelin thrower making adjustments. National Archeological Museum, Athens.

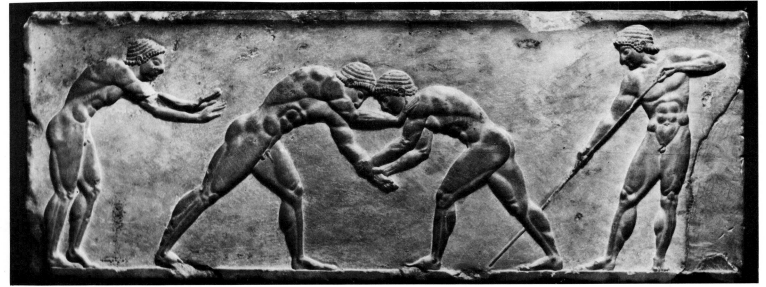

Far right: *Discus Thrower*, after Myron. Roman copy of the Greek original of *c*. 460–450 B.C. The original figure was in bronze. Myron was famous for his naturalism, and it is said that his sculptured cow in Athens attracted moos of greeting from passing cattle.

Right: The bronze figure of Poseidon (possibly Zeus) found off Cape Artemision less than sixty years ago and dating from about 460 B.C. National Archeological Museum, Athens.

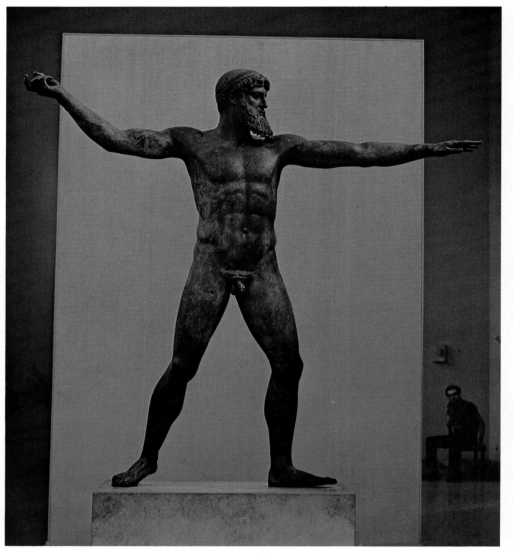

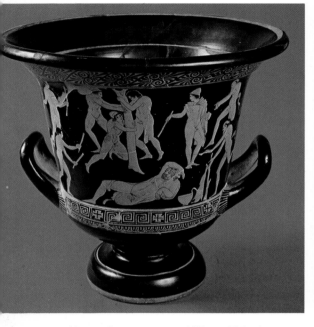

Above: Calyx krater. *c*. 425 B.C. 18 inches (45.7 cm) in diameter, red-figure pottery from the Greek colonies in southern Italy, showing the companions of Odysseus about to blind the one-eyed giant Polyphemus. British Museum, London.

5th century, when such great sculptors as Polykleitos, Myron and Pheidias flourished. They worked mainly in bronze, and therefore we know them almost exclusively through marble copies made by lesser artists in later times. To be frank, these copies, as representatives of one of the highest points human art has ever reached, are often rather disappointing. Although some Roman copies are very distinguished, they can only give an approximate idea of what the original looked like. When we hear, for example, that one of the great figures of 5th-century Athens was noted particularly for his surface texture, and that this was one of the most remarkable distinctions of his style, we can only shake our heads ruefully, for that could obviously not be reproduced in a marble copy, no matter how skilful. However, the existing copies, plus one or two possible originals, together with the opinions of the sculptors' contemporaries, give us enough information to form a reasonable judgment of their work. It is unlikely, as some critics have suggested, that the quality of the sculpture of 5th-century Athens has been exaggerated in modern times.

There are a number of small bronzes surviving from classical Greece and there are also one or two life-size figures, most of which escaped destruction because, like the *Venus de Milo*, they were sheltered by the sea for hundreds of years. We have seen one example already. Another, even more exciting, was the discovery off Cape Artemision in 1928 of a bronze figure of a bearded god. At first it was thought to be Zeus in the act of hurling a thunderbolt but it is now generally believed to be Poseidon, god of the sea, throwing his trident, although Poseidon was usually portrayed as a rougher fellow than this powerfully calm figure.

If bronze sculptures are sadly scarce, paintings are even scarcer: in fact, none at all has survived from this period. Fortunately, pottery is tougher, and a remarkable number

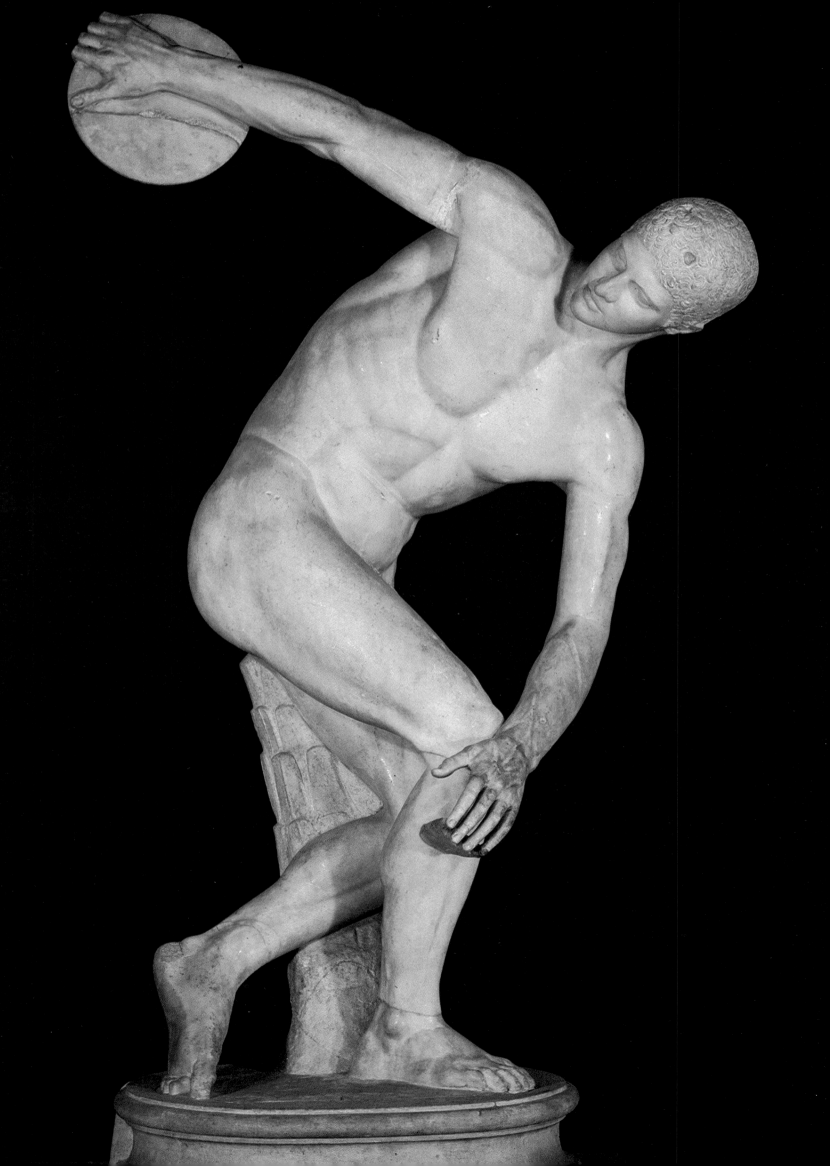

of Greek vases can be seen in the museums of the world today. Pottery was painted with scenes from mythology similar to those which inspired artists in other media, and while some of the decoration is the work of copiers not especially talented themselves, other pieces show the hand of a genius at work.

Once the Greek sculptors had broken away from the constricted, static figure of the Archaic period, they began to experiment with a wide variety of poses showing action and movement, usually in figures of athletes or warriors in battle. The sculptures from the Parthenon now in the British Museum are among the most familiar examples, and the bronze *Poseidon*, which was probably made about 460 B.C., is one of the earliest examples of a free-standing figure in action. Accomplished though it undoubtedly is, it is not completely successful in suggesting that a spear is being thrown. The sculptor was so concerned with establishing perfect balance that the figure remains rather static. As Lord Clark pointed out, if it had been only the torso that had been found, we should not have been able to tell that it belonged to a figure in action; it might equally have belonged to an orthodox standing figure.

A better attempt was made by Myron in his immensely popular sculpture of the *Discus Thrower*. Many copies were made of this work, one of the most famous pieces in the history of art, and even without the original we can see what a remarkable achievement it was. Myron managed to create the perfect symbol of the body in action while sacrificing none of the strict rules of symmetry which governed the work of 5th-century sculptors. Unlike the bronze *Poseidon*, who really looks as though he is posing rather than throwing in earnest, the discus thrower is caught at an instant of perfect balance in his wind-up, an instant so brief that, in real life, the eye could never catch it. Slow-motion films of athletes throwing a discus have been carefully studied by those who want to prove when, or whether, the moment caught by Myron ever actually occurs, but with no very definite results.

In a sense, the experiments with vigorous action were a false turning for classical sculptors. It was all-but-impossible to achieve realistic action and movement while remaining faithful to the rules of Euclidian geometry which were the basis of classical art, and in the later 5th century artists largely abandoned

action in favour of stationary figures.

To the uninformed eye it may not be easily apparent that classical sculpture is based on rules of geometry scarcely more flexible than the rules of physics. Polykleitos said that every line of his figures was carefully calculated, from the toes to the hairs of the head. We know that his rule for height was $7\frac{1}{2}$ times the measurement of the head, but unfortunately his whole system or code has not survived. Just how complex and subtle it was may be guessed from the fact that no one has ever been able to reconstruct Polykleitos's system by studying copies of his works. He had a standard scheme or plan for the torso which followed human anatomy closely enough for armourers to use it when they were making breastplates.

The citizens of Athens said that, although Polykleitos was unsurpassed at depicting men, he was less successful with gods, meaning that he just failed to achieve that divinely ideal form for which sculptors aimed. The man for a god, they thought, was Pheidias. It is therefore all the more regrettable that we have even less experience of the work of this supreme artist of Pericleian Athens than we have of

other 5th-century sculptors. We do know, however, that Pheidias was put in charge of the building of the Parthenon by Pericles, a personal friend, and it is likely that he worked on some of the sculpture that adorned that superb building. It is tempting to see the hand of the master in, for example, the reclining figure which is thought by some to represent the god Dionysus, now in the British Museum. Though rather mutilated, it makes a forcible impression of grandeur and strength, yet the pose is relaxed and thoughtful: 'one of the most grandly conceived nude figures in the whole history of art,' wrote Donald Strong, who as a curator of Greek and Roman art in the British Museum could gaze daily upon this wonderful sculpture in his charge.

The fundamental inspiration of art in mid-5th century Athens came from two sources: Greek religion and the greatness of Athens herself. The Pelopponesian War brought the rule of Athens to an end, and it coincided with – and perhaps helped to cause – a decline in religion. The gods became less mysterious, less awe-inspiring; their petty human characteristics became more pronounced, their divinity less so. Such changes in society were naturally reflected in art. In any case, strictly classical art had been brought to a pitch of perfection in Pericleian Athens which could hardly have been excelled, and perfection, in art as in other things, can quickly become stultifying. No serious artist can be expected to continue faithfully in the path followed by his predecessors when the end of the journey has already been reached. Art, if it is not to descend into lifeless copying, must change. The severe ideal that had governed Pheidias began to be abandoned; strict rules were relaxed a little, and new interests appeared. Of course the Greeks did not abandon their intense interest in the human body, nor did they cease to regard the nude as the noblest form in art. But until this time practically all nudes were male. The Greeks were accustomed to the sight of naked men, as athletes in the Olympic Games competed nude, but, except in Sparta, the naked female body was a less common sight. Figures of goddesses and women were always clothed,

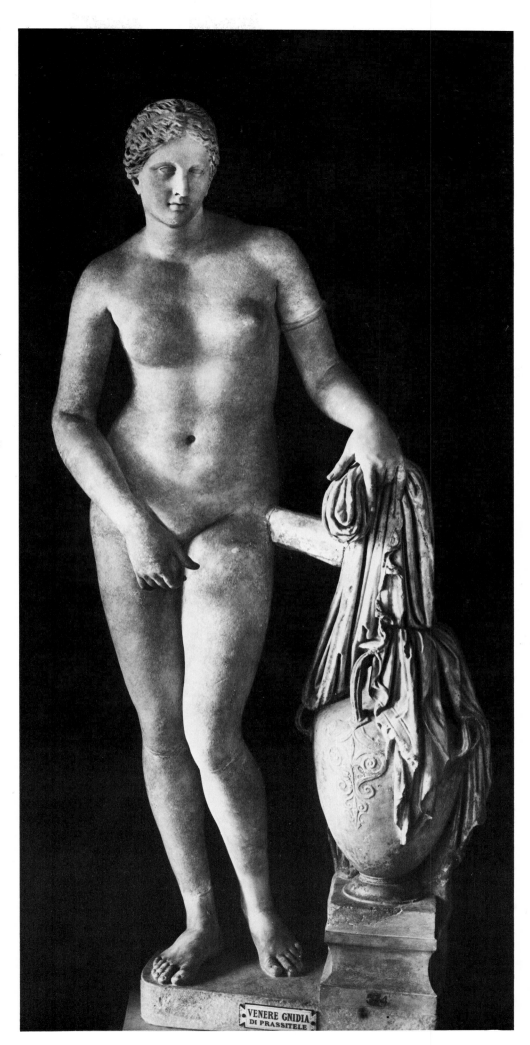

Far right: Praxiteles. *Hermes with the Infant Dionysus*, marble, about 350 B.C., a rare example of a surviving Greek original. Archeological Museum, Athens.

Left: An athlete with *halteres* (weights held in the hand to facilitate jumping), from a Greek vase. 510 B.C. Athletes in ancient Greece competed nude, and the male body was no mystery to Athenian sculptors. British Museum, London.

Below: Reclining figure of a river god (*c.* 440 B.C.) from the west pediment of the Parthenon and now among the Elgin Marbles in the British Museum, London.

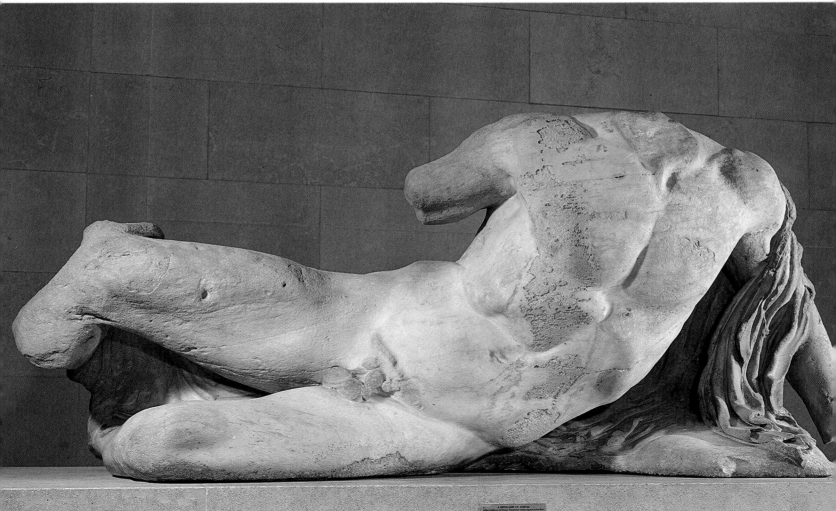

although latterly the clothing had been growing more and more skimpy, and the artist's interest in the flesh and bone beneath had become increasingly obvious. Now, in the 4th century, attention was focused on the female. The nude Aphrodite joined her brother Apollo.

The most famous of the sculptors of the new age was Praxiteles, whose delicate touch was perhaps better suited to the smoother lines of the female nude. He liked to work in marble as well as bronze, probably preferring the silky finish of marble and, thanks to that preference, there remains at least one standing figure which can without much doubt be ascribed to him. As it happens, it is a male nude, *Hermes with Dionysus as an Infant*. It is a much less athletic figure than those of Polykleitos, for example, but perhaps to our eyes more beautiful. In fact, if one were forced to pick a single statue to represent the peak of the Greek passion for beauty in the male nude, the *Hermes* would be a tempting choice. But it was for female nudes that Praxiteles was best remembered, in particular for his *Cnidian Venus* of about 350 B.C., of which there must be about fifty surviving copies. According to tradition, the *Cnidian Venus* was modelled on Praxiteles's mistress, and this is a significant new departure: the ideal nudes of the 5th century were not based on human models. In fact, Praxiteles's *Venus* is still an 'ideal' figure – more a fulfilment of academic rules than a thoroughly realistic portrait, beautiful but not very sensual. She is the prototype for an enormous number of rather similar Venus figures in the Greek world.

Praxiteles was not the only great sculptor at work in Greece around the middle of the 4th century B.C., his contemporary Scopas being regarded no less highly by the discriminating Greeks. He was especially brilliant at portraying strong emotions – artists were regaining an interest in the depiction of action which had been abandoned in the late 5th century – but unfortunately there is very little left that can be attributed to him. Finally, a slightly younger man, Lysippus, had a great reputation in the late 4th century. He represented the growing interest in realistic

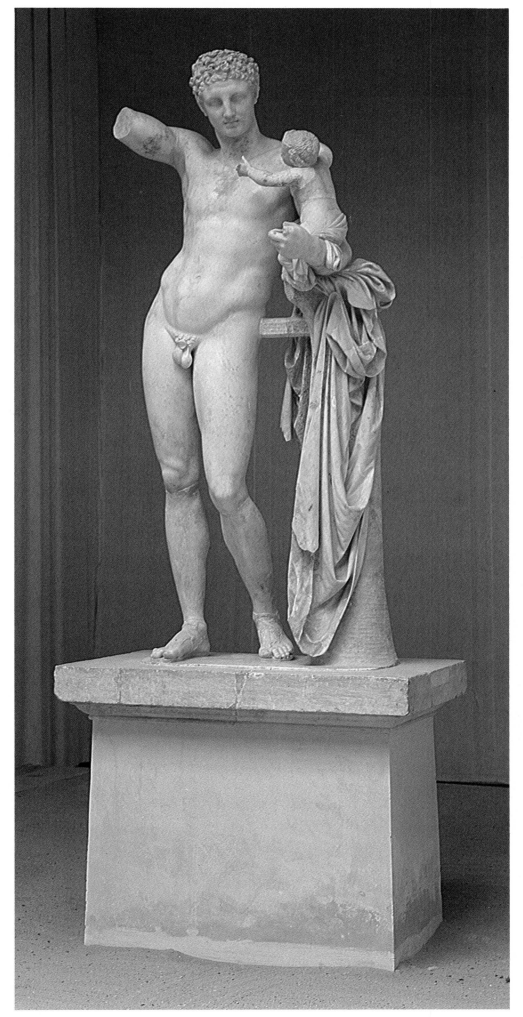

Far right: The *Laocoön* group of the 1st century B.C. impressed Renaissance artists with its emotional power, though to some modern eyes it seems theatrical. The incident illustrated occurred in the Trojan War, when Laocoön and his sons were killed by a serpent from the sea. Musei Vaticani.

Right: *Venus de Milo*, or Aphrodite of Melos. *c.* 100 B.C. Thanks to its preservation by the sea, this female nude in the tradition of Praxiteles is today perhaps the most famous of all ancient statues. Musée du Louvre, Paris.

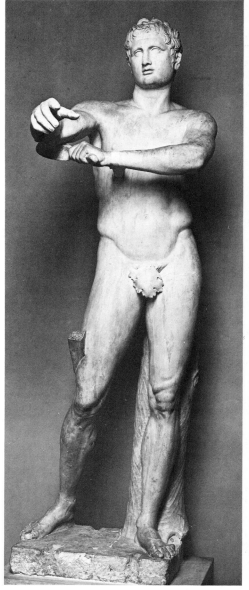

Above: The *Apoxyomenos* of Lysippus, an athlete scraping himself with a strigil. Roman copy of a Greek bronze of *c.* 325–300 B.C. Musei Vaticani.

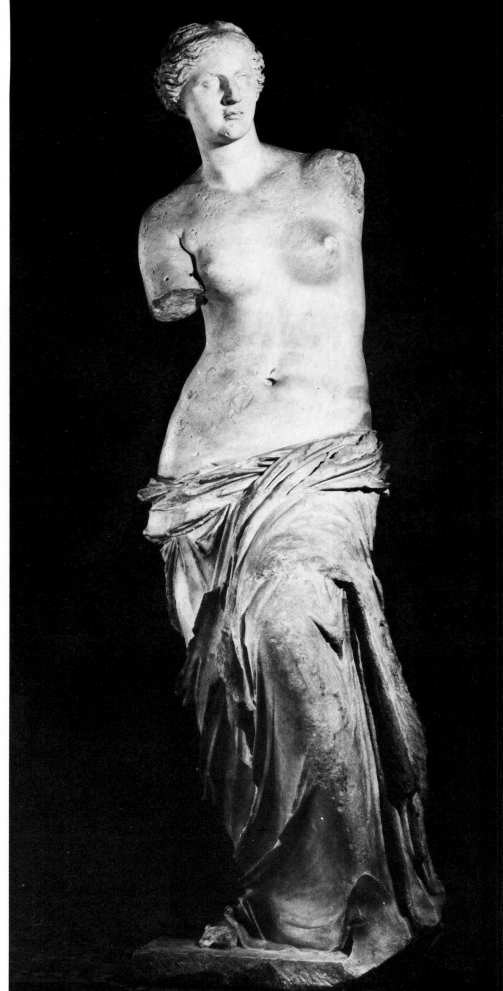

portraits – Alexander the Great was one of his subjects – and, like Scopas, he made a number of groups (i.e., more than one figure) sculpted in the round. His is the last great name among classical Greek artists. With the coming of Alexander the Great the old Greek society disappeared.

Alexander and his successors established a huge world empire, made up of many different peoples. The cultural basis of Alexander's empire was Greek, and the name given to this society and its art, from the late 4th century to the 1st century B.C., is Hellenistic, which in fact means simply 'Greek'. Hellenistic art is enormously varied and therefore impossible to describe in a few words. Although Greek traditions remained strong, Oriental influences also had an effect. There was a great mingling of different styles, combined with a spirit of restless experiment and constant curiosity, though decreasing originality in any but a superficial sense. Perhaps the single most important difference between the classical Greek and the Hellenistic age is that art became something to enjoy. It is quite obvious that the great Athenian sculptors worked with a consuming love of their subjects; they took a sensual delight in the way skin ripples over bone and muscle. But their art was still essentially moral in purpose: it was meant to instruct, to serve the interests of their own community and to glorify their religious and political beliefs as well as to express purely aesthetic ideas. In the Hellenistic age artists no longer worked for their community. More often they worked for a rich patron, like the artists of the Renaissance, and they were hired to create objects which were purely enjoyable and ornamental. Some works were even intended to raise a smile, like the humorous group of Venus, Eros and Pan, which was made for a rich Syrian merchant. This is decorative art; it preaches no moral message.

Hellenistic art produced some of the finest nude figures, especially groups, that we possess, though its sheer variety and eclecticism, often showing a strikingly profound knowledge of earlier traditions in Greece, makes it, taken as a whole, rather indigestible. Art historians, by careful study, have distinguished numerous schools, influences and

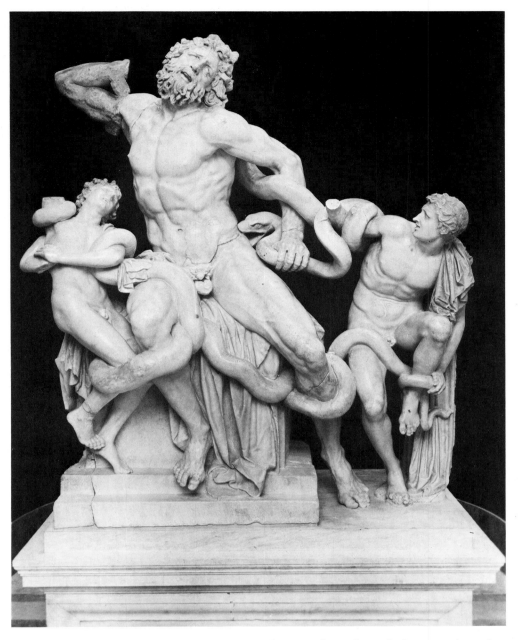

styles, sometimes on what seems very slight evidence, but it is only necessary here to pick out some of the high points in the development of the nude.

Lysippus, Praxiteles and other great sculptors of the past had their disciples who developed the traditions they had established. For example, many very pretty young men can be seen in debased versions of the Lysippus *Hermes*, and what has become probably the most famous female nude in the world, an international symbol of feminine beauty, is clearly in the exquisite tradition of Praxiteles, though made over a century after his death. This figure, which is now in the Louvre (thanks to the French explorer Dumont d'Urville, who was present when it was found in 1820), is the *Aphrodite of Melos* or, as she is better known, the *Venus de Milo*. For a time

she was thought to belong to the 5th century, but she is clearly a Hellenistic work: the sophisticated curves of the figure's general pose are foreign to the simple ideal of Praxiteles. Hellenistic artists constantly attempted new poses, striving at one time for greater realism or for a more powerful and immediate emotional effect. 'In the female nude,' wrote Lord Clark, 'there is hardly a single formal idea of lasting value which was not originally discovered in the 4th century.'

One of the most striking of all Hellenistic marbles is the group of *Laocoön and His Sons*, which illustrates an incident in the Trojan War as narrated by Homer. To say, as some experts have done, that it smacks rather too much of showmanship in its bravura treatment of the human body under extreme stress is carping

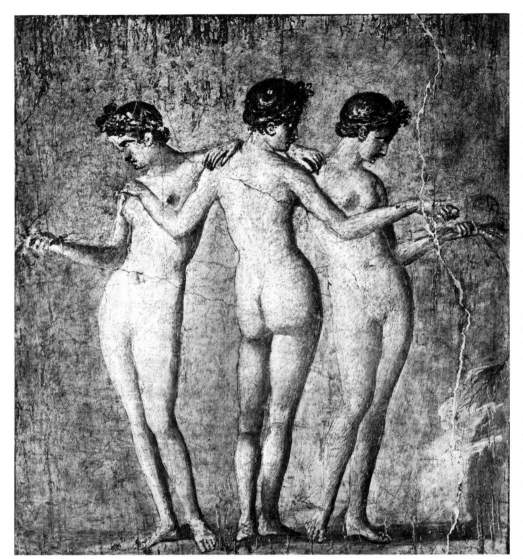

Above: The Three Graces were a favourite subject of decorative art. This example comes from a fresco at Pompeii.

Far right: *Aphrodite, Pan and Eros*. *c.* 175 B.C. Some Hellenistic sculpture had no higher aim than decoration; the gods and goddesses became creatures of light-hearted entertainment. National Archeological Museum, Athens.

criticism, although the work does not have quite the same effect on us that it had on Michelangelo, for example, when it was discovered in Rome in 1506.

On the whole, Hellenistic artists were perhaps more successful with groups than with single nude figures. An extremely attractive subject, which became very popular, was the Three Graces – the three goddesses, also called the Charities, who were vaguely associated in Greek mythology with Aphrodite, and were usually portrayed as three dancing maidens. They are found on pottery and as decoration on objects such as mirrors, as well as in sculptures and paintings of the Roman period. There was less distinction between 'art' and 'craft' in ancient times, and the same artist might be responsible for a life-size statue in marble and for a silver-backed mirror.

There are very few nudes in paintings from this period, but the reason is not that painters avoided the subject, merely that so little of Hellenistic painting has survived.

Notable exceptions are the wall paintings in the Villa of the Mysteries at Pompeii, preserved through the ages by the volcanic debris that destroyed the city in 79 A.D. Not many years ago female tourists were refused permission to view these paintings, and although they hardly seem very shocking now, there is no doubt of their powerful eroticism. No one is entirely sure of what went on in the Villa of the Mysteries, but the general explanation is that these paintings illustrate an initiation ceremony for a cult connected with the worship of Dionysus, which apparently included ritual flagellation. Although the painter made little attempt at illusionism – three-dimensional effects – and the total effect is rather flatter than in some other wall paintings of Pompeii, the human subjects are very expressively portrayed.

During the 2nd century B.C. most of the Hellenistic world came under Roman influence and, by the end of the 1st century, under Roman rule. The Roman Empire extended over most of the known world – not only the Hellenistic kingdoms of the east but also the 'barbarian' tribes of Europe to the west. Although Roman art had many independent characteristics, it was basically a continuation of the Greek tradition, and there is no clear dividing line between Hellenistic and Roman art. Through their predecessors in central Italy, the Etruscans, and through their own conquests, the Romans were well acquainted with the Greek artistic tradition, which they greatly admired. The demand for Greek works of art among upper-class Romans was insatiable; it gave rise to much copying of Greek art by unpretentious artists but also gave birth to some works that were not unworthy of comparison with the best of the past. In the Roman Empire, however, artists were not such great figures as they had been in classical Greece. Although the state became once again the chief patron of the arts, the artist was not an important local personality, as he had been in classical Athens, but the servant of a vast empire; his station in life was no higher than that of a superior craftsman, and few artists of this period are known to us by name.

What we may think of as a 'typical' Roman sculpture is

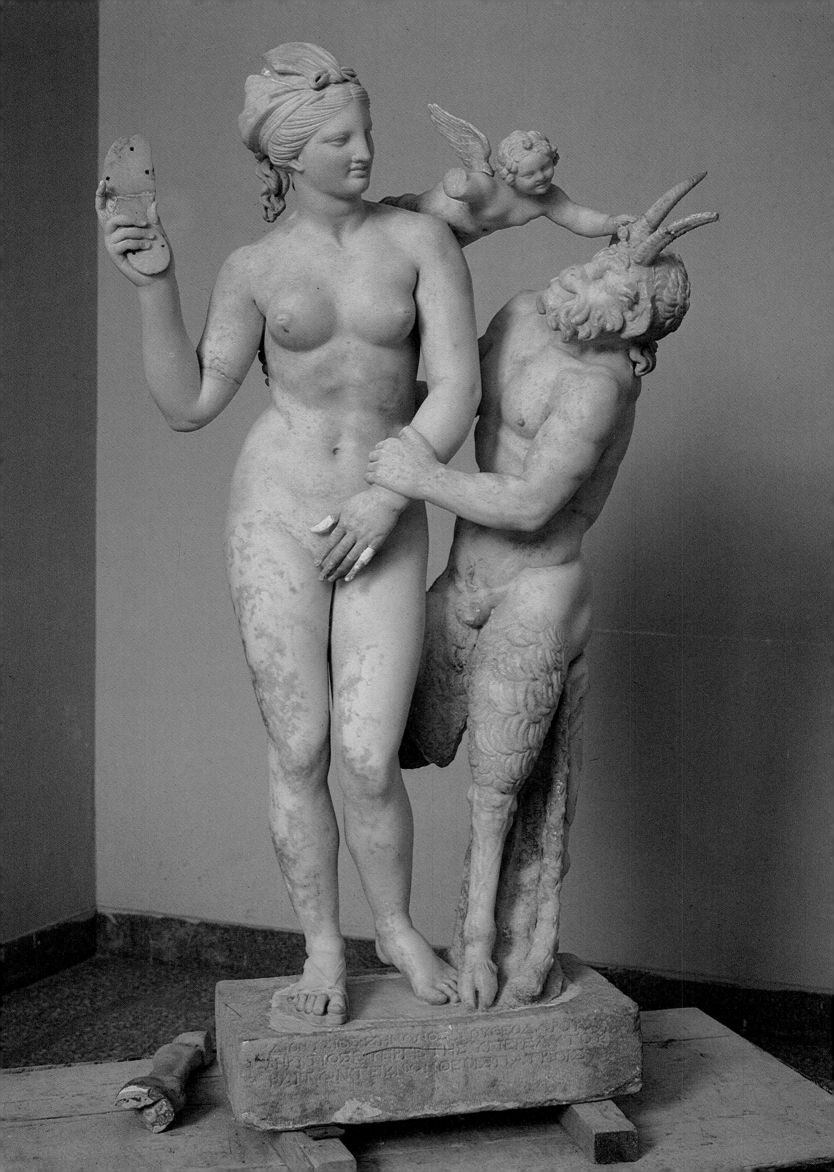

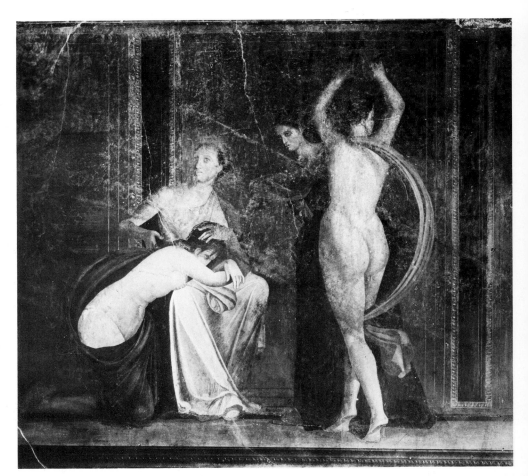

Right: Flagellation scene from the Villa of the Mysteries at Pompeii. *c.* 50 B.C. Although there is not much effort at illusionism, this famous frieze, probably illustrating rites associated with the cult of Bacchus, achieves a powerful dramatic effect.

Below right: *Venus of Cyrene.* Found in the Roman Baths at Cyrene. Museo Nazionale Romano, Rome.

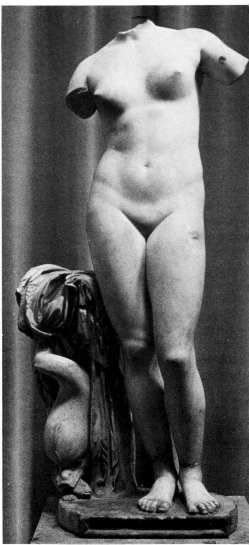

probably a strong, stern-faced figure of a general or a senator clad in a toga, but the ideal of physical beauty which had been perfectly expressed in the nudes of classical Athens continued to be an important theme in Roman art. One innovation was the use of coloured marble (though some Greek sculptors had painted their stone figures). Some of the finest Roman nudes are the statues of young gods which are in fact portraits of Antinous, a youth loved by the Emperor Hadrian who, incidentally, was the greatest admirer of the Greeks among all the Roman emperors. Antinous drowned in the Nile in A.D. 130, to the great distress of Hadrian, who was responsible for commissioning a number of posthumous portraits of him, usually in the form of one of the young male gods. We cannot, of course, tell exactly how close to reality the portraits were but the head is certainly a recognizable portrait – and of a non-Greek youth (Antinous was born in Bithynia in Asia Minor); it had become the fashion to portray figures with a head modelled from life but a body based on the abstract ideal. No doubt this was flattering to customers, but it was also a sign of how the high standards of classical

Greece had become debased in Hellenistic times. The effect – the very human, not to say ugly, face of a craggy old emperor mounted on the body of the divine Apollo – is rather incongruous, to say the least. Propaganda and public works of this kind are often not very rewarding. Some more private art – paintings and mosaics for decorating houses, carved tombs, etc. – are generally more interesting. Paintings have not survived in any great number, but more sturdy forms of decoration, such as mosaics, have sometimes lasted through the centuries with surprisingly little damage. Nautical nymphs and amiable sea monsters figure in the richly coloured mosaics found in Rome's former provinces in North Africa and elsewhere.

Some of the best Roman studies of the nude are to be found not in life-size or over-life-size figures but in small bronzes and in marble reliefs like those on the elaborate tombs of rich citizens; there are some particularly attractive Roman bronzes of Venus brushing her hair, rising from the water and so on. After the 2nd century A.D., however, there are few life-size nudes and almost no female figures at all, partly because the traditional subjects, Venus and Apollo, had lost all meaning but also

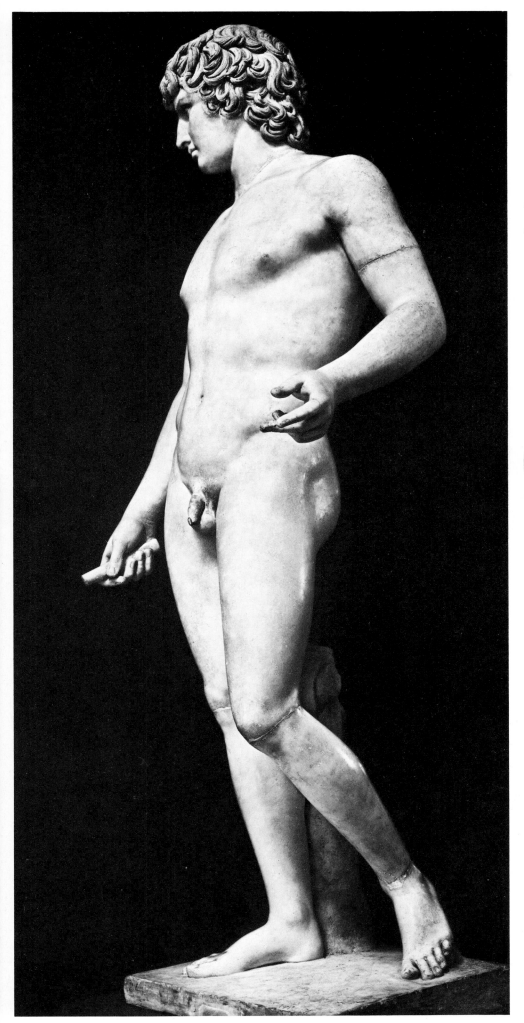

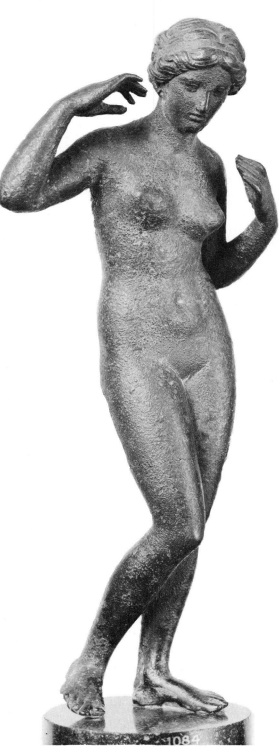

Left: The *Farnese Antinous*, marble, late 2nd century A.D. The Emperor's favourite is represented as the god Mercury. Museo Archeologico Nazionale, Naples.

Below: A charming bronze Venus of the Roman period. British Museum, London.

Below: Nereids and sea-monsters from a mosaic in a Roman settlement in Algeria, late 3rd century A.D. Water nymphs and sea maidens were popular subjects of Roman decoration.

Right: Venus Dressing her Hair, another popular decorative motif, from a late Roman mosaic in North Africa. Musée du Bardo, Algiers.

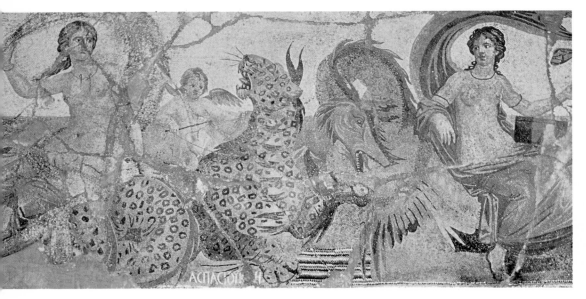

because of more general cultural changes. The classical tradition was fading away, and late Roman art displays a declining interest in the human figure generally. At first sight, in fact, much of the work of the 3rd century looks simply less competent than the classical pastiches turned out in such large numbers by earlier schools of artist-craftsmen, and human figures tended to be more 'frontal' in the Archaic manner. But more important was the fact that late Roman artists found the classical tradition inadequate to express what they wanted to say, much as the pioneers of the modern movement found the academic traditions of 19th-century European painting inappropriate to their own concerns. Late Roman artists strove after a more direct expressiveness, and, while they were not, like the modernists, in full revolt against the established canons of art, they belonged to changing times involving cultural shifts of which they were probably only half aware. In relief sculpture, therefore, we find fewer heroic or divine figures and an

increasing number of realistic, ill-formed and even ugly ones. The proportions are often all wrong, judged by classical rules, with heads too big for their bodies. A new kind of realism is also evident in portraits. Earlier Roman portraits were generally accurate but emotionally 'cool', even abstract. They expressed strength of character or other public virtues but seldom suggested the inner reality. Portraits of the 3rd century reveal the artists' desire to penetrate beyond the public persona, to capture the soul of the sitter as well as the physical features. Physical details which do not contribute to this aim, such as the hair of the head, are sometimes dealt with in a sketchy way.

New religions were among the most important agents of cultural change in the later Roman empire. Under the Emperor Constantine, Rome herself adopted Christianity, and Christianity rejected almost totally the 'pagan' classical tradition. Venus and Apollo were banished, though they would reappear centuries later in rather different guise.

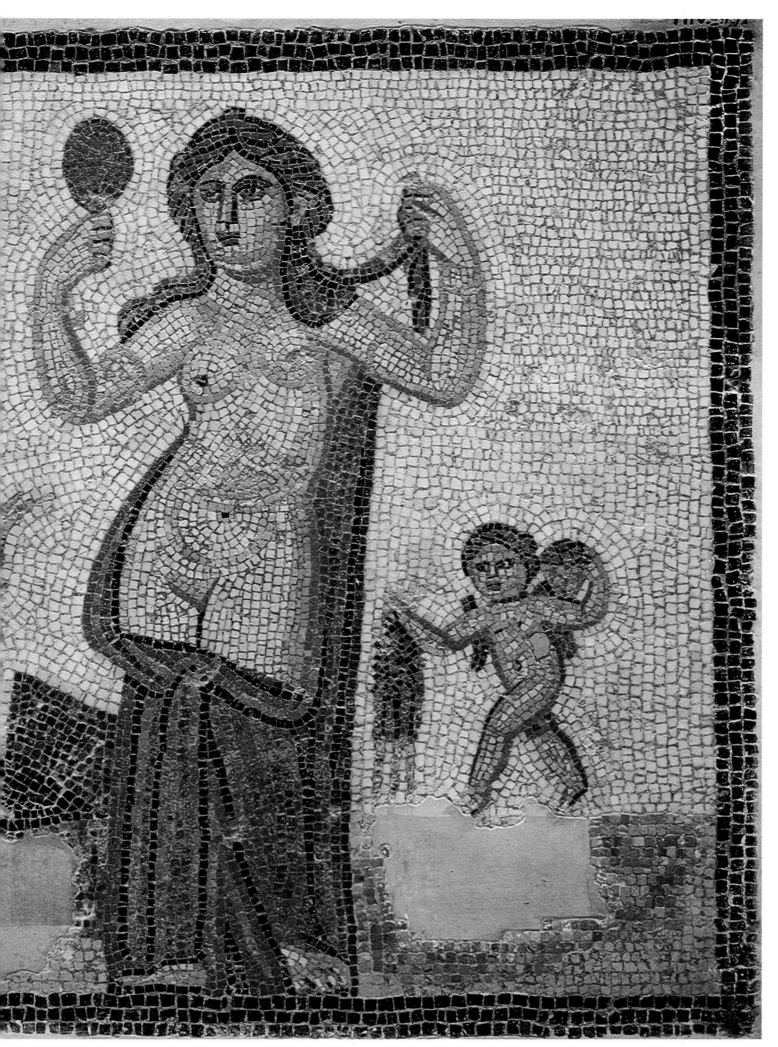

The Body in Medieval Art

It is not difficult to see why
Christianity should have dealt such
a mortal blow to the nude in art. The
essence of Christianity is the denial of
material things and the assertion of
the importance of the spirit. The
body is a disgraceful object, the
repository of evil lusts, which is
destined to rot away while the soul,
released from its mortal prison, lives
eternally. The early fathers of the
Church were shocked by a classical
Venus not simply because they
regarded it as obscene but because it
was pagan and probably inhabited
by a devil. Moreover, Jewish
tradition, which was an important
early influence on early Christianity,
forbade any representation of God.

The early Christians were not
hostile to Roman civilization. That
would have been absurd since they
knew no other kind and anyway they
were 'Romans' themselves. Their art
differed very considerably from the
art of the Roman empire, but that
was initially due more to economic
and social conditions than to
ideological factors. They simply did
not have the resources which
enabled the Romans in the 1st and
2nd centuries A.D. to build great
temples to their God and triumphal
arches to their generals. As we have
seen, the classical tradition was
breaking down in the 3rd century:
the old rules of proportion were
being discarded or forgotten,
leading to greater freedom but not
encouraging any significant new
achievements. Nevertheless, there is
no sharp division between late
Roman and early Christian art,
which overlap for an indefinable
period. The sculpture of, for
example, an early Christian
sarcophagus shows no significant
departure in style. Though it does
show a continuing decline in
technical competence, and the
scenes depicted are incidents from
the Bible rather than stories from
classical mythology, the treatment of
the figures is still essentially classical,
as in the beautiful 4th-century

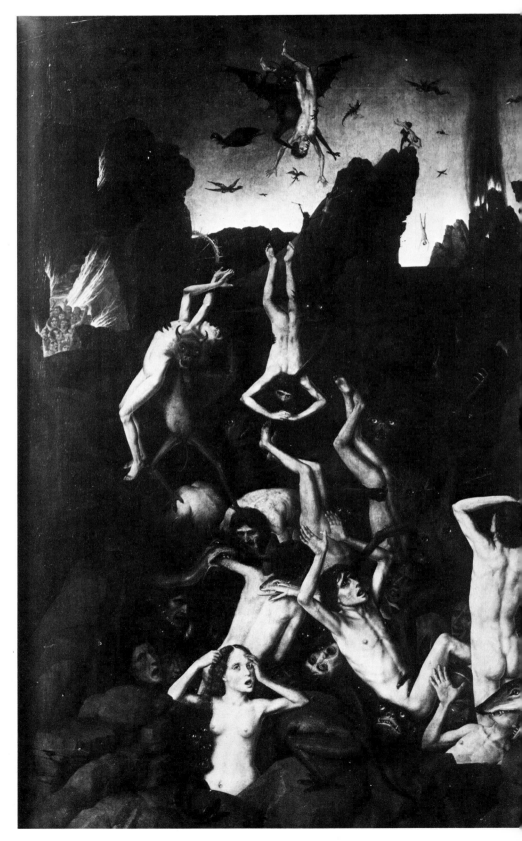

mosaics of the church of Santa Constanza, in Rome.

This hangover from classicism gradually faded and, although it perhaps never died away completely from European consciousness, for all practical purposes it vanished after the 5th century. By that time the most distinguished Christian art belonged to the Byzantine empire – the East Roman empire founded by Constantine which was to last much longer than the Roman empire in the West – and the Byzantine style, a hieratic art of icons, abstract patterns and rigid symbolism, really owed more to the Near East, especially to the arts of Persia and Mesopotamia, than it did to the West. There are a few nude figures in early Byzantine art, some more or less in the classical tradition and others in a more characteristically Byzantine style in which the body is divided into a series of geometric zones, but they are of no real importance. With the Iconoclastic Crisis of the 8th and 9th centuries (precipitated when the Emperor Leo III replaced an image of Christ with a symbolic cross because – he said – he could not bear to see the living Christ represented by a figure which could neither speak nor breathe), the nude naturally disappeared altogether.

For medieval Christians, the idea of a beautiful human body was a dangerous illusion and therefore not only are nudes in medieval art uncommon but beautiful nudes are almost non-existent. Nude figures occur only when demanded by the particular Biblical incident being illustrated – the Garden of Eden, the Crucifixion, the many admonitory scenes of the damned descending into hell, and so on. The figures in these paintings and sculptures are entirely alien to the classical tradition. As the human body was an object of disgust rather than admiration, it could not be portrayed as something beautiful. In fact it would be difficult in the whole of medieval art up to the 14th century to find any examples of the nude in which the artist has betrayed unmistakably a trace of sensuous delight in human flesh. On the contrary, most nude figures, even figures of Adam and Eve in the Garden of Eden, are rather repellent. One might almost wonder how human beings went on reproducing themselves, unless out of a sense of pure duty, since artists showed no sign of being aware that the human body is sexually desirable. The total suppression of the beautiful nude was a remarkable success for Church teaching, all the more remarkable by comparison with literature, which was less successfully purged of all elements of physical desire.

But if there are no beautiful nudes in medieval art until the dawn of the Renaissance, it would not be true to say that there is no eroticism. In the words of Georges Bataille, 'The Middle Ages gave eroticism its place in painting, but relegated it to hell!' He was of course referring to those

Far left: Dirk Bouts. *The Damned*. Nude – therefore shameful – figures were required for this subject, a very popular one among medieval and Renaissance artists.

Below: Remarkably naturalistic figures appear in the frieze of figures rising from the dead, from the tympanum of the north transept, Reims cathedral. *c.* 1225–30.

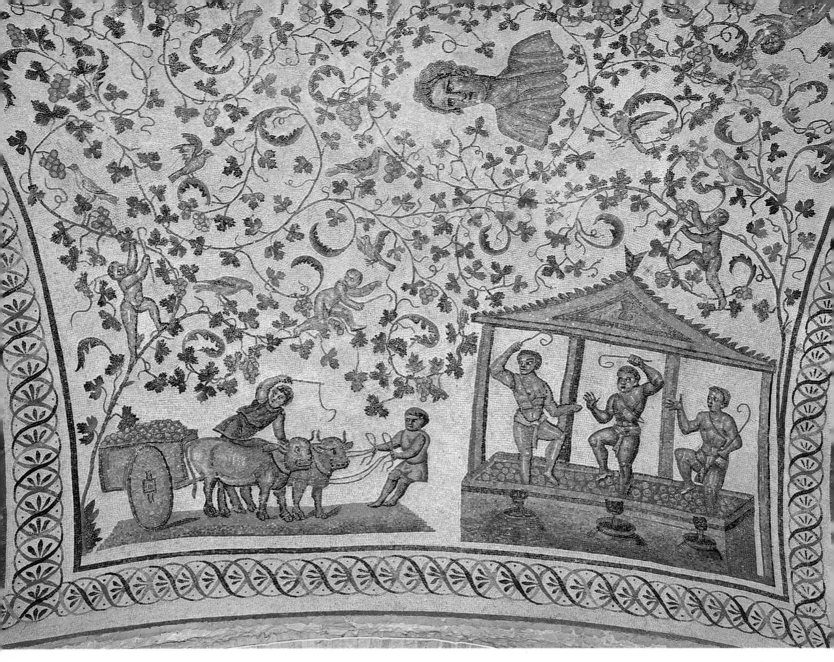

scenes of the damned suffering torments in hell in which there is often a suggestion that the artist contemplated the grisly activities he depicted with a certain amount of relish. That was not, of course, the purpose of the exercise. The artist was in the service of the Church and his painting was Church propaganda, intended to warn sinners of what lay in store for them after death if they failed to obey the laws of the Church. Nevertheless, there is something more than propaganda in the vivid imagination that gave birth to these scenes of horror. They remind us that, although Christianity was the universally accepted dogma of Europe, earlier pagan beliefs retained a vigorous existence somewhere below the top level of society, and that witches and demons could seem quite real to the people of medieval Europe.

Nude figures in medieval art are generally undergoing some extreme

form of suffering, their nakedness being, in the view of the Church, the very symbol of suffering and degradation. According to the Book of Genesis, the awareness of Adam and Eve that they were naked was a sign of their fall from divine grace, and in wooden carvings they often appear, ugly and cringing, being driven from the Garden of Eden. Otherwise, the most common appearances of nude figures are in scenes of saints undergoing martyrdom. Some of the early work is crude in the extreme, and artists made little attempt to carve or draw realistic human figures. Surrounding foliage and decorative details are usually much more convincing.

A rather happier scene involving a large number of nude figures is the Resurrection, as depicted at Reims Cathedral. While treating the human body in a fairly rudimentary way, the sculptor has achieved a strong sense of realism by breaking

Above: Peasants trampling grapes, from the vault of Sta. Constanza in Rome, 4th century A.D. These beautiful mosaics contain a mixture of Christian and pagan themes. Santa Constanza, Rome.

Far right top: Figures of Adam and Eve in a misericord at Gloucester cathedral, England. Nude figures appeared in Gothic art only when required by the context.

Far right: In a scene of the Resurrection of the Dead at Bourges in north-west France, there is evidence of a knowledge of classical sculpture and considerable command of anatomy. The central figure shows that a Gothic female nude could indeed be beautiful. Second half of the 13th century.

up what is fundamentally a repetitive series by the use of unequal spaces and an imaginative variation of the poses: although each figure is doing the same thing – climbing out of his or her coffin – every one is different. There are several signs in this work that the sculptor was not entirely unaware of the classical tradition. The proportions of the figures are rather un-Gothic and, interestingly, one or two people are rising not out of Gothic coffins but out of 'classical' urns.

It might be said that the classical Apollo and Venus were echoed by the Adam and Eve of early medieval Europe, although nothing could be more different from the classical view of the human–divine Venus than the medieval Christian view of Eve, the first sinner. The Adams and Eves of the Romanesque period are scarcely more than symbols: as representations of the human body they are less expressive than, for example, the *Venus of Willendorf* or a Cycladic idol.

However, a great advance took place during the 12th–13th centuries, an era in European history which some historians have thought no less worthy of the name 'Renaissance' than the 15th century in Italy. Changing ecclesiastical attitudes permitted wider use of the human figure in religious art, and if the early Gothic figures remained crude and blocklike, in the 13th century a movement towards a greater naturalism, first evident in the depiction of plants and animals, allowed the formulation of the characteristic Gothic nude.

It must have been rather difficult for the artists to find models. Medieval people were much less familiar with nakedness than the ancient Greeks, and some of the crudeness of 11th- and 12th-century Adams and Eves may have been due simply to a lack of familiarity with the subject. However, medieval artists were not so totally unfamiliar with the classical tradition as some accounts of the Renaissance seem to imply. In countries such as Italy, where classical civilization had been established for many centuries, the evidence lay round about for anyone to see. It is evident that the sculptors of the Resurrection scene at Bourges, for example, must have been aware of the classical interest in the human

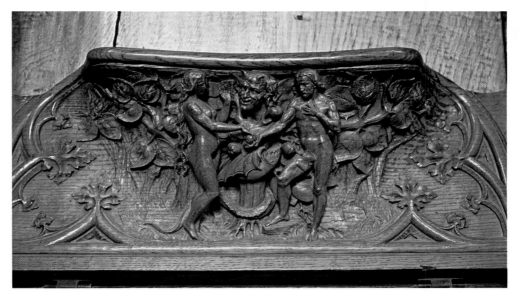

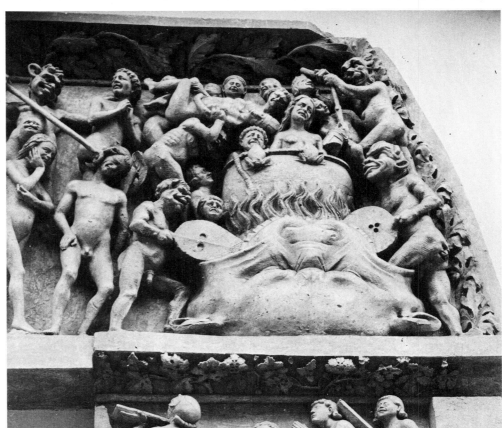

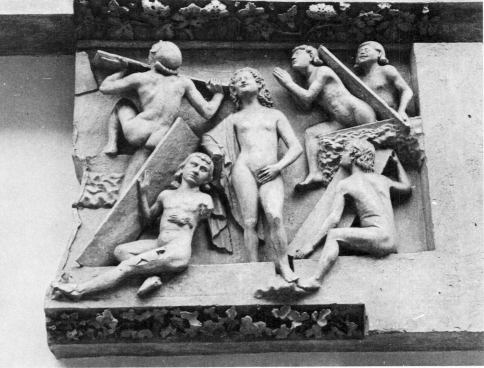

Below: The Van Eyck brothers. *Adam and Eve,* panels from the altarpiece at Ghent cathedral. Completed in 1432.

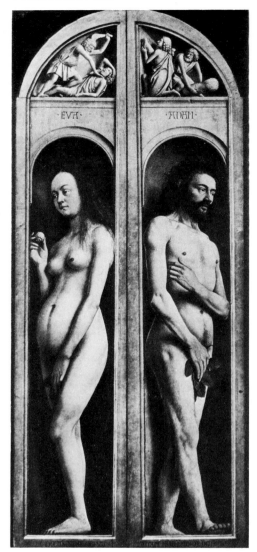

Right: Detail from the façade of Orvieto cathedral, showing the creation of Eve from Adam's rib.

body, and indeed shared it. The figure of the man with one knee raised as he lifts the lid of his tomb shows a remarkable mastery of bone and muscle, far removed from the roughly carved, symbolic wooden figures of the early Gothic period. Even more interesting is the female figure standing below and to the right, described by Lord Clark as 'a maiden of confident virtue who shows, for the first time, the Gothic style applied to the female nude'. It is clear that this figure too owes something to the antique, notably in the relaxed stance with the weight resting on one leg only. Nevertheless, this is a Gothic figure: lean, slightly elongated, with small, widely spaced breasts and rather large head. Here is the prototype of the Eves of the Flemish and German painters of the early 15th century.

Rather more is known of individual artists in Italy than in France during the Middle Ages. We know, for example, that the Sienese sculptor who was responsible for the well-known nudes on the façade of Orvieto Cathedral was Lorenzo Maitani. Like the unknown sculptor at Bourges, though it was unusual among the artists of his time, Maitani was particularly interested in the nude as a subject, no doubt as a result of looking at relics of classical art in Italy. The crowded scene of his *Last Judgment* owes something to Roman relief carvings of men in battle, and while the individual figures in their graphic angularity

are thoroughly Gothic, it is possible to pick out examples which appear to have been based on Roman models; some were to reappear in Michelangelo's rendering of the same scene in the Sistine Chapel.

The Gothic nude was fully realized in the work of the Van Eyck brothers and their school, in Rogier van der Weyden and other artists of early 15th-century Flanders. Painting in northern Europe grew from illuminated manuscripts like the *Très Riches Heures* of the Duc de Berry, a kind of illustrated calendar painted by the Limbourg brothers about 1410. It includes the Temptation and Expulsion of Adam and Eve from the Garden of Eden, along with realistic scenes of everyday life in each month of the year. The heritage of manuscript illumination was responsible for the very detailed style of the Flemish painters. In the Ghent altarpiece of the Van Eycks, the figures are portrayed with painstaking realism, down to the hairs of their heads. Unlike their contemporaries in Italy, the Van Eycks painted in oils, usually on wooden panels, achieving an enamel-like texture and glowing effects of light.

The Flemish Eve is a very different figure from the classical Venus, but as it is clear that 15th-century artists were aware of the Roman Venus, why did they arrive at a figure so different in its proportions, with elongated body and generously curving belly? Of course, both the

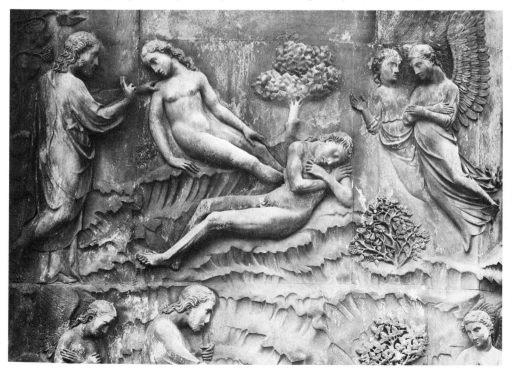

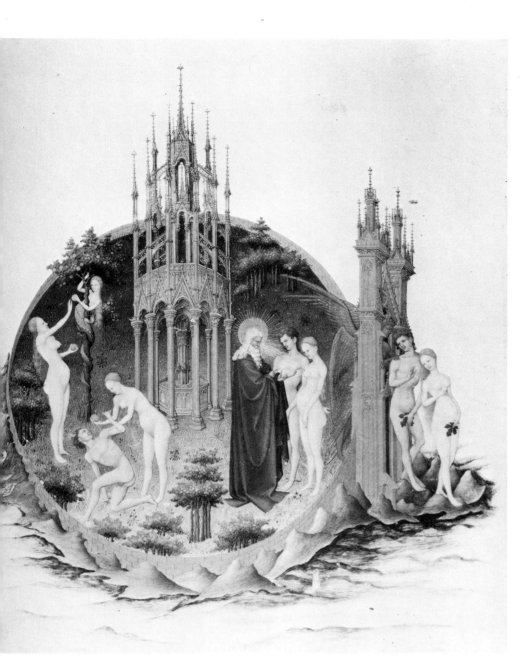

Left: The story of the Garden of Eden, from Eve's acceptance of the fatal apple to the expulsion from the garden, as illustrated in the *Très Riches Heures* of the Duc de Berry. Musée Condé, Chantilly.

Above: Albrecht Dürer. *Four Witches,* the artist's academic interest in the female nude overcome by his personal distaste for the subject.

classical and the Gothic nude are conventional, meaning that they follow certain generally accepted rules more or less closely, and even if living models were used they did not attempt a faithful reproduction of their dimensions. If that were so, one would have to conclude that the women of ancient Greece and the women of medieval Europe were strikingly different shapes! To us, the classical convention seems more attractive and perhaps closer to nature; the Gothic Eve does not, as a general rule, appear very desirable. But it would be unwise to conclude that she was not desirable to Flemish burghers of the 15 century. It is perhaps true that the Van Eycks' Eve from the Ghent altarpiece was not intended to be a figure of desire, but when, a little later, artists in the Gothic tradition did paint female nudes that undoubtedly *were* meant

to arouse feelings of desire, they still adhered to their native style, even when they were well acquainted with classical sculpture and with the work of their contemporaries in Renaissance Italy.

On the face of things it may seem surprising that the Gothic nude, which had such a struggle to emerge from the shadow of ecclesiastical disapproval, should provide the first examples whose purpose was frankly erotic. But in fact, periods of repression usually give way, sooner or later, to stark eroticism: making a secret of sex tends to make it all the more alluring, spiced as it is with mystery and a sense of sin.

By the late 14th century the nude in Italy had again become, as in ancient times, a standard subject of art. Artists like Albrecht Dürer of Nuremberg, the outstanding draftsman of the Renaissance in

northern Europe, were intensely interested in this turn of events. They began to experiment in this same area and several, such as Dürer himself, actually visited Italy to see for themselves what was happening. The earliest results of their experiments were rather odd, a curious mixture of highly disparate styles in which the Gothic naturally predominates, but the artists' experience of classical nudes and of contemporary Italian works crops up in certain features. Some very peculiar physical specimens appeared as a result of attempts by northern artists such as Dürer to draw nudes based on strict geometric principles. Dürer indeed believed that there was a secret formula, known perhaps to the Italians but not to Germans, for composing the classical nude.

The painter who was perhaps the most successful in assimilating Italian influence while remaining faithful to the German tradition – and in painting nudes of unabashed eroticism – was Lucas Cranach (1472–1553), who was court painter to the Electors of Saxony at Wittenberg. Although he painted

figures that suggested the influence of Florence as early as 1509, his famous pictures of seductive ladies clad only in gaudy hats and filmy strips that merely accentuated what they might be supposed to conceal (a trick known to all pornographers) were painted when he was an old man. He would not have been the only painter to have produced his most sensuous work at an advanced age, but in the case of Cranach the reason was probably that at an earlier period of his career such pictures would have been considered objectionable. By the late 1530s times had changed, and female nudes were accepted without question even in Germany. The date, in fact, makes Cranach almost a post-Renaissance artist, though his earliest known nude shows that he overcame the difficulties of adjusting the Italian style to the Gothic tradition without great difficulty. There is no mistaking a Cranach nymph: with her long legs and gentle curves she appeals to us far more than the customary Gothic nude, and we can probably assume that Cranach's contemporaries would have agreed.

Lucas Cranach the Elder. *Nymph. c.* 1530. Thyssen-Bornemisza Collection, Lugano.

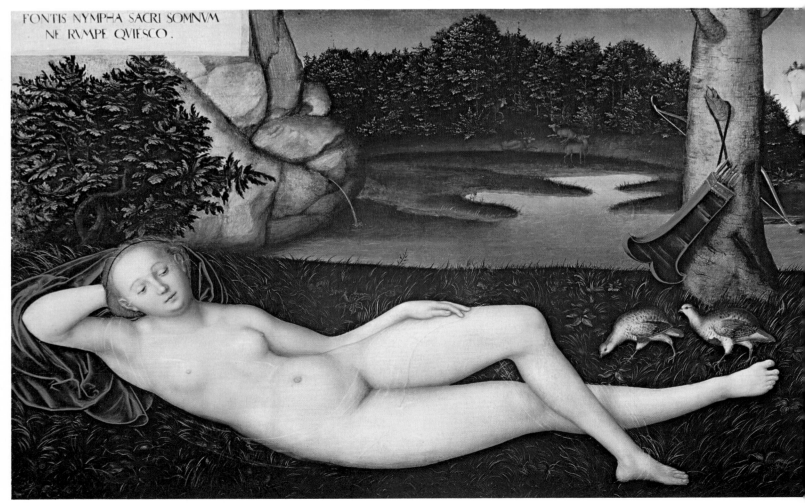

FONTIS NYMPHA SACRI SOMNVM NE RVMPE QVIESCO.

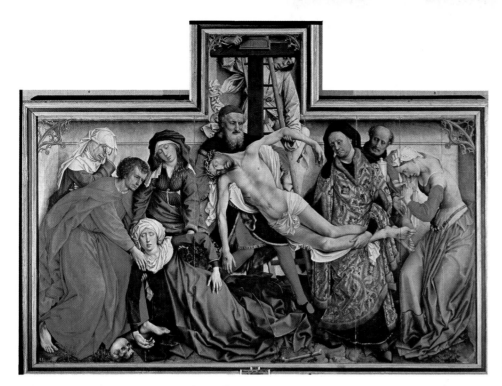

Left: Rogier van der Weyden. *Descent From the Cross*. *c*. 1435. One of several versions of this subject by the master of the early Flemish school. Museo del Prado, Madrid.

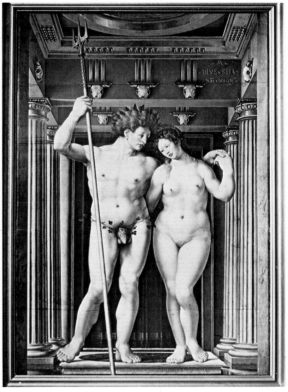

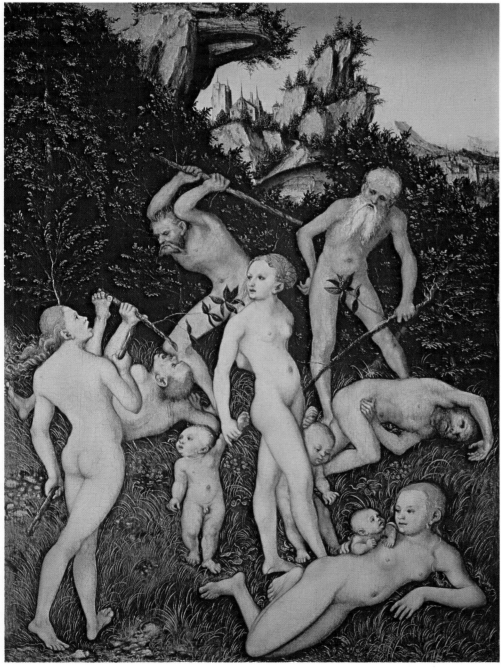

Above: Mabuse (Jan Gossaert). *Neptune and Amphitrite*. *c*. 1435. A rather curious mixture of Flemish and Italian traditions. Gemäldegalerie, Berlin-Dahlem.

Left: Lucas Cranach the Elder. *The Close of the Siver Age*, sometimes called *Jealousy*. National Gallery, London.

43

India and the Far East

Contrary to what one might suppose, the nude is not a 'natural' subject in art, and when the term 'naturalistic' is used to describe a successful rendering of the nude it is a relative term only. A classical statue may be 'naturalistic' compared with a Cubist figure, for example, but it is not naturalistic in an absolute sense. There appears to be a curious paradox here. The human body is a pleasant and desirable object, and the prospect of seeing it naked is, generally speaking, one which most people would entertain with enthusiasm. When a public beach in southern England was opened to nudist sunbathers recently, such numbers of spectators arrived to watch that the police had to be called to control the crowds. Yet it is doubtful if those spectators found the sight a particularly attractive one. Only the sexually deprived are likely to derive the remotest titillating thrill from the sight of a lot of ordinary men and women naked. Doctors, who by the nature of their profession are very familiar with human nakedness, seldom derive much incidental pleasure from this view of their patients. An artist drawing a nude is not as a rule strongly moved by sexual desire; other matters are uppermost in his mind.

The fact is that a nude does not become a work of art by straightforward transcription from life to canvas. That may work with a Siamese cat or a flowering tree, but it does not work with the human body. The athletes of ancient Greece were no doubt well-built and attractive young men by and large, but none of them looked exactly like a statue by Polykleitos; nor did the models of Courbet, a realist, look exactly like Courbet's pictures of them. The nude is a vehicle for art, an object from which the artist fashions the particular kind of art for which his own imagination strives. As we have seen in the Introduction, the nude is a vehicle of a particularly significant kind, but it is a vehicle nonetheless. Among the ancient Greeks it became the vehicle for the highest form of art, and it is largely as a result of that Greek conception that the nude is so prominent in Western art generally. During the Middle Ages it ceased to be one of the basic motifs of art: the vehicles of Gothic art were different, and the part played by the human

Above: *Daphne and Apollo*. 13th century. Ravenna. Museo Arcivescovile, Ravenna.

Far right: *The Woman with a Lotus*. A copy of the famous wall painting in Cave One at Ajanta, Hyderabad.

body in classical art was played by the clothes instead – the folding and twisting of drapery. Obviously, Gothic artists did not set out simply to depict the appearance of cloth; they were not public relations men for the wool industry. It was simply the vehicle of their art, or the basis from which they began. Gothic artists simply could not draw beautiful nudes like the Greeks because they had no *idea* of the nude, and when on rare occasions they did attempt to reproduce the human body faithfully, as they thought, the ruling Gothic conventions often made their results little better than comical.

It is not therefore necessary to look beyond Western traditions in art to discover that the idea of the nude is not universal. In many other artistic traditions it is entirely absent. In Byzantine art, as mentioned earlier, the odd nude figure sometimes appears, but although Byzantium was founded by the Romans, Byzantine art was rapidly transformed as a result of contacts with the East as well as by influences developing from the character of Byzantine society, and in any case the nude was already disappearing in the West by the time Constantinople was founded. The odd surviving Byzantine nudes are freakish exceptions.

In China and Japan, the human body was never regarded as a vehicle for expressing the kind of values it expressed in ancient Greece or Renaissance Italy, and the only naked figures that appear in paintings and on porcelain, ivories, etc. are either part of the scenery – bedroom or bathroom scenes in which naked figures naturally appear – or examples of what used to be called curiosa – erotic, if not downright pornographic works made for a particular class of clients. Coloured woodcuts of this kind were produced by masters of the Japanese *ukiyo-e* (the 'painting of the passing scene') or popular school, of whom the best known in the West are Hokusai (1760–1849) and Utamaro (1735–1806), one of the first Japanese artists whose prints were imported in some numbers to Europe.

The absence of the idea of the nude in the art of Far Eastern societies made it rather difficult for a Chinese or a Japanese to appreciate

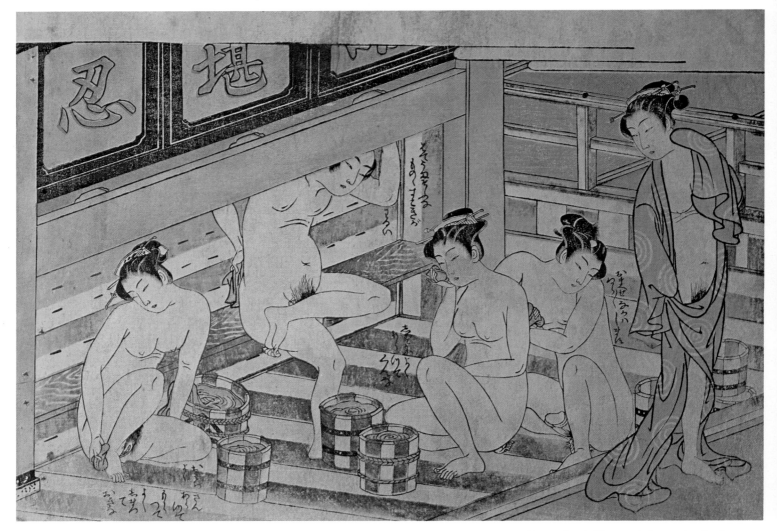

some Western art, much as Westerners wrestled with the aesthetics of Chinese calligraphy. Faced with the works of Michelangelo for the first time, an Oriental mind tends to recoil in shock and bewilderment.

Someone whose only previous experience of the sculptured nude was gained in India might also tend to misunderstand Michelangelo, but for rather different reasons. The nude is not absent from traditional Indian art. Far from it. As everyone knows, India is the home of the most remarkable erotic sculpture in the world, sculpture which has also been frequently misunderstood. The main cause of the problem has been the idea that erotic art is shameful, an idea held by some Indian as well as European art historians of an earlier generation. They tended to interpret the erotic sculpture of Indian temples in terms of religious mysticism, creating, as Reay Tannahill puts it, 'esoteric mountains out of the molehills of their own embarrassment'. At the other extreme, Michael Edwardes has suggested that some of the figures

on the 'Black Pagoda' at Konarak (so named not for its erotic sculpture but for its appearance to sailors approaching from the sea) may have been nothing more than advertisements for the temple prostitutes. However, the art of India, like all traditional art, is religious and didactic, and since it was intended to instruct or illustrate religious teaching, it follows that it was not deliberately intended to be obscure.

There was more contact between India and the West in ancient times than there was to be until the modern era. Even before Alexander the Great led his armies to the Indus valley, various Greek and Persian travellers had reported from that same region, and Greece imported cotton and spices from India. The first authoritative description of the country was written by a Greek ambassador at the court of the Maurya ruler, Chandragupta, at the end of the 4th century B.C., and by the 1st century A.D. there was a large and regular trade in the Indian Ocean which embraced South-East Asia and the Roman world as well as

Above: Isoda Koryusai. *Scene in a Bath House*, a Japanese print of the late 18th century.

Above right: A *yakshi* or tree goddess, from one of the gates of the Great Stupa at Sanchi, India.

46

Above: *Asparas*, or heavenly dancer, relief sculpture at Angkor Wat, Cambodia. First half of the 12th century.

India. The rise of the Sassanids in Persia in the 3rd century A.D. and, later, the spread of Islam in western Asia reduced the contacts between Europe and India to a minimum and, apart from the reports of occasional travellers such as Marco Polo, Europeans learned little of India until the Portuguese arrived there via the Cape of Good Hope at the end of the 15th century.

As a result of the establishments of 'Greek' kingdoms in north-west India, some of which lasted nearly 300 years, Indian art reflected considerable Hellenistic influence which, indeed, is also evident much further east, for instance in carved figures of the Buddha from South-East Asia. But apart from certain pieces which are really more Hellenistic than Indian, it is doubtful just how important overall the Hellenistic influence was. Native traditions were already firmly established, and to suggest that the typical softly sensuous nudes of India owe much to the successors of Praxiteles seems to be little more than a piece of unjustified cultural aggrandizement.

Buddhism is essentially a democratic form of religion, although this varies according to time and place, and early Buddhist shrines like that at Sanchi were decorated with scenes of everyday life. The Buddha was originally represented by symbols, like footprints or the Wheel of the Law, but by the time the gates at Sanchi were carved, approximately 2,000 years ago, he appears in human form in scenes from his earlier incarnations, along with naturalistic animals, trees and flowers, and *yakshis*, minor divinities or nature spirits which originated in pre-Buddhist times.

Sculpture is normally less vulnerable than paintings, but a number of wall paintings survive from Gupta times (4th–5th centuries A.D.) in the cave sanctuaries at Ajanta. The very sensual female figure holding a lotus flower was probably intended to represent the female energy of the Bodhisattva, or Buddhist saviour, who appears next to her in a famous painting in Cave One. She is an impressive example of a familiar

47

type, round-breasted, wasp-waisted, with generously curving hips and tilted head: Indian art was highly conventional, although the conventions were never so rigid as to strangle all artistic creativity. The interest in the nude of the artists of Gupta times is also shown in contemporary figures of the Buddha, clad in raiments so thin that they reveal every line of his body.

In the slightly later religious complex at Ellora, there are lively figures in relief of flying Hindu goddesses and erotic sculpture illustrating the various recommended positions for sexual intercourse, as described in the manuals of sex such as the *Kamasutra*. The same poses are found, for example, in courtly miniatures of a much later date.

At Bhubaneswar, a Hindu city in northern India, the style is somewhat different, but the well-known figure of the *Lady Beneath a Palm* is probably some kind of fertility figure closely related to the

One of the great wheels of the Sun Temple at Konarak, India. The circular apertures in the spokes are filled with erotic figures.

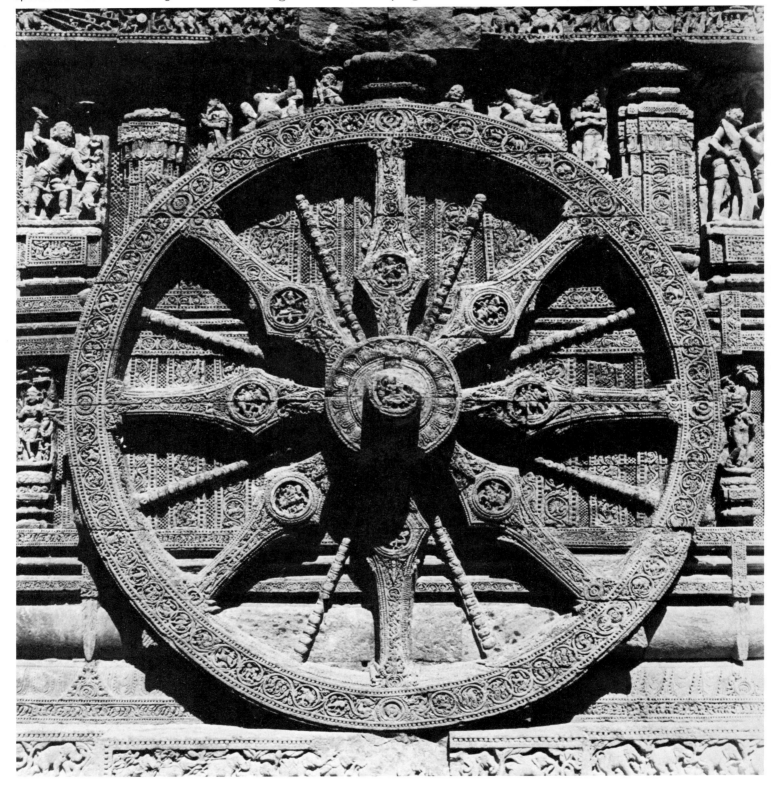

The *Lady Beneath a Palm*, Bhubaneswar, northern India.

yakshi of Sanchi, though separated from her by almost a millenium, as well as to similar figures from South-East Asia. The culmination of the style of Bhubaneswar can be seen in the erotic figures at Konarak, probably made about the middle of the 13th century. Today, the great temple known as the Black Pagoda stands in ruins on a deserted site, but not, as was once suggested, because the local people grew ashamed of it. In the European Middle Ages Konarak seems to have been a busy port in the trade with South-East Asia; the trade eventually declined when the harbour became silted up.

The relief sculpture at Konarak and at Khujarao in central northern India is so deeply carved, with such a mass of decoration and pierced work, that the main features of the actual structure of the buildings seem to dissolve before the eyes of the spectator. At Khujarao the quality of the work is especially fine, with the heavenly scenes full of airy figures of female deities who, despite their exaggerated movements, have an air of placid calm. Virtually all traditional Indian art is anonymous, but the unknown artists who were responsible for such figures as the goddess from the sanctuary of the Visvanath temple at Khujarao had nothing to learn from anyone when it came to depicting female sensuality.

49

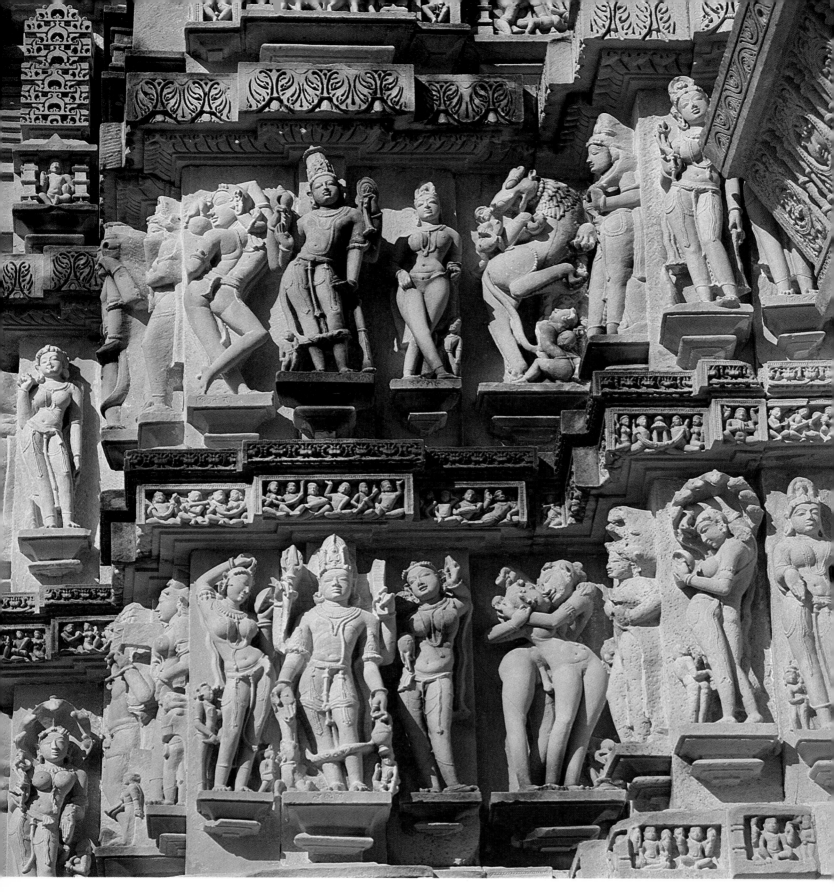

In spite of the explicit nature of Indian erotic sculpture, of which Khujarao probably presents the finest examples, the most thoroughly philistine among the crowds of tourists traipsing around the temples today could hardly suppose that he is looking merely at dirty pictures in stone. As Michael Edwardes remarks, 'the overwhelming effect is not so much of sexuality as of bliss'. The effect is partly the result of the facial expressions of the figures which, however contorted the actions of their bodies, maintain an other-worldly contentment, a spirit of peaceful calm. The exotic poses are managed with a sinuous line, following softly undulating contours, with no attempt to suggest the muscular tensions and energy which a Greek sculptor, for example, would have conveyed.

Detail of carved figures which manage to combine athletic poses with a spirit of peaceful calm, adorning one of the temples at Khujarao, India.

The Renaissance Nude

In ancient times the Romans had thought of the people beyond their borders as 'barbarians' who threatened civilization as represented by the Romans themselves. This feeling persisted in Italy long after the Roman empire had disappeared and the 'barbarians' had come to think of themselves as 'Romans'. The legacy of Rome was everywhere apparent; the Romans had built their roads, temples, aqueducts and theatres to last as long as Roman civilization itself, which to them meant for all eternity. In fact, the buildings long outlasted the empire.

Besides this cultural heritage, the Italians in the Middle Ages enjoyed remarkable prosperity, largely due to Italy's fortunate position as an entrepôt of trade, and city life in Italy developed sooner than in any other European country, with the possible exception of Flanders. The prosperity of the Italian princely and merchant families reinforced the belief that Italy was somehow special: Rome might no longer be the world's ruler, but it was still its leader; although no longer the residence of the Emperor, it *was* the residence of the Pope.

In another respect, however, the medieval Italians were far less successful than their Roman forbears in establishing their predominance over other European societies. Not only was the country no longer the central unit of a vast empire, it was not united in itself. Politically, Italy was a mess, divided into innumerable little states. Some, like Venice and Milan, were great powers thanks to their material or naval resources. Others amounted to little more than a smallish market town and a few square miles of countryside. Intense commercial rivalry made political divisions even sharper, and not even the threat of invasion by foreign powers could – as it had in ancient Greece – create any lasting alliance of the proud and prosperous Italian states.

During the 15th century, Italy enjoyed a comparatively long spell untroubled by foreign encroachment, since the great powers beyond the Alps were busy with other conflicts. Five princely states emerged as the principal centres of power, around which other smaller states congregated. They were Venice, Milan, Florence, the Papal States (Rome) and the kingdom of Naples.

These small, rich and competitive states demonstrated their wealth and power by lavish indulgence in decoration and display. Their rulers vied with each other to attract the finest artists of the day to their courts, and every Italian prince of any pretention at all was a patron of the arts on a remarkably generous scale. It was this combination of material wealth, political rivalry and extravagant patronage which

Ghiberti. *The Sacrifice of Isaac*. From the bronze doors of the Baptistery, Florence Cathedral.

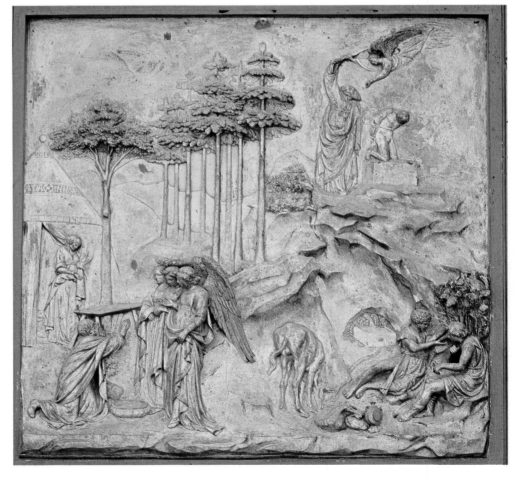

created a situation in which art flourished as it had never flourished before and as it has never flourished since.

In the city of Florence especially, during the 14th century, there was a growing interest in the ancient world. At first it was mainly an intellectual interest, but the recovery of classical writings inevitably led to a revival of classical art. The artists, first made aware of the richness of ancient philosophy and literature, and infected with the philosophy of humanism which was founded on such studies, looked at the ancient buildings and sculpture around them with new eyes. Many of them visited Rome in order to examine their classical heritage in greater detail.

It would be much too simple, and in fact incorrect, to say that Italian artists of the 14th and 15th centuries looked at classical art, went home to their studios, and simply tried to imitate it. One thousand years of history, which divided Renaissance Italy from Imperial Rome, cannot be written off quite so easily, although contemporary writers tended to do so. The artists of the 14th century, in Italy as elsewhere, belonged to the Gothic tradition, which by that time had become 'international', though not, of course, everywhere identical. Broadly speaking, the standard sculptured figure – for instance, of a saint to stand in a niche in a church – was most notable for the rendering of the clothes. Gothic artists were always more interested in the outward drapery than the body within. In Florence, an outstanding practitioner of the International Gothic style was Lorenzo Ghiberti (1378–1455), who in 1401 won a competition to design a pair of bronze doors for the baptistery of Florence Cathedral with a relief panel of the *Sacrifice of Isaac*. The figure of Isaac is beautifully modelled in the classical tradition, although the comparatively unemotional rendering of this fearful moment is also characteristic of the late Gothic style. In fact art historians have shown that Ghiberti was strongly influenced by earlier Gothic sculptors, notably Pisano, as well as by antique art. Similarly in painting, Masaccio (1401–28), a vitally important figure in the development of Florentine painting, studied closely the work of the 14th-century artist Giotto, as well as Roman sources. Neither Ghiberti (who collected antique sculpture) nor Masaccio were deliberately intent on reviving classicism; they merely borrowed from it. Moreover, such were the stylistic upheavals going on in 15th-century Florence that the whole question of attributing sources or charting the

The *Apollo Belvedere*, a Roman marble copy of a Greek bronze, which had a powerful influence on artists following its discovery in the late 15th century. Musei Vaticani.

general development is extremely difficult.

The triumph of classicism in sculpture can, however, be assigned to a single work by one of the most original artists of any period, Donatello (1386–1466). (This was not his given name – many Renaissance artists are known by their nicknames.) Donatello's early works were calm and mystical religious figures in the late Gothic tradition. His *David*, completed in 1432 when he was about forty-six years old, was something quite different. This life-size bronze of a nude shepherd boy was, in the words of Lord Clark, 'a work of almost incredible originality, which nothing else in the art of the time leads us to anticipate'. Broadly, Donatello took the Greek figure of the ideal youth and fused it with the Christian tradition of the biblical boy-slayer of Goliath to produce perhaps the first really beautiful nude in Christian art. Technically, there are some interesting variations on the classical nude which were to differentiate the art of Renaissance Italy from that of classical times. Donatello's *David* is not an 'ideal' young man in the Greek sense, since he is clearly modelled from life, the boy whom Donatello immortalized in bronze being a good deal skinnier than his Greek counterparts. More important, the figure is articulated in a different way. The Greeks had generally treated the torso as a single unit, with an emphasized pelvis acting as the main pivot of the standing figure. In Donatello's *David*, as in most later Renaissance nudes, the main centre of emphasis is the waist rather than the pelvis.

Although contemporaries believed that Donatello had rediscovered the ancient secret of physical beauty in art, this remarkable bronze had less effect on Florentine art than we might expect from our perspective five centuries later. Florentine painters were not to achieve this mastery of form and space for at least two generations, and in sculpture Donatello's *David* had no immediate successors, not even in the work of Donatello himself. He was best known for vigorous, forceful expressiveness than for figures in repose, and in that also he was characteristic of Florentine art generally in the 15th century and not of the ancient world;

in the restless city of the Medici there were few 'cool' nudes.

The Florentine predeliction for violent movement can be seen in the well-known study of *Hercules and Antaeus* by Antonio Pollaiuolo (*c*. 1432–98) who was basically a sculptor, like Donatello, and a student of anatomy. This is a very small painting, little more than 6 inches by 3 inches (152 mm by 76 mm), a replica of a larger one that no longer exists (there is also a bronze of the same subject). The artist's knowledge of anatomy enables him to convey convincingly the attitude of Hercules as he raises Antaeus off his feet; the pose owes nothing to classical art. Yet it is the overall composition that is chiefly important, and fine details are subordinated to the general design.

The finest 15th-century painter of the nude was perhaps Sandro Botticelli (*c*. 1445–1510), a key figure in several ways who links the painters of *Quattrocento* Florence with the High Renaissance. Hitherto the subject matter of Florentine painting

had been mostly religious, even when it made obvious use of classical models. Botticelli himself certainly painted far more clothed Madonnas (a nude Madonna would, of course, have been regarded as blasphemous) than nude Venuses, but he was one of the first to make extensive symbolic use of pagan mythology. Paradoxically, however, Botticelli was to fall under the influence of the puritanical friar Savonarola whose savage denunciations of the pleasures of the flesh drained Botticelli's painting of the sensuous pleasure which is apparent in the *Primavera* and the famous *Birth of Venus*. The latter work is particularly apposite, for in this painting the Aphrodite of the Greeks is born again. While the *Primavera* is in spirit a medieval painting, the *Birth of Venus* was deliberately intended as a celebration of antiquity, and the beauty of this Venus is not merely a sensual beauty, although of course it is that as well, but it is also the beauty of truth and virtue – 'beauty' as an abstract concept. Although the Greeks would certainly have approved, Botticelli's *Venus* is nevertheless a far from classical figure. His most remarkable quality was his elegant, rhythmical line, and although the pose of the figure is based on classical stereotypes, Botticelli's rhythmic sense, as Lord Clark remarked in a notable phrase, has transformed her 'into the endless melody of Gothic line'. Oddly enough, the proportions are classical, although they may not look

Below: Pollaiuolo. *Hercules and Antaeus*. c. 1470. The subject comes from classical mythology and offered the artist a chance to present powerful figures engaged in terrific muscular effort. Galleria degli Uffizi, Florence.

Right: Botticelli. The Three Graces, detail from *Primavera*. c. 1475. Galleria degli Uffizi, Florence.

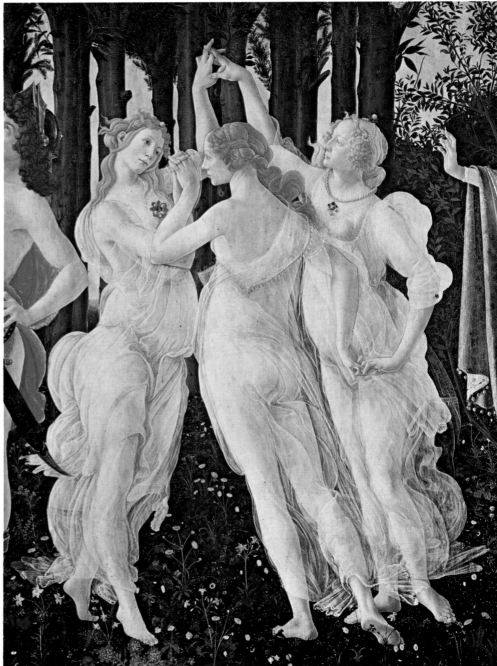

Left: Michelangelo. *Bacchus. c.* 1475. The technical mastery is already evident, though the tipsy young god is not one of Michelangelo's most moving works. Museo Nazionale del Bargello, Florence.

Below: Leonardo. *Leda and the Swan*, a drawing which is unlike the pose he adopted for the finished picture (now lost). Teylers Museum, Haarlem.

it, but the figure is not solidly rooted, as a Greek artist would have shown her. As she stands, her weight is too far over to her left for her feet to support it; she is really not standing at all, but gently floating. Another respect in which Botticelli's humanism leads him away from classical stereotypes is the individuality of the face (much more human than the expressionless Venus of antiquity), with its soft, slightly sad expression. This face, in fact, appears in many of Botticelli's paintings: the fact that he used the same model for the pagan goddess of love and the Mother of God merely confirms the heavenly quality of Botticelli's *Venus*.

Throughout the 15th century artists in Florence studied antique art and frequently borrowed from it.

But it was not until towards the end of the century that they began to understand it as a whole, instead of as a marvellous assortment of examples. The real triumph of antiquity came with the High Renaissance, a very short period covering little more than the first two decades of the 16th century and associated more with Rome than Florence (although many of the artists working in Rome were in fact Florentines). Perhaps the two greatest artists of the High Renaissance, and certainly the greatest artists of the nude, were Michelangelo and Raphael. Nothing could illustrate more effectively the enormous variety to be found in a single 'school' of art. Michelangelo and Raphael were both artists of the High Renaissance,

both had trained in Florence (though Raphael was not a Florentine), both worked in Rome, and for the same patrons – notably the Pope. Yet their art could hardly be more different. Each founded a tradition of the nude – the 'heroic' and the 'graceful' if they can be summed up by a single adjective – which can be traced, with much overlapping of influences, through the centuries down to modern times.

Naturally Michelangelo and Raphael also influenced each other; they influenced, and were influenced by, other artists as well. In this book we are concerned only with those artists who made a special impact on the tradition of the nude, and a great company of Italian Renaissance painters, including many who contributed to that tradition, must

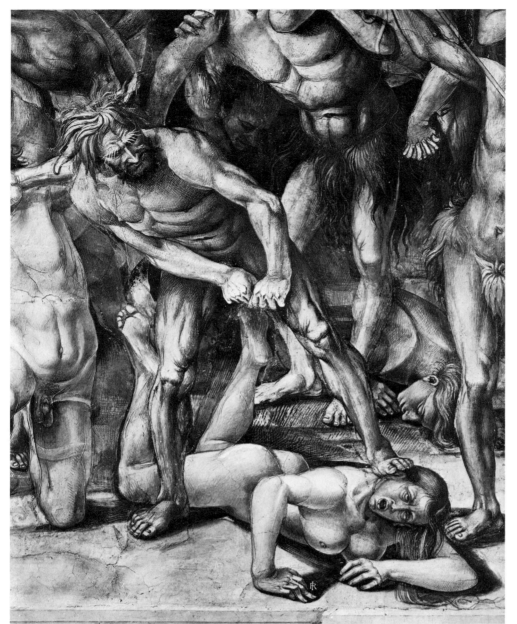

Left: Detail from Signorelli's rather horrifying picture of *The Damned* in Orvieto Cathedral.

Far right: Michelangelo's *David* (1501–04), his heroic monument to his native city. Galleria dell' Accademia, Florence.

be passed by without a nod. One who cannot be ignored was that extraordinary genius, Leonardo da Vinci (1452–1519).

Leonardo was not especially sympathetic to the world of antiquity. He painted few nudes and he was not sexually attracted by women. However, Leonardo emphasized the difference between the various arts, notably between sculpture and painting, and unlike the semi-classical painted nudes of many contemporaries, Leonardo's *Leda* (known only from copies by other artists, albeit a large number of them) could not possibly be conceived as a sculpture. Leonardo's delicate line, owing something to Antonio Pollaiuolo, his soft colours and shadows, subtle grace, and the softly smiling faces of so many of his women (the 'Gioconda smile'), in a word the overall gentleness of his

painting, created a new standard of beauty which was to have a marked effect on the next generation of artists, especially Raphael and the Venetians.

For all the soft allure of Leonardo's painting, he was a rigorous intellectual with the objectivity of the philosopher. His interest in the Leda legend, shared by many other artists, probably arose out of his anatomical studies; Lord Clark has 'no doubt that he intended her as an allegory of generation'. Though the pose is based on a classical prototype, slight changes have effectively emphasized the parts of the body which in antiquity were usually concealed by the arms and hands. But for Leonardo, the experimental scientist, a painting was essentially the answer to a particular problem. Like the ancients, the artists of the

Renaissance in their search for perfect beauty of form sought help from mathematics and geometry. Leonardo's well-known drawing illustrates the principle stated by Vitruvius, an architect of the 1st century b.c. who was enormously influential in the Renaissance. In describing the basic rules for building a temple, Vitruvius remarked that the building should have the same proportions as the figure of a man. These proportions were ideal, he added, because a man with arms and legs outstretched fits neatly into the two basic geometrical forms, the square and the circle. Renaissance artists took this statement very seriously (there are many drawings like Leonardo's *Vitruvian Man* by other artists), as it seemed to be the answer to the philosophic question of the relationship between form and

56

beauty. Another powerful concept was the 'Golden Mean', as propounded by Fra Luca di Pacioli in his *De Divina Proportione* (1498). According to this influential notion, in a line divided into two unequal parts, the difference between the shorter and the longer part is proportionately the same as the difference between the longer part and the whole.

It may seem to us that such ideas have very little to do with beauty or perfection of form. That they do not provide the whole answer is sufficiently evident from attempts to draw nude figures strictly according to theory. Dürer, for example, devoted profound study to the matter of proportion and measurement but produced some rather ugly results; not because he got the proportions wrong but because, at that time, the nude was an unfamiliar and unsympathetic subject for him. Later, after he had studied classical nudes like the *Apollo Belvedere* at first hand, he achieved much better results: his memories of what he had seen in Italy provided him with images of what a beautiful nude looked like, and he was able to abandon the strict rules of geometry.

Another contemporary of Leonardo who was also influenced by Pollaiuolo was Luca Signorelli (*c.* 1441–1523), a devoted student of human anatomy and movement. In his special concern with expressing a variety of emotions through the human body, he appears as the immediate forerunner of Michelangelo, although art historians differ on the question of Michelangelo's debt to Signorelli. Probably the most famous example of Signorelli's mastery of the human form contorted into an astonishing variety of positions is his enormous fresco of *The Damned* for a chapel at Orvieto. It would be hard to say whether the artist's first concern was to convey the horrors of hell, like the many Gothic versions of this scene, or merely to demonstrate his knowledge of muscular structure. In fact some critics would say that this latter ability was the artist's undoing: the exaggerated muscular angularity of the figures makes them less than convincing. As with many other artists, Signorelli's remarkable talent can sometimes be more easily appreciated in his preliminary

drawings than his finished pictures.

The career of Michelangelo spans the period of the High Renaissance, extending a considerable distance either side. He was recognized in his own time as a uniquely great artist, and posterity has not been much inclined to quarrel with that view. As a man of his time, Michelangelo, like anyone else, reflected contemporary ideas. Antique art had a tremendous effect on him, but so did some more recent artists, such as Masaccio and Donatello. Yet Michelangelo's art was quintessentially personal, and for an artist of universally acknowledged genius it was in some ways surprisingly idiosyncratic.

After the fall of the Medici, the ruling family of Florence and Michelangelo's earliest patrons, the young artist made his first visit to Rome, returning in 1501 with his reputation as a sculptor firmly established. The two works completed in Rome which made him famous were the *Bacchus* and the St Peter's *Pietà*. The *Bacchus*, a more than life-size figure, is fundamentally a tribute to classicism, yet it is not a conventional classical figure and could hardly be taken as such (although one of Michelangelo's minor works *was* mistaken for a genuine antique). There is something slightly vacant and flaccid about the *Bacchus* which has

Above: Raphael. *The Triumph of Galatea*. 1511. Villa Farnesina, Rome.

Michelangelo. The figure of *Dawn*. 1526–34. From the Tomb of Lorenzo de'Medici. Medici Chapel, San Lorenzo, Florence.

Raphael. Detail from the ceiling of the Loggia di Psyche in the Villa Farnesina, Rome. 1517–18.

led more than one modern critic to call it repulsive, but nevertheless it shows the young Michangelo's mastery of his medium. The *Pietà* had, and has, a better reputation; for most people it is perhaps the most successful work on this theme (to which Michelangelo was to return obsessively in his last years) ever created. The dead body of Christ is poignantly expressive, and the spirit of gentle sorrow is captured as surely and subtly as Leonardo at his finest.

If Michelangelo's art had to be summed up in one word, most people would call it 'heroic' or 'monumental'. Although the St Peter's *Pietà* could hardly be called monumental, Michelangelo's interest in structure and mass was already evident in his early drawings. His *David* (a favourite figure of Florentine artists) for the city of Florence is 'monumental' in every way (it is about three times life size). With this figure Michelangelo

brought to a culminating peak the ancient tradition of the heroic youth, as manifested by all the Apollo figures of antiquity. It also marked the beginning of Michelangelo's lifelong preoccupation with the male nude, his greatest subject, which gradually drew him further and further from classicism. Michelangelo believed that the male body was more beautiful, or anyway more expressive, than the female, and on the occasions when he executed a female nude he used a male model. It is not, therefore, surprising that the figures of *Night* and *Dawn* on the tombs of Medici princes look like men with breasts applied.

Unlike Leonardo, Michelangelo believed that painting and sculpture are in principle the same and, although it was as a sculptor that he originally gained his great reputation, during his second long period in Rome he proved himself an

59

equal master of both media (not to mention architecture). His decoration of the Sistine Chapel ceiling – 6,000 square feet (5,574 sq m) of it – is possibly his greatest single achievement. It contains many examples of male nudes, perhaps the most familiar being the figure of Adam at the Creation, though the complex poses of some of the figures of athletes which punctuate the Biblical scenes are of special interest for the development of the nude.

Michelangelo's later works are even more intensely personal, and more expressive of his inner spiritual yearnings. His superhuman perfectionism always made it difficult for him to finish a work, and much of his late sculpture was left incomplete. To our generation it does not necessarily lose much by that, but this modern liking for uncompleted works and for preparatory studies and sketches that seem more expressive than the final work is possibly no more than a passing fashion. Nevertheless, in the figures of struggling slaves still half-imprisoned in stone we see a symbol of Michelangelo's heroic anguish more easily than in a polished, finished sculpture.

Between the two great figures of the High Renaissance, Michelangelo and Raphael, it is tempting to draw contrasts and make comparisons which, while they may not be untrue, may be facile and misleading. It could be said, for example, that whereas Michelangelo was the greatest exponent of the male nude, Raphael was the supreme expositor of the female. But that does not tell us very much about them as artists or indeed as men. One of Raphael's most remarkable qualities was his ability to digest and absorb a vast number of different influences, so that art historians have devoted many learned pages to the search for his sources. He studied the great Florentines, learning something from both Leonardo and

Michelangelo. *The Creation of Man.*
1508–12. One of the scenes on the vault of the Sistine Chapel in the Vatican.

Michelangelo among others, and his time in Rome as supervisor of antiquities (1508–20) gave him a deep knowledge of classical art.

While Michelangelo inspired deep respect, even reverence, Raphael inspired affection. A genial character, he was the supreme decorator – in the highest sense of the word – of the High Renaissance, elegant, charming and lovable. His classicism is pure but human, and such were Raphael's powers of assimilation that it almost seems to have been instinctive rather than learned. So fertile was Raphael's mind, so sure his genius, that he seems to have achieved perfection

without having to strive for it: a greater contrast with Michelangelo could not be imagined. There is no doubt that he was splendidly qualified to be the supreme painter of the ideal female nude, the 'Praxiteles of the post-classical world' as Lord Clark put it. Unfortunately, however, there are very few female nudes by Raphael, partly because he was always overwhelmed with work commissioned by various patrons which offered no chance for him to pursue what seems to have been his greatest artistic interest (his drawings are evidence of his long preoccupation with Venus), and

Raphael. *The Three Graces.* The Graces, a favourite subject of painters of the nude, were a nebulous trio associated with Aphrodite in Greek mythology and were probably derived from ancient goddesses of fertility. Musée Condé, Chantilly.

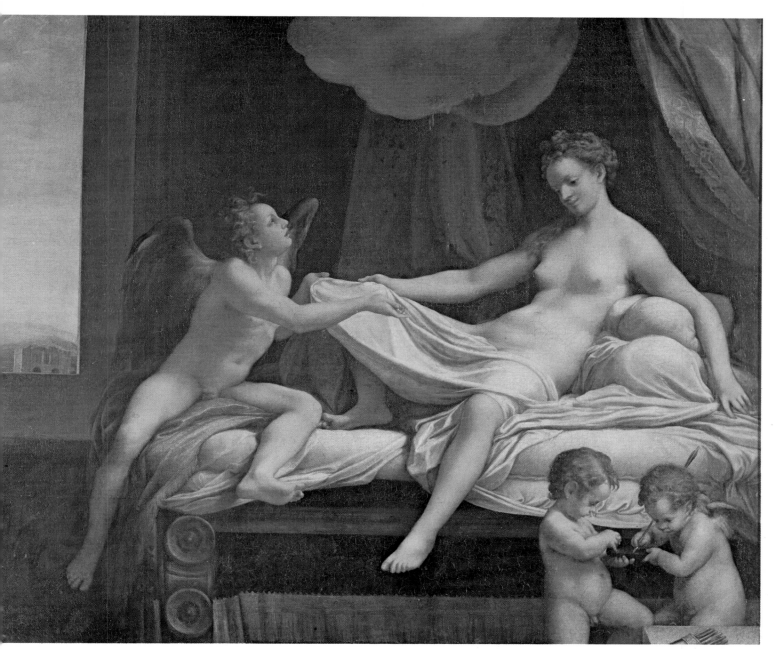

Above: Correggio. *Danae*. 1531. The subject is one of the loves of Zeus. Danae was shut up in a bronze chamber, but Zeus succeeded in impregnating her in the form of a shower of gold, and she subsequently gave birth to Perseus. Galleria Borghese, Rome.

Left: Mantegna. *St. Sebastian*. 1470. The saint martyred by shooting with arrows was a favourite subject, usually treated by Renaissance artists primarily as a chance to depict a beautiful male nude, whose response to the painful assault is rather nonchalant. Musée du Louvre, Paris.

partly because, when he did get the chance to exploit his marvellous gift, the work was often carried out by his pupils, of whom he had a great number. One famous exception is the *Triumph of Galatea*, believed to be exclusively the work of the master himself. This painting, incidentally, is constructed according to the rules of proportion in which the artists of the Renaissance put such faith, and is based on the pattern of a triangle and two circles. The picture is full of action and movement, but ruled by elegant harmony. The pose of Galatea herself, a highly complicated series of twists and turns, is said to have been based on a figure by Leonardo which, like so many of Leonardo's works, has not survived, and the figure at bottom left would appear to owe his massive, knotty torso to Michelangelo (who was painting the Sistine vault at the

time) but the spirit of the painting could not be farther removed from the monumental grandeur of Raphael's great contemporary and rival.

Raphael's frescoes in the Vatican may well have inspired Antonio Correggio (1489–1534) when he visited Rome, although the most obvious influence behind Correggio's subtle *chiaroscuro* (handling of light and shade) was Leonardo. The gentle expressions of the god and goddess in his *Mercury Instructing Cupid Before Venus*, a painting, like Raphael's *Galatea*, of which the careful, intellectual construction is not obscured by its undeniable charm, also derive ultimately from Leonardo. Correggio clearly found him a more sympathetic authority than his actual teacher, Mantegna, a relatively austere and classical

painter, although Correggio's brilliant illusionism (achievement of apparent three-dimensional effects) may have been learned in Mantegna's studio. It was extremely fortunate that Correggio was commissioned to paint a series of the love affairs of Jupiter, which gave him full range to indulge his love of female beauty.

Andrea Mantegna (*c.* 1431–1506) was also an influence on Venetian painting, though it was not from him that the Venetians learned their rich exploitation of oil paint and colour. Nor their perception of landscape – for the Venetians, so to speak, took the nude outdoors.

In Giorgione and Titian, Venice produced two of the greatest of all painters of the female nude. Giorgione is rather a problem painter: very little is known about him except that he was undoubtedly a genius and that he died of plague in 1510 when he was in his early thirties. Few paintings are known without doubt to be by him alone; even the famous *Concert Champêtre* is

not absolutely certain. Nevertheless, Giorgione is generally regarded as a great innovator, and in several respects – for his rich, warm colouring, achieved with the relatively new medium of oil paint (Florentine artists were still using tempera) and for his subject matter, which was not drawn directly from religion, mythology or history. His paintings have a mysterious, moody, motionless beauty, and his sensuous nudes were to have a powerful influence on later artists. The Dresden *Venus*, in particular, inaugurated a fertile new theme – the reclining nude. Titian (1487?–1576), Giorgione's friend and collaborator, who may have completed the Dresden *Venus* and was to achieve greater fame thanks partly to his long life, repeated it in several paintings. One of the drawbacks of the standing nude figure is that gravity tends to exert an undesirable influence on the human body; another is that the torso, such a rewarding form for the sculptor especially, has to be

Right: Giorgione. The *Dresden Venus*, a late work which may have been finished by Titian after Giorgione's death. Gemäldegalerie Alte Meister, Dresden.

Below right: Titian. *Venus of Urbino* (1538), owing an obvious debt to Giorgione's similar painting. Galleria degli Uffizi, Florence.

Below: Giorgione. *Concert Champêtre*, a dreamy, enigmatic picture setting the female nude in unaccustomed surroundings. Musée du Louvre, Paris.

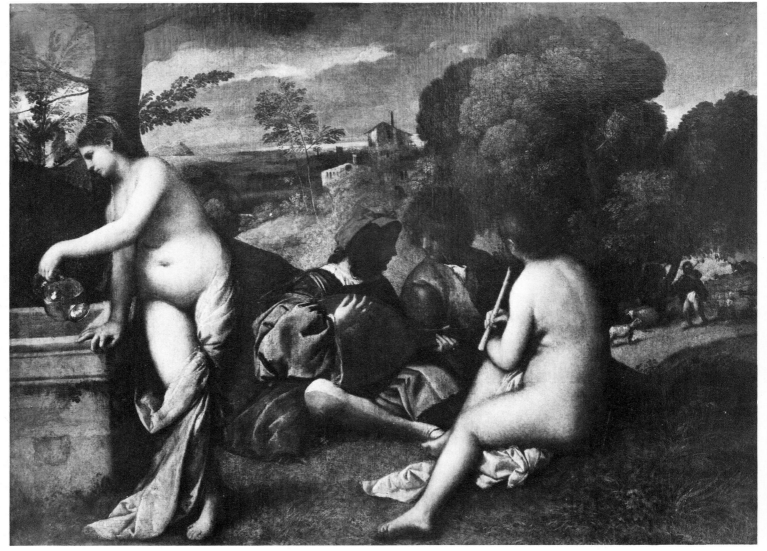

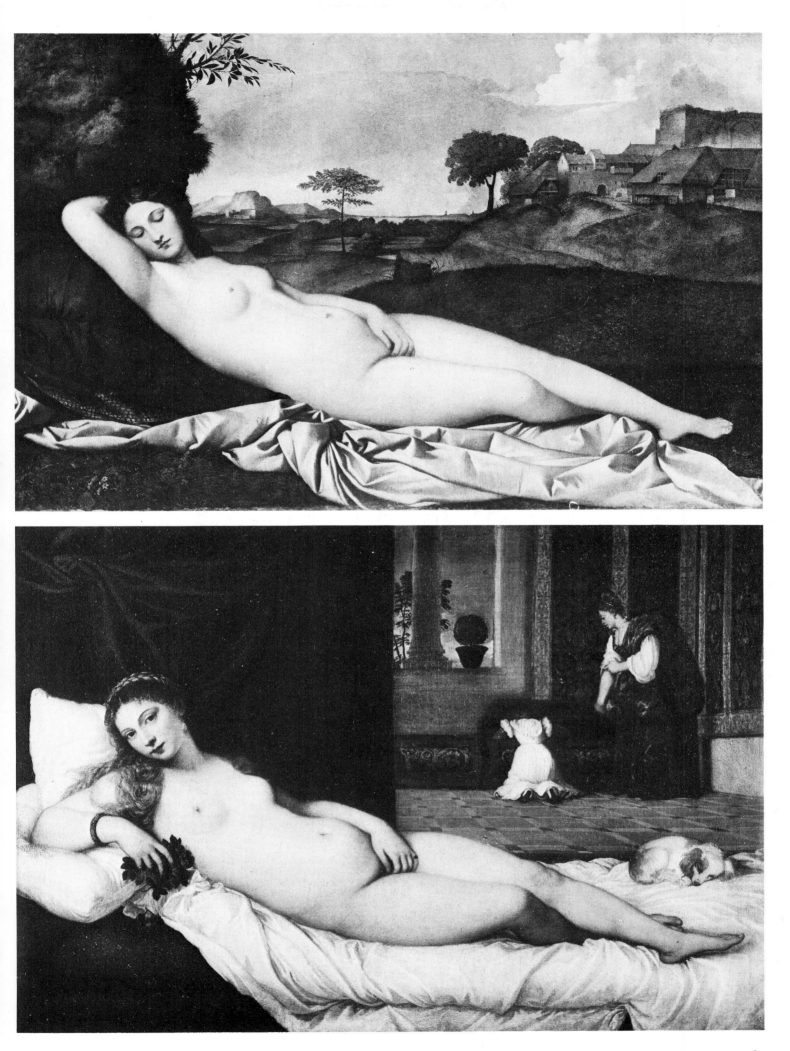

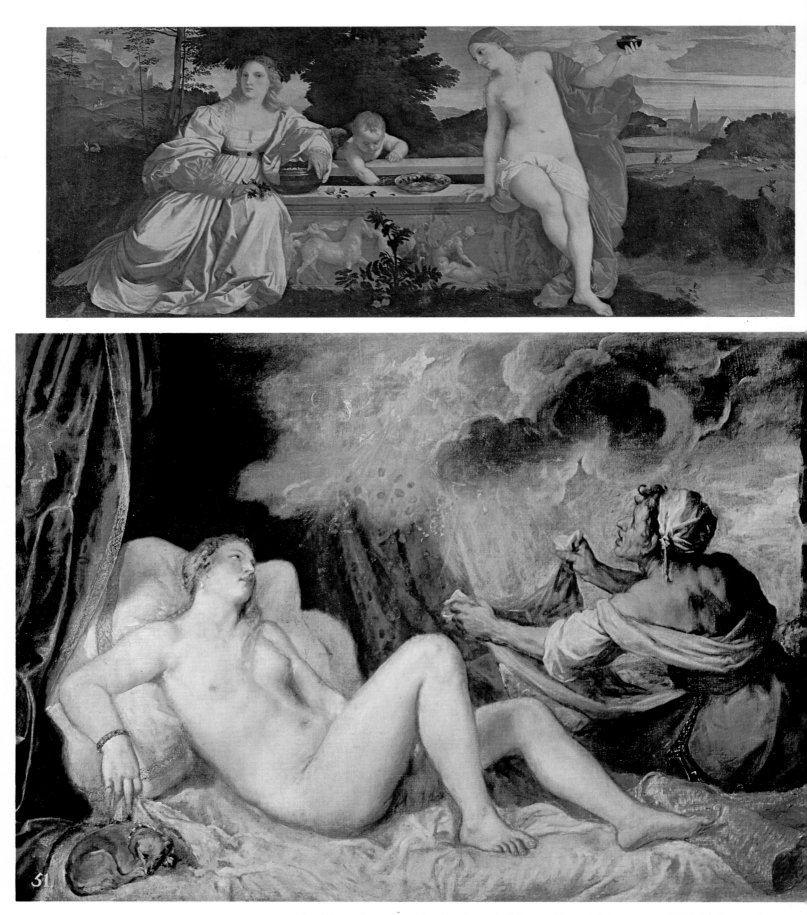

Top: Titian. *Sacred and Profane Love.* 1515.
Galleria Borghese, Rome.

Above: Titian. *Danae.* 1553. It is interesting to
compare Titian's version of this famous
seduction with that of Correggio. Museo del
Prado, Madrid.

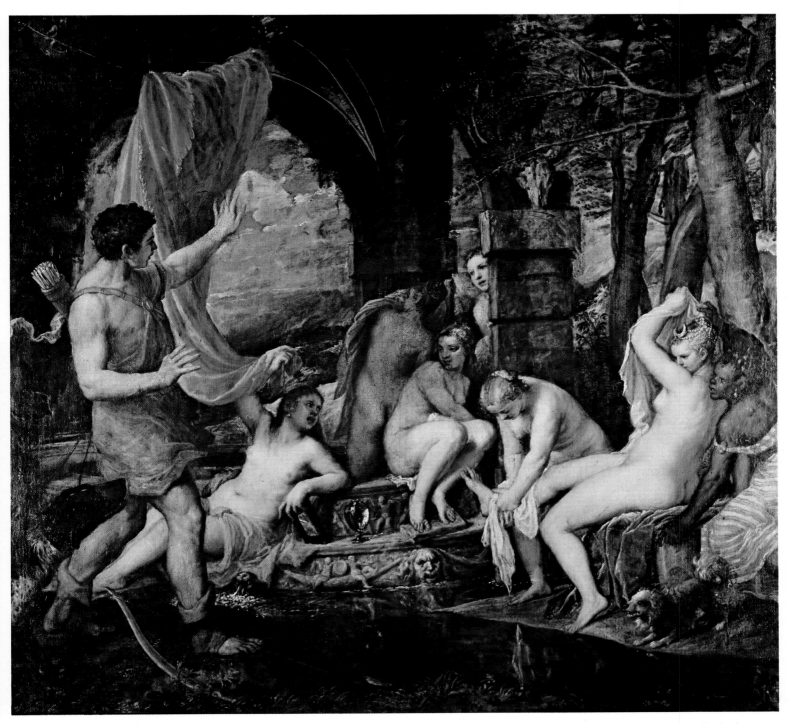

supported on legs that seem too thin for it. Both these drawbacks are overcome by the reclining nude.

Titian was probably the greatest *painter* in the 16th century, the man who liberated the art of oil painting from the art of drawing (other painters drew an outline, which they followed with the paint-laden brush; Titian relied on paint alone) and who, at different stages of his immensely long career (getting on for seventy years according to some calculations), seems to have foreshadowed almost every 'new' technique in painting during the next 300 years. He was also one of the three or four finest painters of the female nude in the whole of Western art.

One of Titian's best-known paintings, *Sacred and Profane Love*, is a comparatively early work in the Giorgionesque tradition – calm and mysterious. No one has ever succeeded in explaining what it is about and probably any attempt at specific explanation is irrelevant; as Lord Clark has said, the painting is a poem, not a puzzle. Much later, when Titian came to paint his great series of mythological subjects for his ardent patron, King Philip II of Spain, his style had changed considerably, becoming much more fluid and more energetic. Though the artist was elderly when he painted these pictures, Philip was a young man, and there is some evidence that he had an erotic

Titian. *Diana and Actaeon*, a mythological picture of the hunter surprising the goddess at her bath, painted for Philip II. The arresting figure of Diana has been the subject of special praise. Collection of the Duke of Sutherland, on loan to the National Gallery of Scotland, Edinburgh.

interest beyond the normal in paintings of nude women. A cryptic remark in one of his letters to Titian says 'Don Juan de Benavides will say to you what I shall not set down here', and Titian once pointed out to the King that the nudes in two of these paintings are complementary – the same pose seen from the front and the rear. There is little doubt that Titian, despite his age (he was probably over eighty when he painted the *Rape of Lucrece*), was no less enthusiastic at the prospect of the female nude in a variety of poses as was his patron, nor need we suppose his enthusiasm was provoked entirely by aesthetic considerations. We know, quite apart from his paintings, that Titian was a great admirer of women, and at the banquets he gave at his luxurious house in Venice a certain amount of sexual horseplay sometimes took place.

Art history, like any academic discipline, is compelled to categorize, to define 'periods', 'schools' and 'styles'. Without these categories it would be difficult to make much sense of the constant process of change and development which art, like all human activities, undergoes. But all such generalizations must be interpreted in a very broad way. As we have seen, the leading figures of the High Renaissance – Leonardo, Michelangelo and Raphael – suggest more contrasts than affinities. Moreover, Michelangelo's later style belongs not to the High Renaissance but to the style which succeeded it, generally known simply as Mannerism (there are in fact Mannerist symptoms in a work as early as his *David*). Therefore, in defining Mannerism or any other similarly broad concept in art, there is always a risk of causing more obscurity than enlightenment.

After about 1520, art in Italy became more individual, and more work was produced which was

Tintoretto. *Susanna and the Elders. c.* 1560. Certain incidents in the Bible and in classical mythology reappeared time and again because they offered an opportunity to portray the nude. Susanna observed by the elderly voyeurs was especially attractive to some because of its specific eroticism. Kunsthistoriches Museum, Vienna.

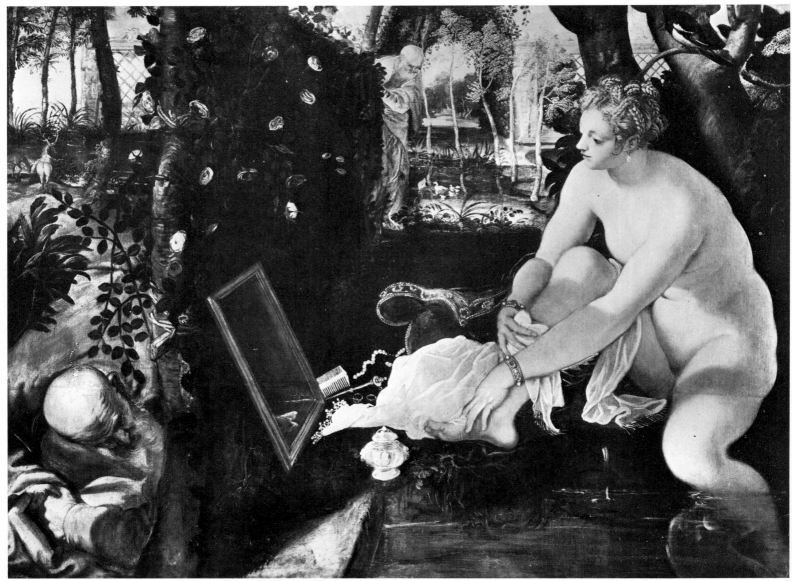

Left: Bronzino. *Venus, Cupid, Folly and Time* c. 1545. (Like many other well-known pictures, the title is not the artist's choice.) This technically brilliant and frankly erotic picture, an allegory of desire, nevertheless fails to suggest much warmth of passion. National Gallery, London.

Below: Giovanni da Bologna. *Apollo*, bronze. Palazzo Vecchio, Florence.

curious or unexpected, often in ways which seem to call for psychological explanation. As with any new style, there was an element of reaction or revolt – a deliberate turning away from an earlier generation – although to describe the art of the period solely in those terms would be as incorrect as describing 15th-century Florentine art as a reaction against the Gothic. Much Mannerist art was in fact based on admiration for the great figures of the Renaissance, especially Michelangelo. Among the most obvious, though not universal characteristics of Mannerism, particularly in regard to the nude, were exaggeration – elongation of the figure, or excessive muscularity, and violent movement often appearing rather strained – together with the use in painting of strong

colours. In courtly art, like that of Bronzino in Italy or the School of Fontainebleau in France, there was a certain frigidity, if not soul-lessness, and also a fairly frank eroticism.

The Venetian painter Tintoretto (1518–94) took for his motto, 'the drawing of Michelangelo and the colour of Titian', though he never quite achieved that perfect combination. His elegant nudes, with more slender bodies and smaller heads than Titian's, show his mastery of unusual poses. As no model could remain for long in the attitudes he required, he used wooden models strung on wire. Bronzino was hardly less elegant – as a draughtsman he had few equals – but his paintings are essentially interior decoration for a highly sophisticated clientele. Very

Far right: Barthol Spranger. *Hercules and Omphale.* 1575–80. Kunsthistoriches Museum, Vienna.

Below: *Gabrielle d'Estrée and her Sister in the Bath*, perhaps the best-known painting of the early School of Fontainebleau. Musée du Louvre, Paris.

different types were painted by Caravaggio and his successors, who were known as realists and peopled their religious scenes with ordinary folk from the streets. Among sculptors, the prince of Mannerists was Benvenuto Cellini, whose figures were not the less elegant for seeming rather affected. Cellini, trained like so many Renaissance artists as a goldsmith, always remained a goldsmith at heart, unsurpassed at detail but less effective on a large scale, despite his famour *Perseus* in Florence (so warmly recommended by the creator himself in his *Autobiography*). In recent times Giovanni da Bologna has come to be regarded as probably the greatest sculptor of his generation. His mythological figures, lithe and vigorous, are marvels of lightness and movement.

Among northern painters in the Italian Mannerist style, a frequent painter of the nude was the Flemish artist Barthel Spranger. He worked in Rome for a time and later for the Emperor at Vienna, for whom he produced many pictures of mythological incidents which the members of the imperial court no doubt found rather more satisfactory than we do. In this area of elegant, erotic, courtly art, the School of Fontainebleau is outstanding. The early masters of the school were Italians, though they had Flemings as well as Frenchmen among their pupils. Their work has often been brusquely dismissed as decadent – voluptuous, simpering nudes which the ladies of the French court liked to imagine were modelled on themselves – and to step from, say, the Sistine Chapel into the bedchamber of the Duchesse d'Etampes can only be regarded as a considerable step downwards – from heaven to earth, one might say. Nevertheless, the School of Fontainebleau is held in much higher repute today than it was by earlier generations of art critics.

The Eighteenth Century

Art and design in Europe from about the end of the 16th century to about the middle of the 18th century are generally classified by the name 'Baroque'. Originally a term of abuse, meaning tortuous or bizarre, it has often been misunderstood. In the first place it is necessary to make a rough distinction between the Baroque period and the Baroque style. Not all the art produced within the period mentioned above can really be considered Baroque in style. It is often said that the style belonged essentially to Roman Catholic countries, and although that is a generalization subject to almost endless qualifications, it at least provides a rough indication.

What was the Baroque style? Like the Renaissance, its place of birth was Italy and, like Renaissance artists, the masters of the Baroque style looked back to classical art, although they often saw it through the filter of the Renaissance itself, and in general they painted the same sort of subjects – religious, mythological, historical – as their predecessors. Baroque art is grander, more deliberately dramatic than the art of the Renaissance. In painting, colours are stronger, textures richer, there is more emphasis on light and shade, less of the poetic restraint of the Renaissance. Baroque artists made a more direct emotional appeal to the spectator and endeavoured to involve him or her more closely in the work of art. One of the ways they did this in representing the nude was to bring the human figures into the foreground of the picture, shrouding the background in darkness. This device was especially associated with Caravaggio (1571–1610), mentioned in the previous chapter, who was one of the most influential forerunners of the Baroque.

Caravaggio's influence was not confined to painters in the Baroque style. He is also regarded as one of the founders of the school of realism associated particularly with the Dutch and Flemish painters of the 17th century. The life of Caravaggio was short and hectic: he was constantly involved in fights and had to leave Rome in a hurry after killing a man. In technique he was more of a Mannerist than a true Baroque painter. His chief impact, apart from his dramatic use of light and shade, was his refusal to idealize even

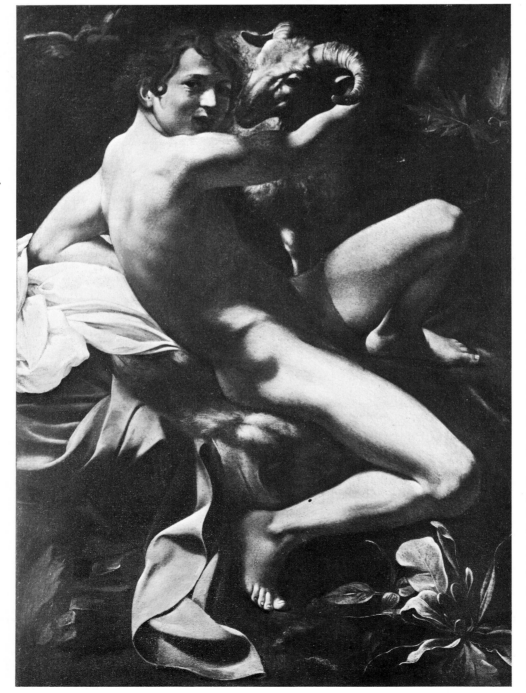

Caravaggio. *St. John the Baptist.* Caravaggio's naturalism and his dramatic use of light and shade had a pervasive influence on 17th-century art. Galleria Doria Pamphili, Rome.

Left: Caravaggio. *Martyrdom of St. Matthew*. San Luigi de'Francesi, Rome.

Annibale Carracci. *Nude Study*. 1597–98. Chalk drawing, one of about 600 studies that Carracci is said to have made for his famous Farnese ceiling in Rome. Musée du Louvre, Paris.

Christian saints and martyrs, whom he painted as ordinary people such as those to be seen any day in the streets of Rome. It was in this sense that he was a realist; his use of light was not, in fact, realistic at all.

Another artist in Rome, Annibale Carracci (1560–1609), the most brilliant of three cousins who all painted in similar style, and who was almost an exact contemporary of Caravaggio, may similarly be regarded as a vital influence, especially on the third main trend in the Baroque period, the classical style associated particularly with France. Carracci arrived in Rome in about 1595 with a commission to decorate the palace of the Farnese family. He was conscious of the fact that he had to follow in the tradition of the decorative art of the Roman Renaissance founded by Raphael, and his work in the Farnese palace, though the main source of his fame and influence, was not entirely typical of him. His objective realism, as opposed to his loyalty to the classical tradition of ideal beauty, is perhaps more evident in smaller works – portraits and landscapes.

Below: Guido Reni. *St. John the Baptist*, continuing the tradition of the beautiful youth, formerly more typical of mythological heroes than Christian saints. Dulwich Picture Gallery, London.

The eldest of the Carracci cousins founded an academy in Bologna, their native city, where some of the most famous painters of the next generation studied. The most brilliant of them was Guido Reni (1575–1642), an artist whose reputation has been subject to more ups and downs than most. In his own time he was regarded as a second Raphael, but a later age found something sterile in the sheer perfection of Reni's homage to the classical ideal.

From its origins in Rome, the Baroque style spread throughout a large part of Europe and across the Atlantic Ocean to the Spanish empire in the Americas. The leaders of the Roman Baroque were the architect Borromini and his rival, the sculptor Gianlorenzo Bernini (1598–1680). What primarily makes Bernini a Baroque artist is his love of striking, illusionist effects – no one has ever excelled him at, for example, fashioning a swirling cloak out of such seemingly intractable material as marble. Bernini's *David*, a comparatively early work, has been called one of the first true Baroque sculptures. Its vigorous movement illustrates very well the gulf between Renaissance treatments of this popular subject (e.g., by Donatello and Michelangelo). Another illusionistic Baroque device employed by Bernini, although it had been used earlier, was to create a focus outside the actual work – within the space of the spectator, so to speak, rather than the work of art itself – thus drawing the spectator more intimately into the work. In the case of Bernini's *David*, one almost expects to see at the opposite side of the gallery a figure of Goliath marching forward before the fatal stone strikes him on the forehead. However, the Baroque of Bernini is not anti-classical: not only is his subject matter the same as that of his Renaissance predecessors, he also uses classical models. The *David* is based on a classical figure known as the *Borghese Warrior*, and his *Apollo* is adapted, admittedly with

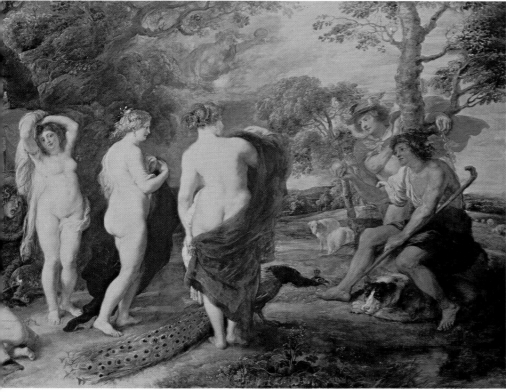

Above: Three splendid Rubens nudes, representing the Sirens, and included a little gratuitously in his painting of *Marie Medicis Arriving at Marseilles*. 1622–25. Musée du Louvre, Paris.

Left: Rubens. *The Judgement of Paris. c.* 1629–30. The atmosphere of this scene is very different from that imagined by Watteau, one of many who painted the subject of the goddesses' beauty contest. National Gallery, London.

Far left: Annibale Carracci. *Venus and Anchises. c.* 1598. The artist's classicism was consciously cultivated and influenced many artists of the succeeding generation. Palazzo Farnese, Rome.

considerable freedom, from the *Apollo Belvedere*. The ecstatic moment of transformation, as Bernini interpreted it, in *Apollo and Daphne* bears some relation to his better-known sculptures of saints undergoing mystical experiences, of which the most famous is the *Ecstasy of St. Theresa* in Rome. But the Church of the Counter-Reformation disapproved of the nude – Pope Paul IV had ordered that the genital areas of Michelangelo's nude figures in the Sistine Chapel should be concealed, while Clement VIII was barely restrained from painting out the whole ceiling – and the nude seldom appears in Baroque religious art.

The Baroque period in art, like the Renaissance, is dominated by a few great names, such as Rubens, Rembrandt, Velazquez and Poussin. All these artists took the nude as their subject, some less often than others; several of them were among the greatest of all painters of the human body. Of these, the first was the master of the Flemish school, Peter Paul Rubens (1577–1640).

Rubens is one of the most influential artists in the whole post-Renaissance tradition. As far as the nude is concerned, it could be said that he did for the female what Michelangelo had done for the male. His genius has never been seriously doubted, especially among those best qualified to judge – that is, other painters; yet he has never been held in quite the same popular affection that embraces, for instance, Raphael or Rembrandt. Even today some people tend to dismiss Rubens as a painter of fat, fleshy, sprawling, unattractive women.

Rubens was trained in Antwerp. The most influential of his teachers was a member of the so-called Romanist school, and it was perhaps through him that Rubens gained his appointment at the court of the Duke of Mantua in 1600. He remained in Italy for eight years, painting conventional Mannerist portraits at which he was very successful, visiting Spain where he was impressed by the large collection of Venetian art in Madrid, and Rome where he absorbed the influence of contemporaries such as Caravaggio and Annibale Carracci. It was probably from the latter that Rubens learned to make careful preparatory sketches for his

Above: Rubens. *Rape of the Daughters of Leucippus*. One of the characteristics of Rubens' and Baroque art generally was dynamic movement, with forms flowing urgently into one another, so that the eye finds few places to rest. Alte Pinakothek, Munich.

Above right: Jordaens. *Susanna and the Elders*. Jordaens has been called a coarser Rubens, in whose studio he worked for a time. Musées Royaux des Beaux Arts, Brussels.

Left: Bernini. *Apollo and Daphne*. 1622–25. One of a series of sculptures, including his *David*, done for Cardinal Borghese. Galleria Borghese, Rome.

paintings, and he certainly studied the Farnese ceiling closely, incorporating some of Carracci's motifs in his own early work.

When Rubens returned to Antwerp, thirty years of enjoyable and rewarding activity lay ahead of him. He was an established painter, soon appointed court painter to the regent of the Spanish Netherlands, and a trusted diplomat who undertook missions to several foreign countries, including England (where in London he painted the ceiling of the Banqueting House which is still the chief glory of Whitehall). A generous, genial man, he had the kind of personality that gets the most out of life: while painting a picture he would simultaneously talk to his visitors and dictate letters. Although his painting naturally developed during those thirty-odd years, his style was established by the time he returned from Italy, and there were to be no very dramatic changes. In Rubens, the traditions of north and south Europe – the realism of Flanders and the classicism of Italy – were combined. The harder, more restrained Italian style of his early period gradually gave way to a style more thoroughly Baroque, a style of terrific energy and force which, however, even at its wildest, is based on careful composition and awareness of the virtues of classical balance. Rubens's brushwork became more fluid, and the colours warmer and more glowing, applied with quick, decisive strokes.

The Flemish Baroque style of which Rubens is the supreme master (in a way the only master) is not 'idealistic' in the sense that his figures represent an ideal type – as in Italian Renaissance paintings. Even his figures of Christian saints are distinctive individuals, provoking the criticism that, even in the noblest of Rubens's compositions, the effect is jeopardized by the non-nobleness of the figures within them. His female nudes are not representatives of some humane ideal, they are the expression of forceful, individualistic genius. On the other hand they are not strictly realistic either. They are larger than life, not simply in their dimensions, generous though these are, but in their lush sensuality, their vigorous movement, their energy, their powerful rhythms, and they are not always accurate from the strict anatomical point of view. But even those who feel unsympathetic towards the form of the Rubens nude usually admit that, when it came to the actual painting of human flesh, Rubens was supreme. 'Pearly' is the adjective which is often used to describe the glowing, almost translucent effect that Rubens – and perhaps no other painter except Renoir – achieved, though the skin of Rubens's robust nymphs is warmer than any pearl.

One practical aspect of Rubens's work has caused art historians no little difficulty. His paintings were in such demand that Rubens, like Raphael before him, had his pupils

or collaborators do a good deal of the work. Indeed, Rubens's studio was almost like a factory, complete with division of labour. In a letter to a potential customer, Rubens described one of his paintings (for which he was asking the substantial sum of 1200 guilders) as 'a Last Judgment begun by one of my pupils, after one I did in a much larger size . . . this, as it is not finished, would be entirely retouched by my own hand, and will pass as an original'. There is little doubt that comparatively few of Rubens' paintings were entirely the work of his own hand, although as a rule he would be responsible for the design and for the final stages of painting. Some of his collaborators, incidentally, were great artists themselves; they included Jan Brueghel, and among his pupils were van Dyck and Jordaens, who in different ways were to carry on the Rubens tradition. In fact Rubens was one of the most influential artists who ever lived, and apart from those (like Delacroix) who could regard themselves as to some extent his artistic heirs, no painter of the nude during the 200 years after his death was able to ignore Rubens's revolutionary contribution to the tradition.

Poussin. *Bacchanalian Revel. c.* 1630–32. Though faithful to his classical principles, Poussin was of course influenced by Baroque movement and energy. National Gallery, London.

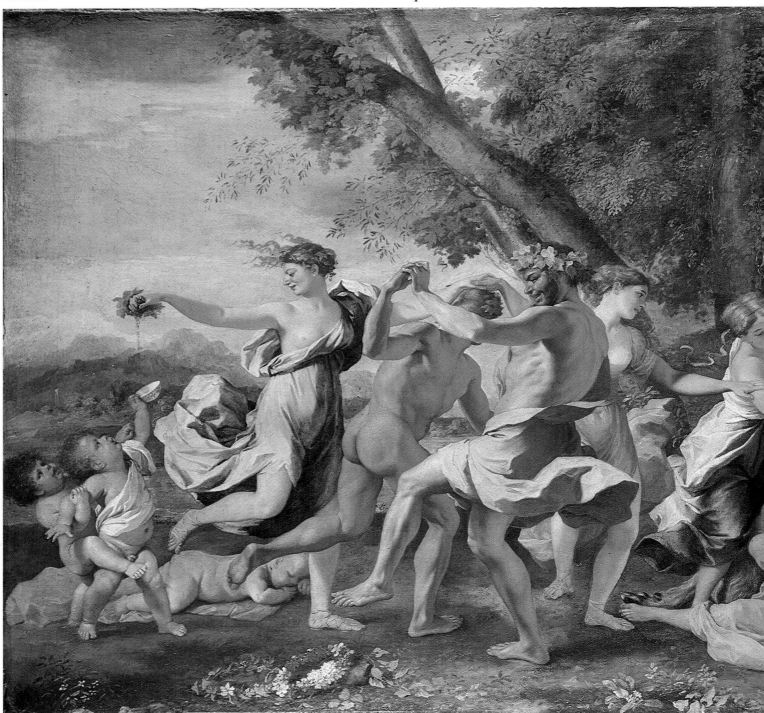

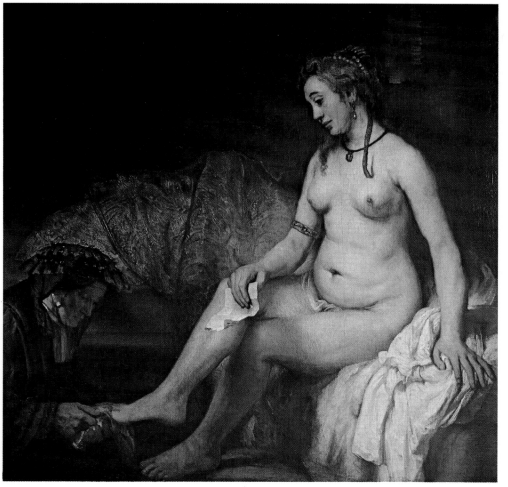

Rembrandt. *Bathsheba*. 1654. The supreme example of that favourite motif of painters of the female nude, a lady at her toilet. Musée du Louvre, Paris.

The Netherlands in the 17th century were sharply divided between the Catholic, Spanish south and the Protestant, independent north. The Dutch held firmly to their hard-won independence, strongly resisted the Counter-Reformation of the Roman Catholic Church, and grew strong and prosperous through their command of trade. Prosperity, patriotism and faith in the Protestant way of life created a demand for a kind of art not found in other European countries, a realistic art which depicted ordinary people, from rich merchants to farm labourers, in scenes of everyday life, an art of rich, gentle landscapes and well-furnished rooms. The Dutch school of art produced several excellent painters, including Vermeer, famous for his landscapes, and Frans Hals, for his portraits. It also produced one towering genius, Rembrandt van Rijn (1606–69), a miller's son from Leyden, who in European art stands with Michelangelo and Raphael on the highest peak of artistic achievement. This is the common judgment today, but it is a comparatively recent one. Delacroix, in the early 19th century,

put forward the suggestion that 'we shall one day find that Rembrandt is a greater painter than Raphael,' but added, 'I write down this blasphemy, which will cause the hair of the schoolmen to stand on end, without taking sides.'

Many of the characteristic elements of the Baroque style appear in Rembrandt's work – an individualistic realism, the drama of night and of death, the strangeness of ordinary people – yet in some ways Rembrandt was a very un-Baroque painter, particularly in his avoidance of flamboyant emotional gestures; Rembrandt is more contemplative, and more profound. Art historians always talk a great deal about his debt to Caravaggio, despite the fact that Rembrandt never visited Italy (he probably never left Holland; the legend of his stay in England is unsupported by facts). Rembrandt's use of *chiaroscuro* is subtler than Caravaggio's, and his realism is due more to the Dutch tradition than to the revolutionary Italian master. Like any other artist, Rembrandt was a man of his own time, and he would have produced a different kind of art if he had lived in any century other than the 17th, yet

he owed less to others than almost any great artist one can think of.

Technically, Rembrandt was prodigiously gifted. He excelled in every kind of painting, and he was also the supreme master of etching. But above all, it is for his portraits that he is most celebrated. His deep insight into human nature, his embracing sympathy for the human race, which his gifts as an artist permitted him to communicate in a way that no one has ever excelled, this supreme quality is most apparent in his portraits. In his *Bathsheba*, probably his greatest study of the nude, how much of the effect depends on the poignant, dreamy expression of the face. *Bathsheba* was modelled on Hendrickje Stoffels, the girl who became his second wife (he never actually married her, perhaps because of some provision against it in his first wife's will), whom he painted often. In this picture of the female body, Rembrandt owes very little to the classical tradition – this could not possibly be regarded as an 'ideal' figure – yet he has gone beyond anything achieved by the great painters of the Renaissance because, with great love and utter sincerity, he has portrayed a human soul. 'The Miracle of Rembrandt's *Bathsheba*,' wrote Lord Clark, 'the naked body permeated with thought, was never repeated.'

The classical style in 17th-century Europe can be seen as a deliberate 'opposition movement' to the Baroque although, as one would expect, they shared many qualities in common. In fact there was one minor school of French decorative art which art historians, in some desperation, have defined as 'Baroque classicism'. Nevertheless, there were vital differences in principle between the Baroque and the classical. All art appeals to both the mind and the emotions, but whereas Baroque artists aimed primarily at the emotions, classical artists believed that art should appeal more to the intellect than the senses. They respected the classical tradition more profoundly than Baroque artists did, although not to the extent that they became merely sterile copiers, and they conformed more closely to classical principles of harmony, balance and form.

This classical tradition, which continued throughout the Baroque period and eventually enjoyed a sort of victory in the late 18th century when Neoclassicism became the dominant European style in art, was fertilized, naturally, in Italy. The influence of the Carracci family has already been noted, and we have seen how one of the most able of their pupils, Guido Reni, became preoccupied with the ideal beauty of the human body. However, 17th-century classicism is associated mostly with the France of Louis XIV, with his serenely 'classical' palace at Versailles.

Below: Rembrandt. *Seated Nude.* Etching.

Right: Poussin. *Venus Asleep.* Poussin was the greatest representative of French classicism, who became more 'classical' and less 'Baroque' as he advanced in years. Akademie der bildenden Künste, Vienna.

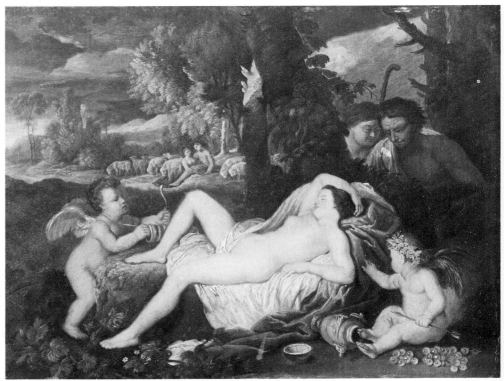

A good example of the fertile cross-currents in 17th-century art is Georges de la Tour (1593–1652). La Tour belongs to that generation of artists who could be called Caravaggesque, chiefly because of the emphatic use of light and shade which Caravaggio had demonstrated, but La Tour's calm, restrained manner is essentially classical. In a late painting like his *St. Sebastian* there is no blood or violence and the saint's body, instead of being festooned like a pincushion, is pierced by a single arrow. La Tour was impelled towards simplicity of form, and his figures appear almost like polished wooden carvings.

The outstanding artists of 17th-century classicism were Claude Lorrain, known for his landscapes, and Nicolas Poussin (1594–1665), the dominant influence in French art for over one hundred years who, in the words of Michael Kitson, 'made classicism into a serious, expressive and deeply moving language as perhaps never before or since'.

After studying in Paris, Poussin went to Rome at the age of thirty and, except for two unhappy years in Paris, he remained there the rest of his life. Poussin had a passion for the antique, and he was capable of altering the pose of a figure in his painting to make it conform more closely to an antique model. That does not mean that he shut his eyes to the movements of ordinary people in Rome, still less that he ignored landscape, of which in fact he was a master (perhaps the equal of Claude Lorrain). Nor were the sculptors of antiquity his only influence. He admired Titian, and his early works have much of the warm colour of the Venetians; he shared the general enthusiasm for Raphael. With characteristic lucidity Poussin wrote, 'My nature leads me to seek out and cherish things that are well-ordered, shunning confusion which is as contrary and menacing to me as dark shadows are to the light of day.' Poussin's paintings are grave, deliberate and restrained, but they are neither lifeless nor dull, even if it is true that Poussin made a conscious effort to exclude feeling. His compositions are full of ideas, but his imagination is always controlled by the discipline of the artist's aesthetic convictions.

By the end of the 17th century the first signs of the Rococo style were evident in the decorative arts in France. Rococo was partly a reaction against the heavy Baroque of the Louis XIV period and partly a development of it. Essentially, it was a decorative style of charm, wit and cunning device. In opposition to Baroque and classicism, it had no weighty intellectual content and was not governed by philosophical theories. It reflected the changed moral climate in which religion had ceased to be a burning issue and upper-class society had become more urbane, more unashamedly pleasure-loving. There was much more emphasis on style as an end in itself rather than as a means of

Watteau. *The Judgement of Paris*. 1721. Musée du Louvre, Paris.

conveying some didactic idea, and the general run of Rococo artists were essentially decorators, whose outstanding gift was their sheer skill. Among lesser artists, the Rococo could be rather dry and heartless, and it produced fewer truly great artists than the Baroque.

The most notable exception was Jean-Antoine Watteau (1684–1721), who apart from a brief visit to England worked most of his rather short life in Paris. Watteau was influenced by Rubens who, by about 1700, was challenging Poussin as the hero of French painters, but he translated Rubens into a quite different idiom. He worked on a smaller scale, avoiding great historical and mythological set-pieces and achieving a highly personal vision in which human emotions were conveyed with unparalleled charm and poignancy, and nature was turned into poetry. He is probably best known for his paintings of courtly entertainments, and this has often caused him to be underrated. There is much more to Watteau than handsome couples in wigs dancing on a terrace.

Watteau in fact painted few nudes, perhaps because, as Lord Clark suggested, commenting on

their exquisite Rubens-like skin texture, he was inhibited by 'a kind of shyness, born of too tremulous desire, which the spectacle of the living surface aroused in him'. His Venus in the *Judgment of Paris* is the rather tall, slender, tapering figure with a trace of the Gothic about her who had been characteristic of French art since the Renaissance, but the beautifully modelled flesh and glowing skin tones are those of Rubens, while the privacy of the scene, which keeps the spectator at a distance, is characteristic of Watteau.

If Watteau is the greatest painter of the French Rococo, François Boucher (1703–70) is the most typical. So far as the nude is concerned, he was also immensely more prolific: Boucher, who nevertheless owed much to Watteau and engraved some of his paintings, certainly had no reservations at all about painting desirable female bodies. He was essentially and contentedly a decorator, since his pictures have no purpose except to please, but he was a decorator of the highest class. 'Voluptuousness,' wrote a 19th-century critic, 'is the essence of Boucher's ideal . . . in his treatment of the conventional nudities of mythology, what a light and skilful hand is his! How fresh his imagination even when its theme is indecent! And how harmonious his gift of composition, naturally adapted, it might seem, to the arrangement of lovely bodies upon clouds rounded like the necks of swans.'

Boucher was the favourite painter of Mme de Pompadour, the King's influential mistress. He decorated her boudoir, and it is no doubt Boucher who is chiefly responsible for the term *style Pompadour*, sometimes used to describe the Rococo. Boucher's Venuses could hardly be more different from those of Praxiteles. They are sex objects: delightful, weightless creatures sporting amid a swirl of curving forms. Probably, Boucher's best-known painting is *Mlle O'Murphy*, another of Louis XV's mistresses, presented in an abandoned pose of animal contentment. In this and even in his less well-known, more explicitly erotic paintings, Boucher manages to express sexual desire without the faintest suggestion of a leer or a snigger.

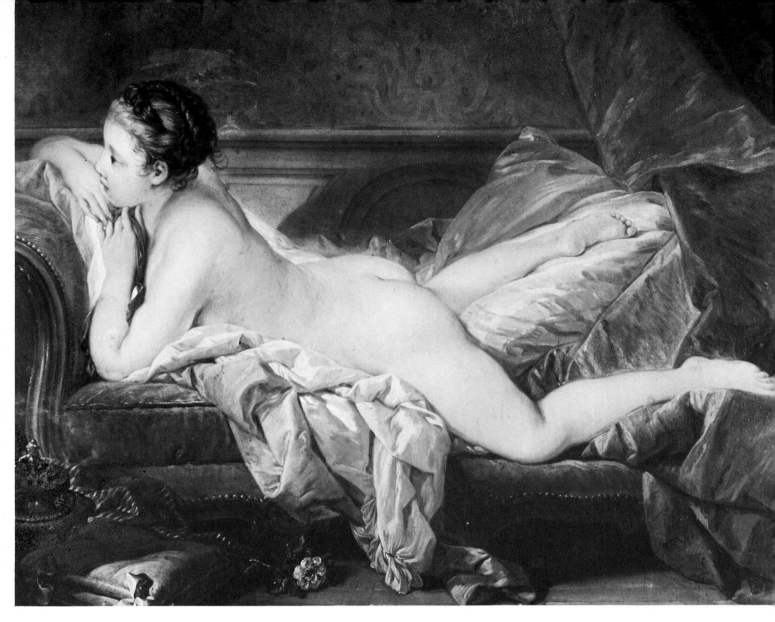

Boucher. *Mlle. O'Murphy*. 1752. A royal pin-up, in which the artist perfectly captures the model's sense of physical self-satisfaction.

The rear view was not a new motif in the history of the nude in art, but in the 18th century it became much more common. It would have been strange if there were no examples in antique art, when this aspect was regarded as more obviously erotic, but perhaps for that reason, it is relatively uncommon in art before the 18th century. The most famous example is the *Rokeby Venus* of Velazquez (1599–1660), after Rembrandt the greatest painter of the 17th century. It appears to have been based – at any rate in Velazquez's original conception – on a Renaissance engraving, but was clearly painted from a living model. The nude is a rare subject in Spanish art generally, and no great Spanish master can be regarded, except incidentally, as a major painter of the nude (Velazquez is known to have painted others, however). It is therefore rather surprising that of the handful of representations of the nude which have become part of the imagery of the mass arts, exploited by designers of advertisements and endlessly commented on in the works

of modern artists, two come from Spain. The *Rokeby Venus*, at one time belonged to the Duchess of Alba, friend and confidante of the great Spanish Romantic painter, Goya (1746–1828), and he must have seen it at her house around the beginning of the 19th century, when he painted his famous *Naked Maja*. Many colourful stories surround this painting, which has gained additional popular renown from the fact that there is a companion piece, painted about the same time, of the same model in the same pose but clothed. Probably Goya, an artist full of surprises (not to say shocks), was prompted by the Velazquez painting into attempting a female nude largely as an aesthetic exercise – though the *Naked Maja* could hardly be called an academic nude. Goya was of course also influenced by Titian, notably by the *Venus of Urbino*, which he would also have known. Goya's characteristic frankness and honesty are no less evident here than in his horrifying engravings of the *Disasters of War*, and the *Naked Maja* can be seen as

closer in spirit to the *Olympia* of Manet than the Venuses of the Venetians (among other technical similarities, both artists made use of a sheet to offset the skin of the subject).

The French Rococo painters, for all their considerable virtues, should possibly not be discussed on quite the same level as such an extraordinary genius as Goya or Velazquez. Nevertheless, they are of greater relevance to the history of the nude in art. Jean Honoré Fragonard (1732–1806) was the successor to Boucher as a painter of charming, frothy, often 'naughty' pictures, largely in the pastel colours of the boudoir. Boucher's petite creatures (it is hard, as a critic once remarked, to imagine Boucher's little powdered Venus taking part in the siege of Troy) became, in the hands of Fragonard, still more plainly erotic playthings. Fragonard was criticized by more 'serious' artists (most of whom we would now regard as vastly less talented) for condescending to the amoral eroticism of the *ancien régime*, and he was to be ruined by the French Revolution which swept away the class to whom he catered. In some ways, however, Fragonard was a superior artist to Boucher, whom he excelled in suggesting airy movement, while the charming landscapes in which his careless lads and lasses frolic were closer in spirit to Watteau. However sexually explicit Fragonard was, and in some of his less frequently reproduced works he was about as explicit as it is possible to be, his stylishness, skill and taste prevented his works being, except in the most literal, puritanical interpretation, obscene. Indeed, Fragonard is seldom impolite.

The same spirit which informs French 18th-century painting can be found in sculpture. There too the classical tradition of the essentially chaste nude was fast disappearing. Étienne-Maurice Falconet's *Bather* is obviously sister to Boucher's *Venus*. Falconet (1716–91) was for much of his working life the director of sculpture at the Sèvres porcelain factory, and the newly discovered art of making porcelain had a marked effect not only on the sculpture of Falconet, Clodion (1738–1814) and others but also on painting. The translucent skin of the nudes of Boucher and Fragonard

may well have owed something to the recent achievements of Sèvres, and their colours too are suggestive of Rococo porcelain. 'By Clodion,' wrote Lord Clark, 'Venus was observed with a more appreciative eye than by any other artist of the 18th century.' His well-known *Nymph and Satyr* is an accomplished and attractive sexual frolic; Clodion was sufficiently interested in sex and eroticism to make some small sculptures of sexually deviant practices.

The great artists of the nude have been moved by different ambitions and have worked in different ways, But the concept of the nude in art, as it was worked out in antiquity, is a constant theme, played with numerous variations throughout history until the late 19th century. Today the concept of the nude is invariably of the female nude, but this was not true at all times and in

Falconet. *Baigneuse.* 1760–80. Marble, a figure 15 inches (38 cm) high which suggests the glaze of porcelain. National Trust, Waddesdon Manor, England.

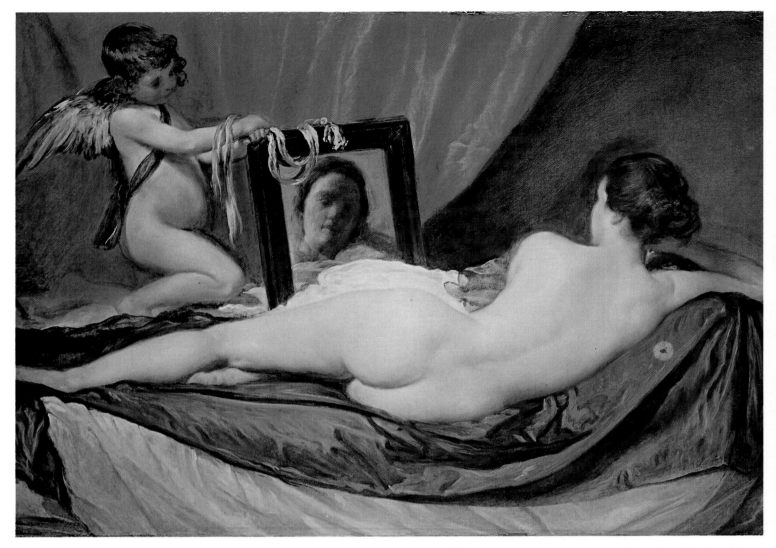

all places. The early classical nudes
were almost exclusively male.
Michelangelo was far more
interested in the male nude than the
female, and it was not until the late
17th century that Venus finally
established her apparently final
predominance over Apollo. The
decorative erotic art of the 18th
century, though it did not represent
the only way of treating the nude,
reinforced the idea that 'nude'
meant 'female nude', and the
Neoclassical reaction did not change
that, although it did change
conceptions of the female nude.
Artists may differ over the question
whether, when regarded as simply a
question of form, the male or female
figure is more rewarding, but the
essential reason for the ascendancy
of the female is surely a basic,
biological one. In the 18th century
eroticism became acceptable. Of
course that does not mean that no
erotic nudes had appeared before; on
the contrary, virtually all nudes are
in some sense erotic, but never before
in European art had eroticism been
so openly displayed and so generally

accepted. Since the vast majority of
artists were men (not all, of course,
heterosexual men) and since their
patrons too were usually men, it is
perhaps not surprising that the
female nude became the norm. On
the other hand, the explicitly sexual
element having been brought into
the open, it is similarly not surprising
that, in the 19th century, the nude
was to run into fiercer opposition
than at any previous time since the
Middle Ages.

Top: Velazquez. *The Rokeby Venus.* Before
1651. The device of the mirror gives an extra
dimension to this immensely popular
painting. National Gallery, London.

Above: Goya. *Maja Desnuda.* 1800–05.
Probably the most famous if not necessarily
the most successful reclining female nude in
the history of art. Museo del Prado, Madrid.

The Nineteenth Century

In 1785, when Fragonard's frothy ladies still reflected the taste of the old French upper class and the French Revolution was still four years away, the success of the season in Paris was the *Oath of the Horatii* by Jacques Louis David, a stark, severe picture deriving from Roman relief sculpture and the classicism of Poussin. The frivolity of the Rococo was banished: art was to be a noble, official affair, an exhortation to social virtue. David, carrying the banner of Neoclassicism, was to become an extremely influential figure, politically as well as artistically, and although many of his later paintings were a good deal less severe and classical than his famous tributes to the virtues of republicanism (inappropriate though it may seem, David was related to Boucher), his influence lasted throughout the Napoleonic period and beyond. David was not particularly interested in the nude as a subject, and when he included nude warriors in, for example, his *Sabine Women*, he did so merely out of faithfulness to classical conventions. However, the painter – a former pupil of David's – who carried the banner of Neoclassicism forward into the second half of the 19th century is one of the most famous of all painters of the nude.

Jean Auguste Dominique Ingres (1780–1867) was, nevertheless, an

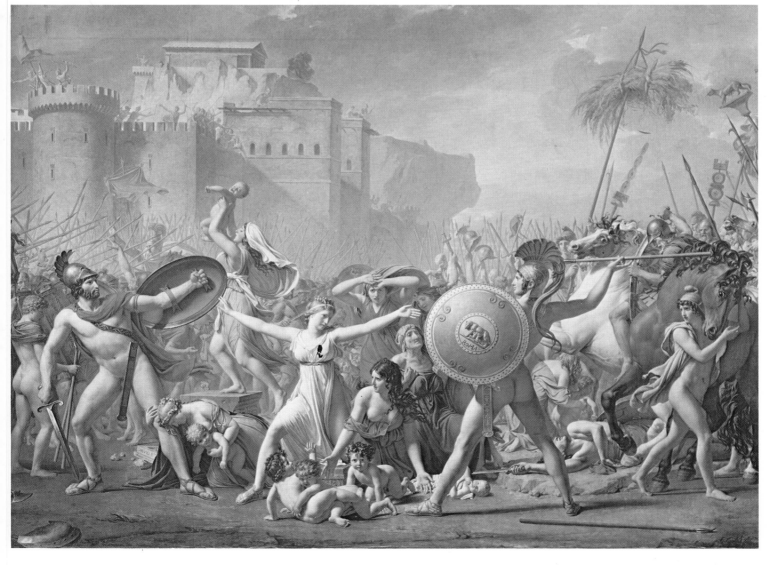

David. *The Sabine Women.* 1799. An incident in Roman legend in which the women established peace between their warring husbands and fathers. David took themes from ancient history to comment on circumstances in contemporary France. Musée du Louvre, Paris.

odd sort of classicist, and despite his fierce antagonism to the Romantics, his classicism was itself fundamentally 'romantic'. He was a conscious classicist, a classicist in principle, who regarded antique art with such reverence that criticism of it seemed little short of blasphemy. Like David, he emphasized the importance of drawing: 'anything well enough drawn is well enough painted,' he said. He distrusted colour, which interfered with the purity of form, and he regarded nature as, on the whole, an unworthy subject for art. His lack of sympathy with contemporary developments in French painting was exacerbated by his long absences in Rome and Florence, but he became extremely successful and supervised a large number of students, from whose efforts he sternly endeavoured to expunge all non-classical elements (they were absolutely forbidden to look at Rubens).

And yet, how very unlike the classical idea of the nude are Ingres's superb odalisques. Ingres is in fact the most idiosyncratic of painters, much more influenced by Rubenesque emotionalism than he would have cared to admit, whose work appeals at least as much to the senses as it does to the mind. If one were to attempt to isolate two factors in his art to explain his distinctive style, they would be, first, his extreme purity of outline, with which he achieved perfectly rounded forms with a minimum of modelling, and second, his powerful sensual awareness of his subject. Ingres subscribed to the contemporary idea that beauty consists of smoothness and continuity and can thus be better expressed in the female nude than the male. In fact Ingres could draw male nudes, as he could draw everything else, very well indeed – a fact evident in his drawings for the great mural painting *L'Age d'Or*, which occupied much of his time

Far right: Ingres. *La Source*. Musée du Louvre, Paris.

Below: Ingres. *Odalisque with Slave*. 1842. One of the most voluptuous nudes in the history of art. Fogg Art Museum, Harvard University, Cambridge, Massachusetts. Bequest-Grenville L. Winthrop.

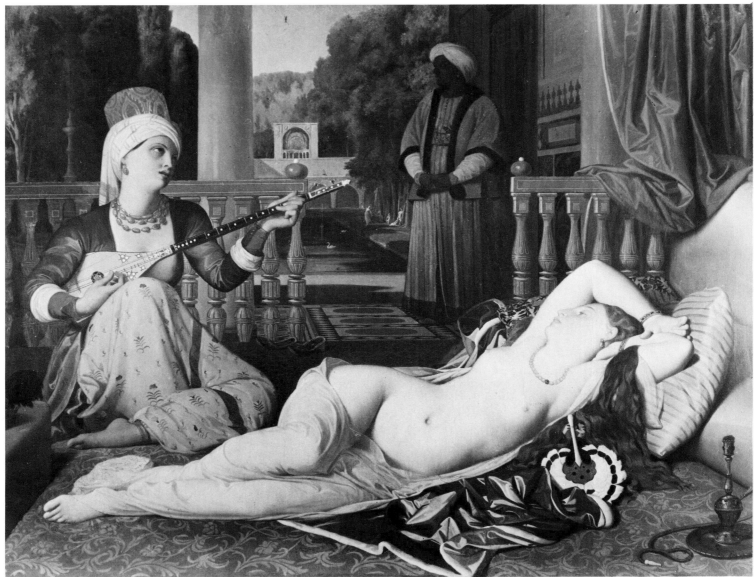

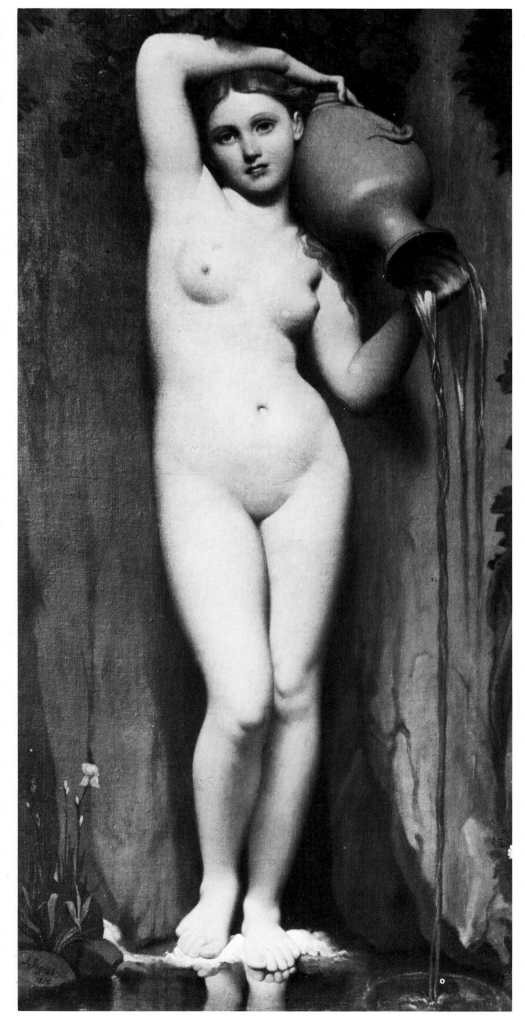

during the 1840s (though he never completed it). But the male body did not excite him, and therefore his male nudes, however technically competent, are rather dull and conventional.

There is to modern eyes an air of hot-house erotic fantasy in many paintings of the nude in this period, and although it is more common in the work of Romantic artists, it is certainly present in Ingres. He shared with his opponent Delacroix a fascination for Oriental scenes: the harem, of course, offered a fine opportunity for painting female nudes. Ingres was also not untouched by the fairly common interest in women placed in some frightening or painful situation – an element in Delacroix's make-up too. Ingres, like Titian as well as Delacroix, was attracted to the subject of the bound, captive female – in this case being rescued by a very Gothic knight in armour – but Ingres's rendering, with the exaggerated tilt of the head, is much more frankly erotic than Titian's. Compare also Ingres's reclining nude, the *Odalisque with a Slave*, with its 16th-century antecedent, the *Venus of Urbino* of Titian. Ingres's figure suggests sexual abandonment; Titian's is far more restrained.

Ingres was always obsessed by form. His painting of the *Turkish Bath*, painted towards the end of his long life (with justifiable pride he wrote his age – eighty-two – next to his signature), is a remarkable summary of his long study of the female body, and it includes nearly all the forms that had chiefly occupied him – a remarkably restricted number in fact – during the previous fifty years and more. The most obvious example is the calm, smooth back of the central figure, which had made its first appearance no less than fifty-five years earlier in the *Baigneuse de Valpinçon*: Ingres's ideas germinated slowly. What is perhaps his most famous painting, *The Source* (1856), once described as the most beautiful nude in the whole of French art, appears in a basically similar form in a drawing made forty-six years before.

Eugène Delacroix (1798–1863), despite his view of himself as a painter in the classical tradition, was cast in the role of opponent to the classicism of Ingres. Delacroix

89

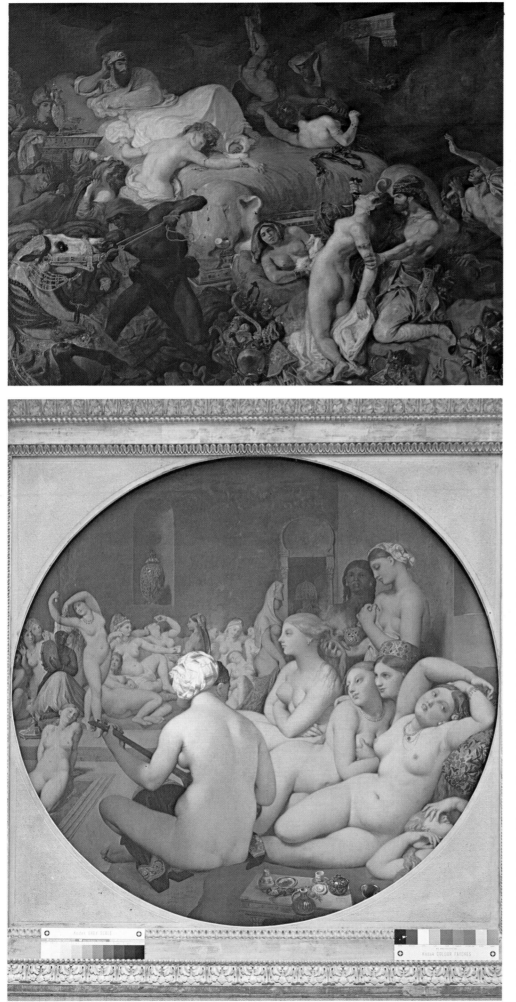

Left: Delacroix. *Death of Sardanapalus.* 1827.
The subject was taken not from ancient history
but from contemporary literature, and the artist
took full advantage of it to indulge his
preoccupation with brutal violence, offset by
the calm, resigned figure of Sardanapalus
himself. Musée du Louvre, Paris.

Below left: Ingres. *Le Bain Turc.* 1863. One of
the greatest paintings of the female nude, an
anthology of forms studied by Ingres over a
long and productive lifetime. Musée du
Louvre, Paris.

Right: Ingres. *La Grande Odalisque.* 1814.
Ingres' classicism safeguarded him from
criticism of the subjects of his pictures. Musée
du Louvre, Paris.

Below right: Delacroix. *Seated Nude.* 1821–3.
The model, Mlle. Rose, was a favourite of
Delacroix. In this early painting Delacroix still
seems pre-eminently a classicist. Musée du
Louvre, Paris.

began, like Ingres, as an admirer of
Raphael and Poussin, but came to
feel greater admiration for Rubens
and Rembrandt. His seated nude, an
early work, shows his classical
inclinations at that time. Delacroix's
Romanticism is evident in the value
he put on warmth, colour, richness,
excitement, although he always
insisted on the importance of
knowledge and training.
'Delacroix,' said one critic, 'was
passionately in love with passion,
but coldly determined to express
passion as clearly as possible.'
 Another characteristic of the
Romantics was a preference for
literary and contemporary subjects
to the traditional historical or
mythological subject matter of
Neoclassicism. Delacroix's famous
painting, the *Death of Sardanapalus*,
was actually inspired by a tragedy
by Lord Byron. The slave girls who
are being killed as part of the
destruction of the king's most loved
possessions are not too far removed
from the Oriental *houris* of Ingres,
though Delacroix is of course less
dependent on line and more on
colour. The human anatomy is not
always exact, and here again
Delacroix resembled Ingres (whose
Odalisque is said to have too many
vertebrae) in sacrificing strict
accuracy for the sake of artistic form.
Delacroix, moreover, painted a
number of odalisques or harem girls,
a type made popular by Ingres.

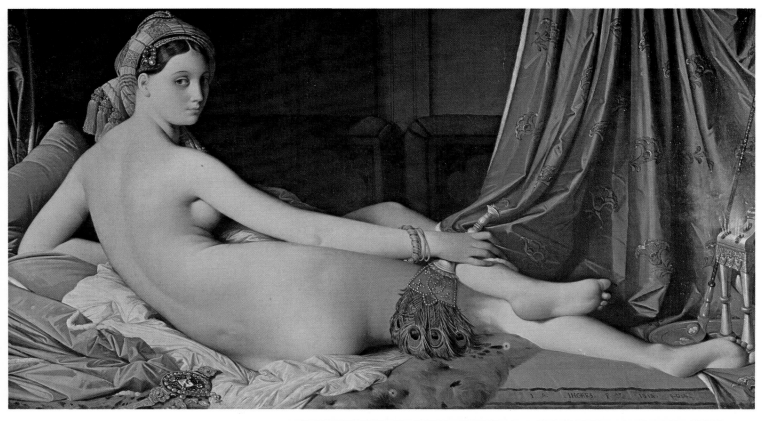

It was due to Ingres above all that
the nude – the female nude in
particular – persisted as a subject of
art throughout the 19th century. It is
extraordinary to think that the
Turkish Bath was painted at a time
when European society was at its
most puritanical. No one except
Ingres could have got away with it,
but such was his age, influence and
thorough bourgeois respectability
that it caused no serious fuss.
Following the example of Ingres, the
academic studios throughout the
Victorian age continued to teach the
nude, and to employ models to pose
for students, some of whom,
presumably, would have been
startled by the sight of a carelessly
displayed ankle anywhere outside
the studio. Wealthy citizens adorned
their villas with marble nudes in the
classical manner, but regarded
nudity in any other manifestation as
shocking. Married couples went to
bed with each other night after night
for years on end, and produced large
families in the process, without
setting eyes on each other's naked
bodies.

In the United States, where there
were at the beginning of the 19th
century few public collections of
great art and therefore fewer
opportunities to see even classical
nudes, puritanism in the realm of art
was perhaps most pronounced.
When Robert Pine, a minor English
artist, took a plaster model of the

Medici Venus to Philadelphia, he was forced to keep it in a cupboard, where it could be inspected by a select and incorruptible few. There was a widespread feeling that American art ought to be an elevating public influence, and that European art, from the Renaissance to the Romantics, exhibited signs of moral decay. The Pennsylvania Academy of Fine Arts, which opened its doors in 1806, had separate visiting days for women, thus encouraging the belief that there was something shocking in the works of the old masters it displayed. A gentleman in Cincinnati earned his living for a time making fig leaves for nude statues, and a copy of the *Apollo Belvedere* in the Massachusetts governor's mansion was commonly kept veiled. On the whole, however, marble was considered less shocking than oil paint, and the figures of

Canova and other less famous Neoclassical sculptors were fashionable in polite society in the early 19th century, though even Horatio Greenough's gigantic sculpture of Washington was criticized in some quarters because the first president appeared with his mighty chest bare. As late as 1886 Thomas E. Eakins was forced to resign from the Pennsylvania Academy after revealing a male model to a class of women students.

Probably the most famous American sculpture of the mid-19th century was the *Greek Slave* of Hiram Powers, a piece of work that can hardly be regarded as anything but soft-core pornography – there was some consternation in Europe at the chained hands – but which was seen and admired by wives, children and committees of enthusiastic clergymen. It was widely distributed in small plaster copies, placed under little glass cases in many blameless homes, and it was followed by a rash of what one commentator called 'sexless, sugary sisters' in much the same spirit. Americans on the European tour, presumably more sophisticated on the whole than those who did not venture abroad, often revealed the most astonishing double standards when confronted by the nude Venuses and Dianas of Italy and France, condemning their sensuality in terms which could equally be interpreted as admiration. The idea that the human body was indecent had become so deeply ingrained that it was very difficult for people to approach the nude without feeling that the artist must have been a lecher, and at the same time they were often blind to elements that were genuinely and consciously erotic. Thus it was that an elderly, middle-class bachelor was able to persuade mothers to let him photograph their prepubescent daughters in the nude without any party to the transaction being aware of the sexual implications.

In Victorian England there was a cult of the nude in art which appears now as a curious mixture of innocence and hypocrisy. The annual exhibitions at the Royal Academy in London were never short of nudes, usually given classical titles but painted with unclassical coyness – welcomed by contemporaries as purity and

Canova. *Perseus*. Canova was the most accomplished of Neoclassical sculptors, but in general the style proved less rewarding in sculpture than in painting. Musei Vaticani.

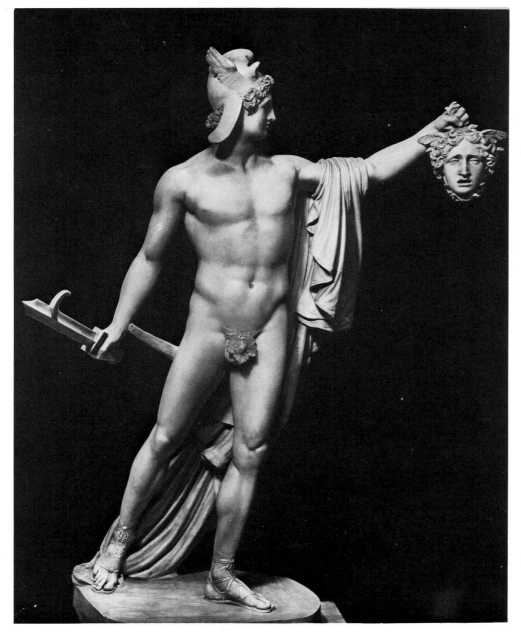

innocence. In the first half of the century England surprisingly produced one very good painter of the nude in William Etty (1787–1849). Like a number of artists whose work has a pronounced erotic content (Gibson of the *Tinted Venus* was another), Etty, so far as we know, had no sexual relations with women (or men), and unlike more knowing artists he never made much money from his work, which until quite recently was seriously underrated. Despite his morally blameless existence, his frequent attendance at life classes caused unfavourable comment: 'I have

been accused of being a shocking and immoral man,' he complained pathetically. His painstaking studies notwithstanding, Etty was no realist. His female nudes are beautified, and their faces betray more than a trace of Victorian sentimentality. Not even Courbet, however, painted a woman with pubic hair, and most Victorian critics, certainly poor Ruskin, felt happier when the figure was obviously immature (what would they have made of Balthus's frightening adolescent nudes?).

Although the classical nudes of the academicians, in England as in

Manet. *Olympia*. 1863. A brilliant and controversial reinterpretation of an old theme, the reclining nude. Musée du Louvre, Paris.

France, were generally regarded as tolerable, they did not escape criticism from guardians of public morality outside the art establishment. The Bishop of Carlisle confessed that his mind had been 'considerably exercised' by a Venus of Sir Lawrence Alma-Tadema (1836–1912), an artist of Dutch origin whose archaeological accuracy, based on solid learning, was combined with a thoroughly Victorian sentiment. The Bishop, no hard-liner, no doubt represented general opinion in admitting that there might be 'artistic reasons which justify such public exposure of the female form . . . In the case of the nude of an Old Master, much allowance can be made, but for a living artist to exhibit a life-like, almost photographic representation of a beautiful naked woman strikes my inartistic mind as . . . mischievous' (quoted by Ronald Pearsall, *The Worm in the Bud*, 1969).

Of the English academic painters, another bachelor, Frederick, Lord Leighton (1830–96), was probably the most successful painter of the female nude. The figures of

Leighton, Alma-Tadema and their fellows were set in a kind of classical fairyland, and apart from the usual mythological favourites such as Ariadne and Andromeda, they were frequently shown preparing for (or vacating) a bath or merely, like *Phryne*, standing about in the sunshine. It is to Leighton's attractive personality and his successful presidency of the Royal Academy that his achievement, unique among British artists, of being raised to the House of Lords must be ascribed, but his reputation as an artist has risen a little higher today than it was during the more anti-Victorian mood of the preceding generation.

It was in France that most of the exciting events in art took place during the 19th century. In 1863, the same year in which that amazing octogenarian Ingres painted his *Turkish Bath*, Édouard Manet (1832–83) painted what he considered his finest masterpiece, *Olympia*, but when it was exhibited at the Paris Salon two years later, it was greeted with a storm of abuse. Manet, whom we think of today as

the father of Impressionism, was a serious admirer of the classical tradition; he carried his reverence for the old masters to the point of basing his own works very closely on them. His *Déjeuner sur l'herbe* is probably the most famous example; it was of course based on Giorgione's great painting, but the *Olympia* too is a modern reworking of an old theme – the reclining nude as painted by Giorgione and Titian. The paradox – an artist of such traditional interests cast in the role of the destroyer of tradition – did not end there. Manet, son of a magistrate, was a temperamentally conservative person with a strong desire for public approval, who nevertheless found himself the hero of young Turks like Monet and Renoir and the villain of the establishment. So far as his public reception was concerned, Manet's drawback was that he was a realist. His *Olympia* is not a generalized type, not a conventional 'classical' nude; she is very clearly an individual, a self-assured young courtesan of contemporary Paris. She is in fact far less obviously erotic than Ingres's nudes and – another paradox – this was one of the basic reasons she aroused such a storm. Her body is hard and flat, not at all luscious in the way of an Ingres odalisque. Ingres's opulent creatures are submissive and sexually abandoned. They appear to surrender to male dominance, while Manet's *Olympia* is a far more independent spirit: she is well able, one feels, to take care of herself so far as men are concerned. The fact that the painting is a technical masterpiece was not understood by its blinkered critics.

The relationship between the artist and the public had been deteriorating since the Romantic period, and with Manet it reached

Manet: *Le Déjeuner sur l'Herbe.* 1863. Inspired by Giorgione's *Concert Champêtre.* There would have been less fuss if Manet had put his gentlemen into 16th-century clothes. Musée du Louvre, Paris.

the lowest level yet – a level from which it has never entirely recovered. It is curious that the commonest complaint against modern artists has been that their work is insufficiently realistic. In the mid-19th century the real grounds for complaint, though not so expressed at the time, were that the paintings of Manet and Courbet were *too* realistic.

Gustave Courbet (1819–77), an older man than Manet, was a great inspiration to him, although they were so different. Coming from a peasant family, Courbet was a man of the political Left, who attracted attention with a picture of poor working people, the *Stonebreakers* (1849), of a kind more often associated with Millet. He was to spend six months in prison for his activities during the Commune (1871) and he lived his last years as a political exile in Switzerland. Courbet rejected both Classicism and Romanticism in asserting his Realist doctrine: that painting should represent 'real and existing things' and should make a comment on contemporary society. His famous painting of the *Artist's Studio*

Above: Leighton. *The Bath of Psyche.* Exhibited 1890. Tate Gallery, London.

Left: Alma-Tadema. *A Favourite Custom.* 1909. Also a favourite subject among members of Victorian and Edwardian society. Tate Gallery, London.

Far right: A photograph of the 1850s, when photographs of the nude tended to ape academic painting.

(1855) enraged the academies and was rejected by the selecting jury of the Paris Exhibition, whereupon Courbet organized a rival exhibition which proclaimed the virtues of Realism. The *Studio* is an allegorical painting, and it includes portraits of several of the artist's culturally eminent friends (the poet and critic Baudelaire is on the extreme right, reading a book), but what especially shocked the public was the matter-of-fact appearance of the nude model looking over the painter's shoulder. Courbet's sensuous but sternly realistic nudes were criticized as vulgar and obscene, and his frank depiction of lesbian love – a subject, incidentally, in which a number of other 19th-century artists were interested – could hardly have been placed on public display in any gallery in Europe during his lifetime. *Sleep* was in fact painted for a wealthy private client – the Turkish ambassador in Paris – and long remained a painting more talked about (in hushed tones) than seen. Even now, reproductions of it are not common although surely no one would deny that Courbet's massive genius has made it hard for the most prurient observer to snigger at his subject.

By the middle of the 19th century, the artist's paint brush had acquired a powerful competitor – the camera. Photography had many implications for fine art and, in the early years especially, fine art had a powerful influence on photography; the interactions were numerous, and critics do not all agree on their precise significance. For the nude, the camera was to effect many changes, opening new doors of perception and at the same time raising fundamental questions about the nature of art and image.

The early photographers of the nude – serious photographers, that is, not the producers of popular erotic pictures – naturally shared the same kinds of ambitions as painters. They produced many rather laboured academic studies, often based on classical mythology, which were equivalent to the paintings of the academicians (although less attractive). Some of these people deserve to be classed as serious artists, but on the whole their efforts do not seem very successful when considered as art. The photographer, obviously, was compelled to use a live model. Most painters did too, but they were much less restricted by the individual characteristics of the model than were photographers. The painter could, if he desired, lengthen an arm or enlarge a breast, or indeed use one model for the body and another for the face. The model is far less important for the painter: a girl with a wooden leg would probably be quite adequate. The photographer is not such a free agent. Variations of lighting plus subsequent retouching of the print – and the Victorian photographer, though he had fewer tricks than his modern counterpart, employed various printing processes to disguise reality – could achieve only so much. They could not disguise all the physical idiosyncrasies of the model. The photographer is the prisoner of mundane realism, a 'realism' very different from that of a Courbet or a Manet. As we have seen, artists of the nude are invariably concerned with problems of form, and even the most naturalistic of painters never reproduced exactly what the neutral eye could see; that is something which only the camera can do.

Right: Courbet. *The Artist's Studio* (1855), in which the inclusion of a nude model provoked cries of outrage. Musée du Louvre, Paris.

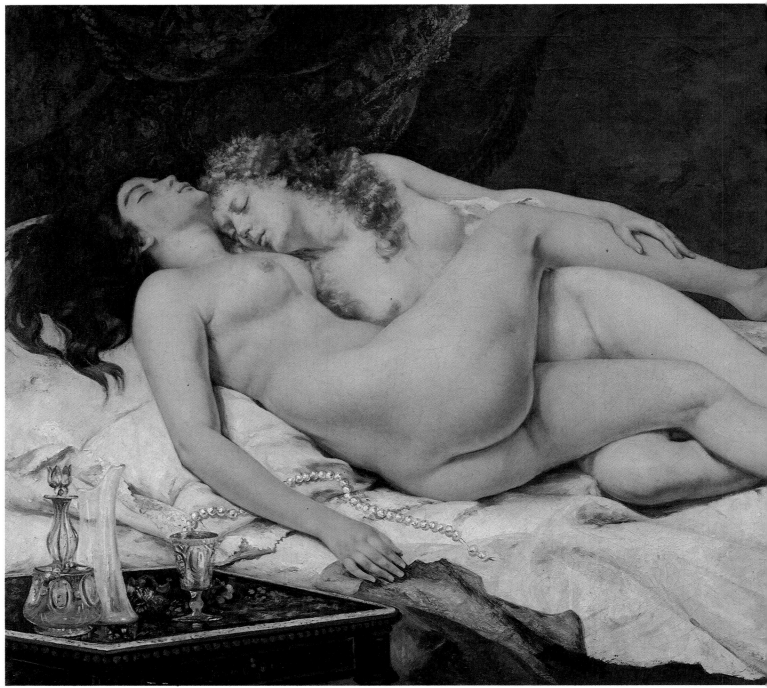

Below: Courbet. *Sleep*. 1866. A privately commissioned erotic work. Musée du Petit Palais, Paris.

Courbet was not, therefore, a 'realist' in this narrow sense: all his nudes, mighty of hip and thigh, have a certain sisterly resemblance, no less than the nudes of Rubens or Ingres. The photographed nude may be many things – beautiful, sexy, frightening, pathetic, etc., but in some respect the photographed body of a naked woman is bound to be, when considered in terms of pure design, disappointing, since what one sees is not quite what one expects (as a result, no doubt, of the cultural conditioning of fine art). However carefully the photographer poses his model, whatever technical devices he employs in the course of producing his final print, the photograph remains an image of an individual who is, to some extent, inevitably at war with the conception of ideal form. In the photographic process, realism is built in. Of course a photograph depends on the human eye of the photographer as well as the neutral 'eye' of the camera, but whatever the virtues of the photographer, the camera remains essentially a recorder of facts.

The camera can do many things which the paint brush cannot do. It can, for example, tell us more about movement, since it can arrest the most rapid movement at any given instant. Before photography, a galloping horse was always represented by artists with each pair of legs moving more or less together, so that the animal proceeded in a series of bounds. That is indeed how a horse appears to move according to the fallible human eye, but its actual movement, too fast for the eye to follow, was revealed by the camera to be quite different. The pioneering work of Eadweard Muybridge (born Edward Muggeridge, 1830–1904) first revealed that at one point a galloping horse has all four feet off the ground. Muybridge's major work of the nude in motion, published in 1887 in eleven volumes with 781 engravings from his photographs, had a great effect on contemporary artists.

The mistaken – as modern critics would say – attempt to borrow techniques and objectives from the traditional graphic arts encouraged the view that photography in the 19th century was more influenced by fine art than vice versa. As Lord Clark wrote, 'photographers have usually recognized that in a photograph of the nude their real object is not to reproduce the naked body, but to imitate some artist's view of what the naked body should be like.' Contemporary photographers of the nude would not accept that view of their objectives, but there seems to be strong evidence for it in the 19th century. Lord Clark illustrated his argument with a photograph by the pioneer photographer of the nude, Rejlander, taken a few years after Courbet's *La Source* was painted. He suggests that although Rejlander may have been unaware of Courbet's painting, the picture was the cultural archetype of the photograph, and that the latter succeeds as art because Courbet happened to be a Realist (photographic attempts to imitate nudes by non-Realists like Ingres being markedly less successful). Recent research has suggested that, whatever the case may be for photographic imitation in this instance, photography may have had greater influence on Courbet than he had on photography. There is, after all, no divinely ordained reason why photographers should imitate artists more than artists imitate them. An interesting example is Courbet's controversial picture, the *Bathers*, which confounded even Delacroix ('quite bewildering') and aroused the fury of the Emperor Napoleon III (who was not above lashing out at Courbet's exhibited canvases with his riding crop). Students of the iconography of painting, a numerous band nowadays, might explain that the *Bathers* is a reworking, in Courbet's Realist manner, of the traditional theme of a woman bathing attended by a maid; one example of this favourite subject is Rembrandt's *Bathsheba*. During the 18th century the 'lady at her toilet' had become a very popular motif of cheap lithography and was depicted with more or less obvious pornographic intent throughout the 19th century (latterly by photo-engravers), as well as by academic painters such as Alma-Tadema. Courbet was undoubtedly familiar with these cheap prints from *La vie Parisienne* but, more particularly, the nude figure in his *Bathers* has a marked resemblance to photographs by Vallou de Villeneuve (who,

incidentally, was a lithographer by training).

Many other connections can be made between photographs or popular lithographs and 'high art' paintings in the 19th century. About a century before the 'Pop Art' movement, it seems, there was already a good deal of cross-fertilization between 'high art' on the one hand and what corresponded to the popular media on the other, and painters were already adopting images from humbler sources of the time.

It certainly would not have done the reputation of a painter like Manet any good if he had admitted that, as has been suggested recently, an important influence on his *Olympia* was the pornographic photograph of the day, though perhaps some dim awareness of such a connection accounted for the cries of outraged virtue which greeted the appearance of that painting. These photographs were very popular: pornography was a thriving industry in the 19th century and, according to the *Saturday Review*, there was 'hardly a street in London' where photographs of naked women could not be purchased. Allowing for obvious exaggeration, this suggests a rather different kind of city from the one represented by Victorian topographical prints. Especially popular were stereoscopic photographs, which gave an illusion of three dimensions. The indefatigable researchers of the present have shown that even these disreputable productions had an influence on high art.

Painters and sculptors also called in the assistance of the camera in more respectable ways, sometimes using photographs as sources in perfectly direct ways. A portrait painter might then, as now, work from photographs when his subject was unavailable, and some artists

One of Muybridge's photographic sequences, illuminating the human body in action. His technique revealed hitherto ill-comprehended facts about the simplest movements of the body.

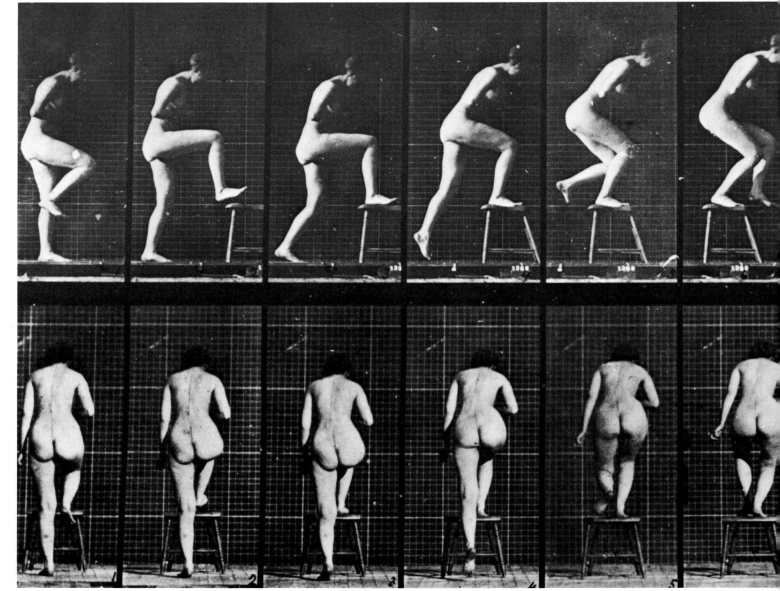

Left: Before photography, lithographs of risqué boudoir scenes were extremely popular.

commissioned photographs for a
specific purpose. The *Small Odalisque*
of Delacroix, for example, was based
on photographs taken by Eugène
Durieu at the painter's request. Not
only did Delacroix describe the pose
he wanted, he also selected the
model.

It would be hard to say what
influence the development of
photography had on the character of
the new movement in art which we
know as Impressionism. The
Impressionists based their art on the
observation of light and colour as
they appear in nature, and not on
the accurate expression of outline
and form. Fundamentally, they were
in revolt against the increasingly
sterile principles of high art as taught
in the academies, which also
explains their preference for
mundane subject matter and open-
air effects which had to be captured
swiftly from nature, not recreated at
leisure in the studio. Given these
preoccupations – lack of interest in
form and rejection of studio painting
– it is not surprising that we associate
the Impressionists chiefly with
landscapes and that the nude was
not a common subject among them.
It is notable, for example, that
Manet, who had painted two of the
most famous pictures of nudes in the
history of art, scarcely painted
another after he had been drawn
into the Impressionists' circle.
Nevertheless, several of the
Impressionists *were* interested in the
nude, and one member of the
original group who adopted Manet
as their hero in the 1870s was one of
the greatest of all painters of the
beautiful female nude, perhaps the
last in the tradition of the idealized
human body that went back, via
Ingres, Boucher and Raphael, to

Praxiteles. In fact Pierre Auguste Renoir (1841–1919) once said that it was this subject which had made him an artist.

Renoir was never such a thoroughgoing Impressionist as, for example, his friend Monet, and for him Impressionism was more of a phase than a lifetime commitment. Essentially a figure painter, he actually painted comparatively few nudes during his Impressionist period. He loved the old masters, spent many hours in the Louvre (sometimes dragging a reluctant Monet with him), and visited Italy on more than one occasion. Under this influence, his nudes eventually became less obviously pretty, while the artist became more and more concerned with form. In his later years he even painted some mythological scenes, such as the *Judgment of Paris*. He always retained the Impressionist love of landscape and, like Giorgione in Renaissance Venice, he placed his figures out of doors. His nudes were young, plump, glowing creatures; Mme Renoir was compelled to select maids on the basis of their skin quality. Their heads are generally rather small and their faces are not remarkable for character; it was the body that interested Renoir. Like so many masters of the nude, Renoir was a rather shy man, though he had several youthful affairs (not very difficult to achieve for an artist in Paris) and became a husband and father in his forties. As he grew older, his nudes became more numerous, while male figures became increasingly rare.

To Renoir, the nudity of a woman seemed perfectly natural (it is difficult to imagine his Arcadian girls in the thick, tight clothing of the time); a naked man, however, was merely an embarrassment. Reversing the process of Michelangelo, Renoir used female models for his rare male figures (all too evident in his *Judgment of Paris*). After about 1900, when he was becoming increasingly crippled by arthritis, his models tended to be more mature, solid, peasant figures; there were fewer alluring schoolgirls – 'high-art pin-ups' – and a stronger suggestion of Mother Earth. Renoir's chief problem as a painter was to reconcile his increasingly classical figures with an Impressionist landscape. The

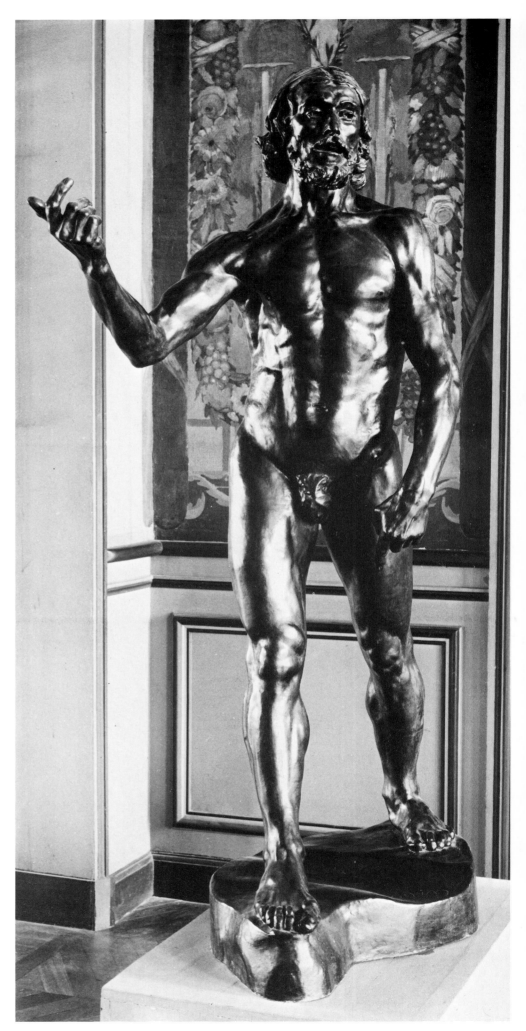

Grandes Baigneuses (1887), over which he laboured for two years, shows him wrestling with the problem, if not completely resolving it. Later, his figures become more relaxed, and there is greater sympathy between the figures and the surrounding scenery.

Among those seated at a table of the Café de Nouvelle Athènes in the Place Pigalle in the 1870s, one might have found not only Renoir and the older Manet but also Edgar Degas (1834–1917). Like Renoir, Degas was not an orthodox Impressionist (if anyone was), and he is generally regarded as belonging to the tradition of Ingres, whom he greatly admired. Like Ingres, he treated drawing as all important, and he was a superb draughtsman. So far as the human body was concerned, what chiefly interested him were the possibilities of movement, and he was greatly influenced by the revelations of photography. What otherwise chiefly distinguished him from Renoir as a painter of the nude was his stark adherence to facts. 'Compared with Degas,' wrote Norbert Lynton, 'Courbet, the self-styled Realist, is a sentimentalist.' After the lovely soft bodies of Renoir's nymphs, Degas's harshly painted pictures of prostitutes caught in awkward, exaggerated movement in sordid surroundings came as a shock. Degas was of course perfectly capable of drawing a beautiful nude, and as a young man he often did so (Lord Clark called them 'the most beautiful life drawings of the 19th century'). But he regarded that tradition as dead, and the phoney 'classical' nudes of the Salon painters only confirmed his opinion.

Archaeological excavations in the early 19th century revealed a large quantity of antique sculpture and this, combined with the teaching of art historians such as Winckelmann and the rather low state of the sculptural tradition at that time, had a deadening effect on the art. For most of the century sculpture was dominated by a rather sterile Neoclassicism, of which Canova was the chief exponent. Degas frequently modelled figures, but mainly as an aid to his study of movement. In the latter half of the 19th century, several more creative figures emerged in France and elsewhere. Far the greatest of them was Auguste

Rodin (1840–1917), who forms a bridge between the generally classical sculpture of the past and the radical innovations which followed. Like Manet, Rodin was eager for public approval and, although in some ways scarcely less revolutionary, he was more successful in achieving it thanks largely to the enormous range of his work. Rodin evolved, for example, an almost unprecedented number of new poses for the nude – not all of them very satisfying. Basically, Rodin was an expressionist: he was prepared to move a long way from naturalism and ideal beauty for the sake of powerful emotional expression, although he did execute many works which could be

Far left: Rodin. *St. John the Baptist.* 1878. Rodin rescued figure sculpture from something of a slough, in which it had languished since the 18th century. Musée Rodin, Paris.

Below: Degas. *Dancer Examining the Sole of her Right Foot.* 1910–11? Bronze. 18½ inches (47 cm) high. Degas' interest in the unusual forms assumed by the human body was encouraged by photography, which he frequently exploited to assist his painting. Tate Gallery, London.

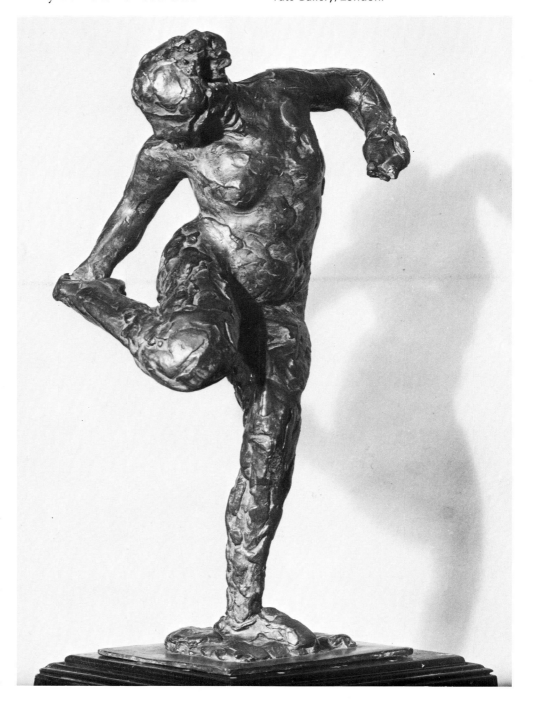

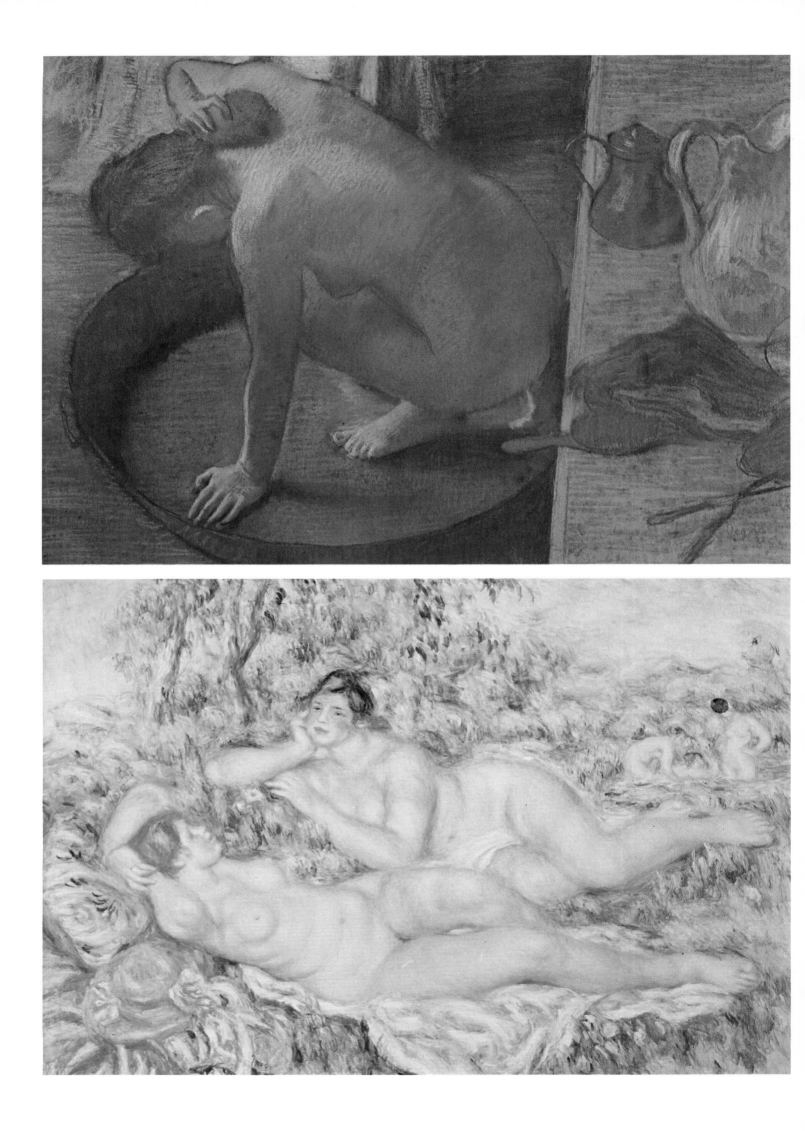

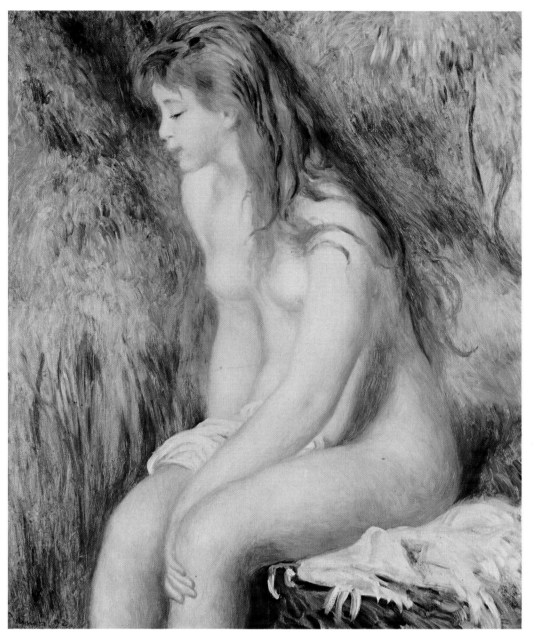

Top left: Renoir. *Nymphs*. 1918. Renoir was an Impressionist almost by accident. As he grew older, his instinctive classicism grew more evident. Musée du Louvre, Paris.

Left: Degas. *The Tub*. 1886. Degas' extraordinary linear command led him to experiment with unusual poses. Musée du Louvre, Paris.

Above: Renoir. *Young Bather*. 1892. Painting, said Renoir, must have the smell of life. Lehman Collection, New York.

regarded as conventionally beautiful, and works so naturalistic that he was accused of making a cast from a live model. Rodin – or anyone else – could scarcely be called an Impressionist sculptor, yet his work does have something in common with the Impressionist painters, particularly his cultivation of light effects, gained by breaking up the surfaces of the marble (his preferred medium) which, at times, can suggest the flickering of dappled sunlight. Rodin's eroticism was perfectly frank, as in the *Eternal Idol* and the better-known *Kiss*, probably the most famous sculpture of the century and a wonderfully tender evocation of physical love (Rodin also made sculptures of couples embracing in a more athletic manner, closer to the sculptures of Indian temples).

To get away from the artificial,

deadening conditions of the life class, Rodin filled his studio with a group of models, whom he persuaded to jump about and play, and this (apart from keeping them warm) allowed him to move among them, noting an interesting pose which he would swiftly sketch. Rodin shared Michelangelo's awareness of the tragedy of mankind's struggle against fate, and many of his most famous works have a doom-ridden air. As he was, after all, a Victorian, it is not surprising that occasionally a trace of sentimentality crept into his work. Nevertheless, Rodin remains the last great exponent of human nobility in sculpture; his work can be related to that of his predecessors, from the sculptors of the Parthenon through late Gothic sculpture and Michelangelo, far more easily than the work of any significant sculptor since his time.

The Modern Era

Impressionism marks the division between traditional and modern art. The Impressionists had effectively completed the destruction of the academic citadel, but their successors, notably Paul Cézanne (1839–1906), saw certain deficiencies in Impressionism itself. Cézanne is usually regarded as the first 'modern' artist, and no one had greater influence than he did on the bewildering profusion of new 'movements' in art – Cubism, Fauvism, Vorticism, Expressionism and so on – which marked the hectic arrival of modern art.

The overthrow of the classical tradition implied the overthrow also of the nude, of all subjects perhaps its most typical. It was not, of course, that artists stopped painting or sculpting nude figures; on the contrary, Picasso (1881–1973) possibly made more paintings and drawings of nudes than any artist before or since. What did disappear was the beautiful nude – in the conventional sense of the word 'beautiful'. The essence of the revolution that produced modern art was the determination to escape from the role of art as representation, as all art, however 'non-naturalistic', had been hitherto. The revolution might have taken a different course, or perhaps never happened at all, if it had not been for the development of photography, but photography was not, of course, directly responsible for it.

It may seem odd that the revolutionaries, artists such as Picasso and Henri Matisse (1869–1954), should have adopted so thoroughly 'classical' a subject as the nude at all, but in fact they found it a rewarding source. They were not interested in the classical idea of beauty, indeed they were in conscious and violent revolt against it, but they were interested in that other aspect of the nude – as an idea or concept, with rich elements of symbolism. Moreover, the fact that the debased 'classical' nude represented the epitome of all they were rebelling against in the official art establishment made it especially attractive as a vehicle for their contrary ideas. This was particularly evident in France: not only was official, academic art entrenched there most strongly, but it was from France that the more important new art movements (except Expressionism) gained their greatest impetus. Modern artists have often seemed to be involved in a kind of love-hate battle with the nude, a

Schiele. *The Virgin.* 1913. Schiele employed his brilliant gift of line in a sometimes ambiguous way in his drawings of the female nude. Graphische Sammlung, Eidgenössischen Technischen Hochschule, Zurich.

Modigliani. *Nude*. Private collection.

Model', his mood was sometimes frankly affectionate, and often spiced with sly humour.

Male fears of female sexuality, illuminated by Freudian psychoanalysis, have appeared in the works of many 20th-century artists. The Norwegian Edvard Munch (1863–1944), a brilliant, neurotic artist, is the most obvious example. He saw women as devourers – vampire figures with the smell of blood about them. Egon Schiele (1890–1918) employed his brilliant gift of line in some markedly ambiguous erotic pictures of women, while the other outstanding artist of *Jugendstil*, the Viennese Art Nouveau, Gustav Klimt (1862–1918), who was more interested in colour and pattern, produced some of the most attractively dreamy erotic art of the century.

In Germany, the Expressionist painters at the beginning of the century adopted strong colours and rough, powerful brushstrokes in their efforts to give painting new vigour and to establish more immediate, more intense communication with the spectator.

Italy's main contribution to the modern movement was Futurism, which joyfully celebrated modern technology: machines, factories and – especially – fast-moving vehicles. The *Futurist Manifesto* of 1909 lavished scorn upon the classical tradition and in over-excited language embraced the structures, crowds, noise and energy of modern industrial society. Curiously enough, the efforts of Futurists like Umberto Boccioni (1882–1916) to capture the essence of energy and motion often resembled the effects achieved by earlier artists with the swirl of drapery. So far as the nude is concerned, the outstanding Italian painter of that period was Amedeo Modigliani (1884–1920), who settled in Paris in 1906 and really belongs to French rather than Italian painting. Though he was not a member of any of the new movements, Modigliani shared some of the interests of the Cubists. The boldly simplified, elongated forms of his nudes suggest the influence of primitive sculpture, though his love of strong colours seems purely Italian. Modigliani sometimes sold his drawings for the price of a drink: he enjoyed little

conflict which was not only an artistic one, arising from the rejection of traditional ideas of beauty, but also a psychological one. Picasso certainly did some extraordinary things to the female form, as in the rather frightening Cubist Earth Mother of his *Woman Dressing Her Hair*, painted in 1940 when the artist was suffering a period of personal distress (he had painted his famous *Guernica* not long before). But in his early 'Blue' period Picasso painted more conventional, romantic nudes, while in his numerous later engravings on such subjects as 'The Artist and His

The final flowering of a romantic exoticism, Art Nouveau is instantly recognizable for its asymmetrical design, its delicate plant and insect form, its curving, sensuous lines and depiction of idealized feminine beauty. The *'femme-fleur'* became a distinctive Art Nouveau theme.

Far right: Louise Abbéma. *Portrait of a Lady with Chrysanthemums.* Oil on canvas.

Right: Louis Chalon. *Cléo de Mérode.* 1900. Gilt bronze.

Below: Franz Hoosemans. Candleholder. 1910. Museum für Kunst und Gewerbe, Hamburg.

De Kooning. *Two Women*. 1954–55. De
Kooning's aggressive methods of painting
and sometimes threatening subjects derived
from the more violent forms of Abstract
Expressionism in Europe. Collection of Mrs.
Samuel Weiner, New York.

commercial success in his own
lifetime, which was cut short by the
effects of his Bohemian life style, but
today cheap prints of his unmistak-
able nudes sell in enormous
numbers.

The style of painting known as
Abstract Expressionism originated
with the Russian Wassily Kandinsky
(1866–1944), as early as 1910. It
enjoyed a remarkable revival,
chiefly in the United States, after the
Second World War. In the work of
Willem De Kooning we are again
confronted with threatening aspects
of the female , while the English
artist Francis Bacon, who used
photographs and other popular
imagery as source material, adopted
the ancient tradition of the male
nude as an expression of torment and
anguish.

The artists of Dada and
Surrealism often exploited the nude
as part of their mockery and
subversion of artistic and social

standards. René Magritte
(1898–1967), for example, turned
the female torso provokingly into a
head. His 'reverse mermaid',
stranded on a lonely beach, is, for all
its oddity, a work of undeniable
pathos. Other Surrealist artists who
employed the nude in novel ways
included Hans Bellmer, a master of
line, Paul Delvaux in his moonlit
nightmare scenes, Salvador Dali in
his Freudian dream paintings, Max
Ernst, Leonor Fini with her exotic
and menacing, bird-like creatures,
André Masson, Dorothea Tanning
and many others. Balthus, one of the
most mysterious of modern painters,
conveyed an oppressive atmosphere
of overheated passions in his pictures
of adolescents and young women.

The revolution which occurred in
the early years of the 20th century,
although it was certainly the most
dramatic in the whole history of art,
naturally did not succeed in
breaking away altogether from the

ideas and traditions of the past. Picasso's *Demoiselles d'Avignon* may be regarded as marking the end of the tradition of the beautiful nude, but artists did not suddenly throw aside everything that had been done before the 20th century. The revolution which introduced modern art was not directed against the great masters of the past but against the debased form of sub-Hellenism embraced by the academies in the 19th century. It became difficult, perhaps impossible, for a serious artist to produce a conventionally beautiful nude but that other face of beauty, which has been defined as the visually sublime, was not banished, and in the work of, for example, the English sculptor Henry Moore, we sense some of the same qualities that we observe in the sculpture of Michelangelo or in the figures from the Parthenon. Moore's great reclining figures derive their strength and nobility from the artist's sympathy with his material; like Michelangelo, he sees the figure immanent in the block of stone or wood. Woman – as Mother, Goddess and giver of life – has been his

Picasso. *Les Demoiselles d'Avignon.* 1907. If modern art can be said to have begun with a single work, this painting has the greatest claim. Museum of Modern Art, New York. Acquired through the Lillie P. Bliss Bequest.

constant theme, and he communicates emotion in a calm, unaggressive way which not only reminds us of ancient Greek sculpture but also conveys a relationship with the resources of nature from which the work is fashioned.

Another British sculptor, Barbara Hepworth, who was associated with Moore and with the painter Ben Nicholson, while more thoroughly abstract and less monumental, created more intimate and personal forms which seemed to gain life from within. But perhaps the only sculptor after the First World War besides Moore who could be placed on the same level as the French sculptor Brancusi (1876–1957) was Alberto Giacometti, best known for his spidery bronze figures, sometimes vulnerable creatures threatened by the anonymous space that gives them meaning. Jacob Epstein, an American-born sculptor who settled in England, studied African primitive sculpture but gained his greatest popular fame from his *Madonna* and his figures of *St. Michael and the Devil* on Coventry Cathedral.

The photograph of a young woman by a modern photographer of no special distinction has very little in common with a Henry Moore sculpture or indeed with any of the works by great artists reproduced in this book. It is not 'art' in the generally accepted sense; it has no intellectual or emotional content – it says nothing. It is merely a picture of a pretty girl, produced by good craftmanship no doubt, which aims to arouse a feeling of sexual desire in the male observer. However, in this one, not very significant sense, it has something in common with, for example, one of Titian's mythological nudes which a

Left: Munch. *Madonna*. Post-Freudian artists have sometimes interpreted the female body in terms of a threat to masculinity. Nasjonalgalleriet, Oslo.

Right: Klimt. *Sea Serpents*. 1904. An example of the artist's use of flat areas of colourful pattern in his compositions. Osterreichische Galerie, Vienna.

modern painting of a nude by, say, De Kooning, does not have. Titian's *Diana* and this contemporary pin-up both have a straightforward erotic intent which De Kooning's *Woman* lacks. Of course Titian's painting has a great many other qualities which are more important, but just because it may appear almost blasphemous to compare a Venetian masterpiece with a cheap magazine pin-up, we should not ignore the fact that the nudes of the old masters *were* erotic; they *were* intended to arouse sexual feelings in the male observer. They undoubtedly succeeded in that aim,

and they still do. As Edward Lucie-Smith remarked, 'The famous nude calendar photograph of Marilyn Monroe is the contemporary equivalent of Goya's *Naked Maja*.'

The camera did not make erotic art redundant, but it did, in a sense, take over the role of providing titillating pictures of naked women. As we have seen in the previous chapter, the camera can produce art, and no reasonable person would deny that status to, for example, the nudes of Edward Weston or Bill Brandt.

The pin-up, in varying degrees of naughtiness, is as old as photography. (In a way it is much older: many great artists, including Rembrandt, produced portfolios of drawings of which eroticism was the mainspring.) Many of the early photographic nudes were shown in reclining poses for the simple reason that exposure times had to be lengthy, and it was therefore necessary to adopt some position in which it would be easy to remain motionless; standing figures often leaned on some handy prop in a manner suggesting ceramic figures supported by Rococo tree trunks as a safeguard against breakage. The pioneers of the daguerreotype also found that it was advisable to give their models a dusting with powder to enhance the reflectiveness of the skin. Victorian popular prints that were sold commercially, if they were to be sold legally, could not of course show nude figures. 'Respectable' nudes in the tradition of photographers such as Oscar Rejlander escaped stricture, except from the most puritanical, because they aped high art.

By the beginning of the 20th century high-speed mechanical printing was making photography more common, and illustrated newspapers and magazines developed rapidly. Nudity was still taboo, but publishers titillated the public with photographic features on actresses and models (euphemistic descriptions, one assumes, for ladies engaged in an older profession) in as few clothes as possible. One popular device was the *tableau vivant*, a posed recreation of a famous painting or historical scene in which there was an excuse for nudity. Bad taste, one may think, can scarcely go further. *La vie Parisienne*, the first 'girlie' magazine

Reg Butler. *Girl*. 1953–4. Tate Gallery, London.

(founded as early as 1863), went further than contemporaries in the early 20th century in displaying nudity but by using drawings rather than photographs.

Despite the popularity of naturism in the German countryside and the growth of striptease shows in murkier metropolitan environments, it was virtually impossible to publish legally photographs of nudes in the 1920s and '30s except in art magazines. The pin-ups of the Second World War (when the term 'pin-up' first came into use – to describe the pictures of girls that U.S. servicemen tore out of the magazine *Yank* and pinned to their lockers) remained fairly decorous in one-piece bathing suits. The pin-up

Bill Brandt. Photograph. Brandt specialized in creating beautiful and unusual images which suggested forms and objects far removed from the human body that was their source.

Right: Henry Moore. *Recumbent Figure.*
1938. In spite of some popular bewilderment,
Moore was never a revolutionary artist; he
combined the theme of 'truth to materials'
with strong and unambiguous human
emotion. Tate Gallery, London.

Below: Paul Delvaux. *Venus Asleep.* 1944.
Surrealist imagery in a world of dreams. Tate
Gallery, London.

Jane Fonda in the science-fiction cinematic frolic, *Barbarella*.

of this period was usually an actress, more specifically a film star. The cinema – that 'temple of sex' as Jean Cocteau described it – had from its earliest days promised to be a powerful erotic agent in society and for that reason films were constrained, in some places, by even tighter censorship than other visual and commercial arts. Once the U.S. Supreme Court had ruled that the cinema could not exploit the constitutional right of free speech, censorship began to clamp down on the burgeoning industry. That did not mean sex was banished. On the contrary, it remained the most likely ingredient of a box-office success. But nudity had to be avoided, even in the lavish orgy scenes of the epics of a director like Cecil B. de Mille. Films that did show nudity, no matter what the context, were almost invariably banned from public exhibition or at least, like many of Erich von Stroheim's movies and most of the Surrealist films of the 1920s, shorn of their more revealing scenes.

Stars like Valentino, Clara Bow or Louise Brooks appeared in publicity posters in a state of near-nudity, but the motion pictures they advertised were more reticent. Hollywood itself, however, acquired a reputation as a den of vice, and Hollywood scandals were alleged to be ruining box-office receipts. Though it seems unlikely that this was the real reason, Hollywood decided to put its house in order by setting up the Hays Office, which imposed rigorously puritanical self-censorship on the industry, especially after the introduction of sound in the late 1920s.

One effect of the Second World War was to undermine those frail and phoney structures like the Hays Code with which well-meaning people had attempted to conceal reality from the masses. The cinema, more particularly the Italian and the French cinema, led the way, and from the early 1950s there was a general relaxation of rigid moral standards, a growing acceptance of taboo subjects, and a bolder approach to nudity in advertising and the popular arts generally. The pin-ups of the 1950s were really no more frankly sexual than their predecessors in the 1930s and 1940s, but they usually displayed more of their bodies. Even the sex queen of still-puritanical Hollywood, Marilyn Monroe, posed nude for a calendar, though before she became famous. (According to legend, when a shocked reporter asked her if it were true that she had posed with nothing on, she replied that it was not; she had the radio on.) Brigitte Bardot, the French sex symbol, was frequently to be seen in a state of near-nudity, though she usually made two versions of such scenes in her films, one of which was a more modest one for the American and British markets.

Scandinavia originated the fashion for films about nudism, which proved that naked human bodies are not in themselves necessarily erotic. This particular genre faded away during the 1960s when it became possible, for the first time, to show total nudity in the popular media without incurring prosecution. In the cinema the taboo against nudity proved strangely persistent, still exercising considerable influence on bathing and bed scenes long after more sensational behaviour, such as rape, had become tacitly accepted as tolerable in popular cinema. Jane Fonda's striptease in free fall in *Barbarella* was regarded as daring in 1968, but within a few years virtually all restrictions on nudity in the mass media had disappeared.

Advertisers have long been aware that goods may be sold profitably by the device of association – erotic images exploited to stimulate interest in an unrelated product. The traditional model on the bonnet of a car at a motor show is a well-known example; it appears that men (and perhaps women too) are more likely to buy the car thus decorated in spite of being fully conscious that the girl will not be delivered with the vehicle. Despite the attacks of the women's liberation movement, the motor industry and associated manufacturers have made heavy use of this type of device, and in the case of the legendary calendars of the Pirelli Tyre Company, what began as a glossy pin-up show has turned

Far right: the archetypal pin-up, Betty Grable, 1942.

Below: Rudolph Valentino as Pan, a film publicity photograph.

into a collectable item, early editions of the calendar, which was never very widely distributed, fetching large sums at auction. The use of the female (and occasionally, male) body in advertising expanded enormously with the development of colour photography and printing. When the Vargas girl, the archetypal American pin-up who originally appeared in *Esquire* magazine (and survived a prosecution for obscenity in the 1940s), moved to *Playboy*, she took second place to the photographic pin-ups in that magazine (which, it is said, convinced a generation of young American males that women have staples in their stomachs). The chief distinction of *Playboy* was the quality of the photography: the picture editor of the magazine in the 1970s was quoted as saying that only eight photographers in the United States were capable of photographing the magazine's central fold-out picture, for which a very large camera was used. It is permissible to suppose that pride in his product led him to name a rather ridiculously low number; however, it is apparently not unknown for a *Playboy* photographer to take three weeks over the central spread, using up hundreds of sheets of expensive colour film in the process.

Perhaps there is some redundancy in craftsmanship of this order devoted to such a purpose (who needs a gilded mousetrap?). Serious photographers of the nude have usually operated less expensively and with more interesting – and often more erotic – results. The American photographer John Rawlings explained in a book published in the 1960s, the significance for him of photographing the female nude. The results, he said, were really the result of a collaboration between three parties: photographer, camera and model. The role of the camera is, or can be, a more important one today than it was one hundred years ago, before the days of high-speed lenses and fast film. In particular, as Muybridge had demonstrated, the camera can see what the eye cannot, isolating a hundred or more separate moments in one split-second movement of the human body. But this quality of superhuman precision is not the only asset for the photographer. By varying the

Left: Mel Ramos. *Ode to Ange*. A good-natured pun on the famous painting by Ingres, *La Source*. Collection Charles Wilp, Dusseldorf.

Right: The nude in advertising, in this case of a goose-down quilt.

exposure time, the camera can be made to see *less* distinctly than the human eye, and the creative photographer can make use of this feature equally. The news photographer or even the fashion photographer may be concerned only with the faithful reproduction of his model, but the photographer-as-artist may have quite different ambitions. He wishes to create a picture, not unlike a painter, with the aid of his tools and his imagination, and he uses the adaptability of lens, lighting, etc., to create a certain kind of effect. For example, he may emphasize mass, at the expense of detail, by placing the model in the foreground against a light backdrop and deliberately under-exposing the film. Or he may achieve a dreamy, insubstantial-looking effect by overexposure and 'soft' focus (i.e. taking the photograph deliberately out of focus). The devices available to the modern photographer are numerous.

The fine arts in recent years have been unwilling to surrender the erotic nude entirely to photographers and commercial artists. It has even been argued that eroticism and the nude have been at least partly responsible for the survival of figurative art in an age of abstraction – it is hard to imagine a genuinely erotic abstract painting. A notable feature of contemporary art, besides its frankness on the subject of sex, is its association with the imagery of popular culture. Not only have the advertisers made free with the whole tradition of fine art (and music for that matter, finding, for example, that Beethoven helps to sell chocolates), but artists have repaid the compliment by plundering the world of the admen and the entertainers. As we have seen, this is

Right: Barbara Hepworth. *Two Figures (Menhirs).* 1964. Polished slate. Tate Gallery, London.

Below: Constantin Brancusi. *Torso of a Young Man.* 1925. Polished bronze on limestone, wood base, 152.5 cm (60 inches) high. Collection Joseph H. Hirshhorn, New York.

David Hockney. *Man in Shower in Beverley Hills*. Acrylic on canvas. 65½" × 65½". © David Hockney 1964. Tate Gallery, London. (Courtesy Petersburg Press.)

not exclusively a recent development – artists in the 18th century used cheap lithographs as source material – but it has become much more pervasive in the past thirty years in the work of artists who are sometimes grouped together under the name of the New Realists, a term which admittedly embraces a wide variety of styles.

A pioneer of this movement was Marcel Duchamp, whose great influence on modern art was a result more of what he was than what he painted: Duchamp executed very few works of art in a traditional sense. His *Nude Descending a Staircase*

interpreted movement in the Cubist manner, but he became better known as an exponent of the 'anti-art' doctrine of Dada, and for his insistence that a 'found object' (such as a urinal or a bottle rack) was art if the artist presented it as such. The Cubists made collages using bits of newspaper and other 'non-art' ingredients, and some American and Russian artists in the 1930s adopted the images of commercial packaging and advertising. De Kooning's *Woman* series seems without doubt to owe something to the contemporary big-busted pin-up, but the next generation of American artists

rejected his 'painterly' qualities and produced works that looked very similar to the actual advertisements, comic strips, etc. from which they derived. They even employed some of the techniques of the popular arts. An artist like the West Coast American Mel Ramos painted pin-up pictures as good-humoured satire on the use of eroticism in advertising. His *Ode to Ange* (the title is a rather horrible pun) recalled the famous painting by Ingres; his *Gorilla* appears to have been inspired by a type of B-movie poster.

A more complex artist, Tom Wesselman, began his series of *Great American Nudes* in 1962; they gradually became more sexually explicit although Wesselman's painterly preoccupations always

remained clearly evident, so that his work was described by one critic as 'genuine high-art pornography' (a category, certainly, which one would not care to have to define too closely). Artists like George Segal and, later, Judy Chicago, specialized in life-size plaster figures. One of the best of the younger generation of British artists, David Hockney, made a contribution to the tradition of beautiful young male nudes celebrated by so many Renaissance artists, while women artists were particularly prominent in the so-called 'New Realism'. Some women painters made humorous if ambiguous comments on the whole history of the nude in Western culture by painting rather beautiful male figures in a style recalling the boudoir nudes of the old masters, while others gave freer rein to female resentment of male domination and adopted a more aggressive attitude towards the male as a sexual object. Although these new variations on an ancient theme may reflect transitory preoccupations only, they do suggest that the concept of the nude as an expression of personal conviction is far from dead.

The future of the nude in art cannot be forecast with any confidence, any more than the future of art itself. But inasmuch as it is undoubtedly safe to assume that art *has* a future, it seems more than probable that, in some way or other, the concept of the nude will continue to exercise the mind and emotions of artists.

Far right: Picasso. *Woman Dressing her Hair.* 1940. In his Cubist phase, Picasso sometimes seemed to take his rejection of the traditional 'beautiful' nude to almost perverse lengths. Collection of Mrs. Betram Smith, New York.

Below: Mel Ramos. *Gorilla.* 1967. Oil on canvas. Collection Thomas McGreery, Kansas.

Bottom: Matisse. *La Danse.* Detail. 1932. Matisse sought to refine the nude to basic elements. Musée d'Art Moderne de la Ville de Paris, Paris.

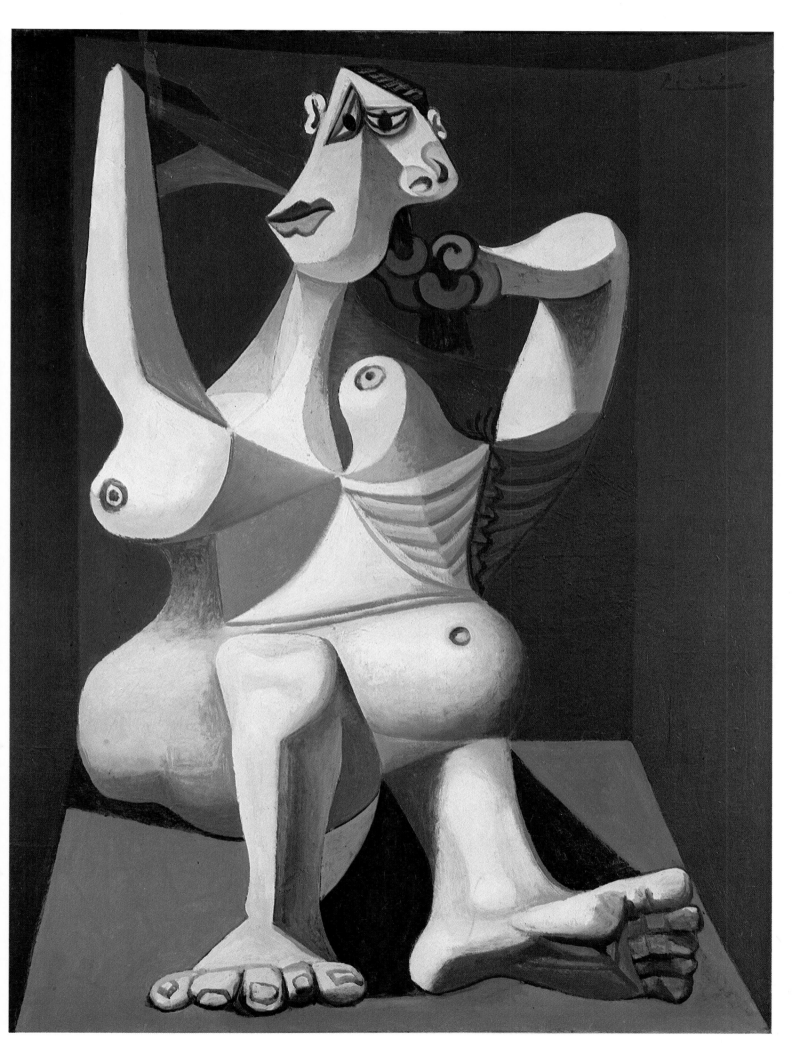

Acknowledgments